THE ART & TECHNIQUE OF
UNDERWATER
PHOTOGRAPHY

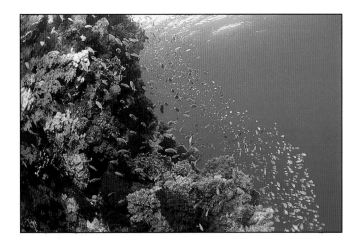

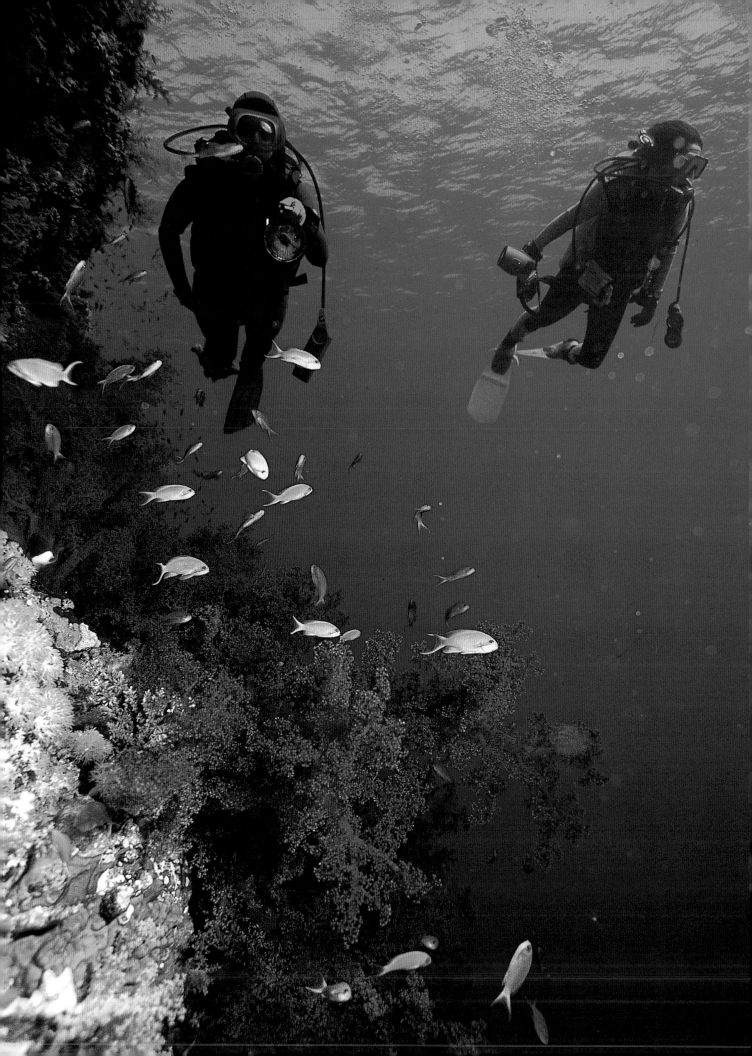

THE ART & TECHNIQUE OF
UNDERWATER
PHOTOGRAPHY

TEXT & PHOTOGRAPHS BY
Mark Webster

DESIGNED BY
Grant Bradford

FOUNTAIN PRESS

*For Puzy for understanding and sharing this
passion with outstanding patience.
Without you this book would not have been possible.*

Published by
Fountain Press Limited
Fountain House
2 Gladstone Road
Kingston-upon-Thames
Surrey KT1 3HD

© Fountain Press 1998
ISBN 0 86343 352 9

Text & Photographs
Mark Webster

Design & Layout
Grant Bradford

Typeset & Planning
Rex Carr

Diagrams
Alisa Tingley

Reproduction
Setrite Digital Graphics
Hong Kong

Printed and Bound
in China

CONTENTS

INTRODUCTION

Many divers find that once they have completed their basic and advanced training, simply going diving is not enough. They need an additional purpose or objective to a diving excursion. This may transpire to be wreck research, salvage or archeological diving, technical or deep diving, an interest in marine biology and conservation or increasingly the desire to bring back a record of the dive in the form of photographs. This can become an occasional or all absorbing activity (for some it becomes the only reason to dive) but many are initially wary of the technicalities or the commitment of both time and money. There is no doubt that any additional activity within diving will cost you something, but with prudent choice, photography need not cost more than the alternatives. Additional pursuits all require dedication of time and effort and mastering underwater photography will require its fair share of both. However, it is an activity that you can pick and choose for each dive and, dependent on the level to which you aspire, by following a few basic rules, techniques and principles, you will be able to produce some very respectable results almost immediately.

Underwater photography is potentially the most difficult of photographic disciplines as most techniques which work well on the surface usually fail miserably underwater. In addition you are required to work in a totally alien environment, monitor your life support system, buoyancy and prevailing sea conditions, whilst using the skills of a hunter and artist and coping mentally with what appears to be a host of technical gobbledegook!

This book is therefore initially aimed at anyone who is considering taking up underwater photography, but it also has the scope to help the more experienced photographer develop specific techniques, perfect particular subjects. There is even advice on entering competitions and selling your work. The subjects covered by each chapter are designed to allow you to pick your entry level so that both the beginner and more experienced photographer can expand and hone their skills within each technique before moving on to the next.

For some the principles and basic techniques will come easily but this will not necessarily lead to immediate success. The key to successful and repeatable results in underwater photography is to practice the techniques until you are satisfied with the results and understand why it worked or failed. Patience and attention to detail, as in most disciplines, are the attributes which distinguish a good photograph from an average one.

Although many of the photographs in this book are taken in warm or tropical waters, these locations are not essential for successful underwater photography. Temperate and cold waters are teeming with life and colour and are often home to species with tropical relatives. Often water clarity is no match for warmer locations, but under these circumstances we must apply techniques and equipment to suit the conditions – examples of this will be found throughout the book. So, if you cannot afford those overseas trips do not be disheartened as your home waters will still offer great potential. Equally, if you do dive regularly abroad, don't dismiss your home waters as they will offer an excellent variety of subjects and provide the opportunity to perfect techniques.

Wherever you choose to dive one of your first considerations must be your personal safety and that of the fragile marine environment around you. Underwater photography absorbs most if not all your attention so you must be qualified and proficient in your diving skills to minimise distractions and also to ensure that you have control of your buoyancy and equipment which can so easily damage delicate corals and reef organisms. Conservation in our seas does not apply only to the disposal of our waste products or over fishing, but also extends to all our activities within it. With the increase in the popularity and accessibility of sport diving, conservation is becoming an increasingly important issue and we as photographers have a particular responsibility to ensure that the environment we are recording remains undamaged for future diving generations.

I hope that this book will provide you with basic skills, speed your development and help you produce successful underwater images time and again.

When I had completed this book I felt that in addition to my own introduction I needed a foreword from someone whose name would be instantly recognisable to both existing and novice underwater photographers. I knew instinctively that this task

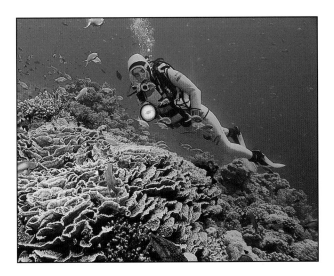

should go to Peter Scoones, a character who has influenced many of today's top photographers and whose career as a stills photographer encompasses all the major developments in equipment and techniques since the late 1960s. He now also enjoys world renown as one of the leading underwater film cameramen and naturalists of this era. Peter was one of the founder members of the British Society of Underwater Photographers and soon gained a reputation as a great technician both through the design and manufacture of his own equipment and the exacting standards he maintained when producing his photographs. Things have moved on dramatically since then with the development of commercially available equipment and the sports diving industry in general. In writing my own introduction I have tried to deliver the message that all divers should respect the environment that they are entering and that underwater photography should be regarded as a conservation tool. I asked Peter to reflect this message in his foreword which I feel he has captivated admirably.

Many thanks Peter.

Falmouth, Cornwall

"Nearly half a century ago I used to play truant from school and sit in the local cinema watching the same film over and over again. It held me spellbound because it combined a sense of adventure with the romance of exploring a world which at the time was unknown to me and millions of other people. The film made that world seem accessible and also was an invitation to explore its wonders.

The film which regularly lured me away from my studies was "Under the Red Sea" by Hans Hass, the legendary Austrian underwater explorer and film-maker. Along with the work of the late Jaques Cousteau it helped to attract thousands of people into the sea to gaze at its wonders.

Purists will point back to Louis Boutan and others as the real pioneers of underwater photography but, for me, Cousteau and Hass were the first to effectively use the medium of underwater photography and films to popularise the world beneath the waves.

Of course, modern diving owes much to Jaques Cousteau. He was the catalyst behind the development of the first practical aqualung and the Calypsophot amphibious camera - subsequently developed into the popular Nikonos range - as well as pioneering underwater exploits.

But it is through the medium of film and television that the photographer reaches out far beyond the underwater world to touch vast audiences and influence the lives of millions of people in all walks of life.

In doing so the wildlife photographer faces a dilemma. Should he or she celebrate the wonder and variety of the natural world or should they labour man's threat to the environment? On the one hand utopian, the other gloom and doom. In Cousteau's films silver-suited heroic aquanauts brought the wonders of the deep into your living room and also carried the environmental warning; very popular entertainment, like "Batman and Robin".

Hans Hass's approach was much more down to earth. Without the heroics or the message, it was the creatures that were the stars. Wonderment, enthusiasm and a sense of involvement seemed to suggest that exploring this world was not the domain of superhumans and I could also join in. So I did – I prefer the romantic".

Peter Scoones, London

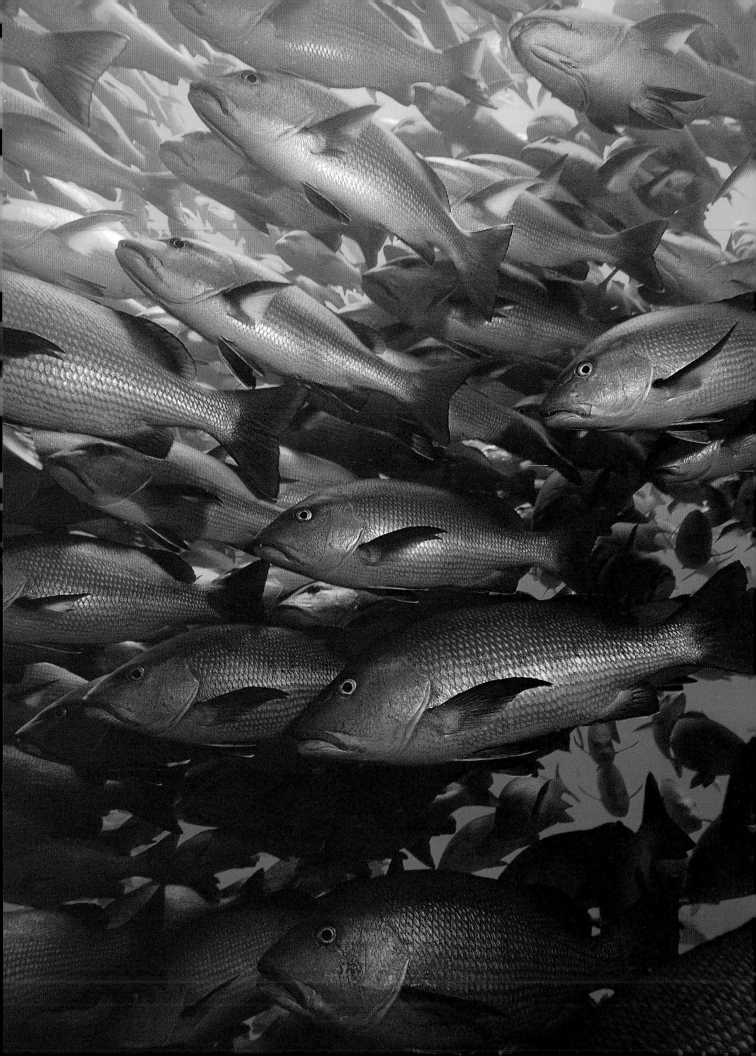

BACK TO BASICS

Okay, so you have taken that momentous decision that underwater photography is for you and the first essential you find you are lacking is the camera. This is where the first of many problems begin with a plethora of both well intentioned advice and cameras to choose from! Unfortunately this initial decision is normally controlled by how much money you can afford, or you are prepared to spend, on this new piece of equipment before you can be really sure that you like taking photographs underwater. So before imparting any advice let's look at the options. Throughout this book we will only consider 35mm film format cameras. Whilst undoubtedly there are a number of excellent larger film format options, these are not widely in use even with professional underwater photographers. The quality of 35mm films is now so good that it can match the larger format for most purposes and for many the bigger cameras and housings are too unwieldy and expensive for underwater use.

Splash Proof and Shallow Water Cameras

If you feel that your photography will be limited to simple snapshots whilst snorkelling or diving in shallow water then this may be the route to choose. These cameras range from the very basic disposable units, which cost only a few pounds, through simple housings for cheap cameras to waterproof high tech compact cameras costing £200 and more. Although they vary wildly in both cost and quality what they do have in common is their depth range which is limited to between 2 to 5 metres.

Amphibious Cameras

These are cameras designed specifically for underwater use and form the basis of a system for various lens types and accessories. Your choice is really

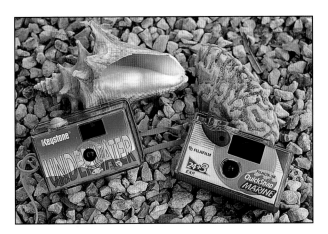

Single use waterproof cameras. Splash cameras are the cheapest way to start underwater photography *but are really restricted to use in snorkelling depths only.*

limited to one of the Nikonos series manufactured by Nikon or the Sea and Sea Motormarine which is currently in its latest Mark II version. Sea and Sea also manufacture a more basic amphibious camera called the Explora which, although it is of a high quality and waterproof to 45m, does not have the range of accessories available for the more serious photographer. All of these cameras are 'range finders' which simply means that the view-finder is separate from the lens (i.e. you do not view the picture you are taking through the lens) which you must focus manually after estimating the distance to your subject – hence finding the range of your subject.

The Nikonos is a professional grade camera which has been in production in various guises since the 1960's, but whilst the earlier models can be perfectly serviceable, spares and accessories can be a problem so it is better to limit your search to the Nikonos III, IVa or V. The Nikonos III is a totally manual camera with no auto-exposure or even a light meter, but is built like the proverbial tank (some would say this is the best model produced). This means that you must 'manually' deduce all your exposure calculations. The later IVa offers automatic exposure and limited manual functions whilst the V has automatic exposure, through the lens metering and full manual

A phenomenon of the summer months in the Red Sea is the gathering of huge shoals of mating fish such as these Red Snappers. With their minds on more important things they all but ignore the patient photographer.

Red Sea, Nikon F801, 16mm f2.8 fish eye, Subal housing, Ektachrome Elite II 100, f11 1/60. Lighting from one Sea and Sea YS120 flash gun set to manual on half power.

1

2

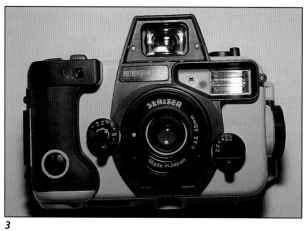

3

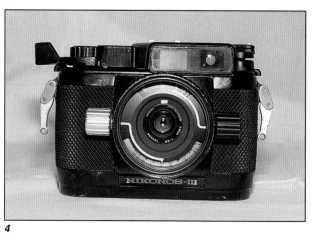

4

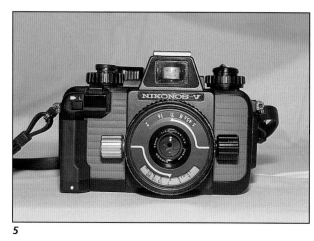

5

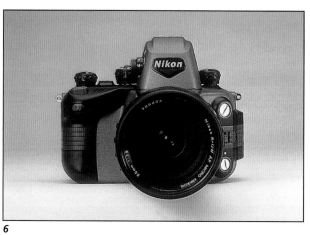

6

7

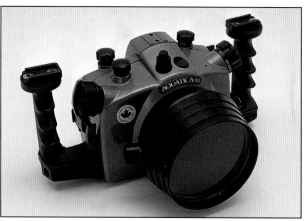

8

override facility. (These terms will be explained fully in the following chapter) Prices range from £300 for a second hand III or IVa to £450-650 for a V or around £800 for a new Nikonos V with standard lens. A range of Nikonos lenses are available from Nikon and independent manufacturers and all models feature the same lens mount.

There is another Nikonos model, which has recently gone out of production, and this is aimed at the very serious amateur or professional photographer, or the very seriously rich beginner! The Nikonos RS is the world's only amphibious auto focus, single lens reflex camera which boasts almost every feature you could hope for. This model differs fundamentally from the earlier Nikonos as it features a through the lens viewing system previously only available on land cameras in an underwater housing. It has a comprehensive range of lenses and accessories available and seems an ideal choice until you realise that the camera body alone will set you back £3000 or more and a basic system at least £6000. However if you are made of money don't be put off by the price as it is the 'Rolls Royce', although not perfect in all respects, and the following chapters will apply equally to the RS.

The Sea and Sea Motormarine cameras originally appeared as a 'mid market' alternative to the splash cameras and the Nikonos. But the latest Motormarine II is now a full system camera which has many of the features of the Nikonos V and is somewhat cheaper. The major differences are that the standard camera lens is not removable, so the differing lens types are 'supplementary' or 'add ons'. Early models lack the range of manual features on the Nikonos, but the latest now has a selection of manual shutter speeds available. Purists may argue that without an interchangeable lens system (or prime lens system) picture quality will suffer, but many photographers start with these cameras and are perfectly happy with the results. Expect to pay around £2-300 for a second hand Motormarine II, perhaps £5-600 for a complete second hand system and £525 for a new camera.

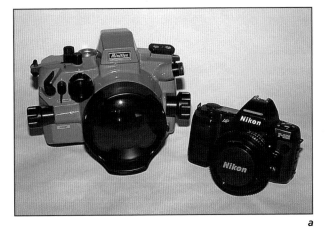
a

b

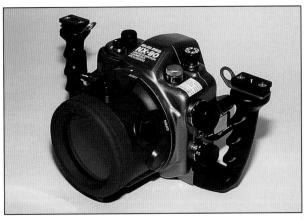
c

Left:
1 Snorkeller with single use Fuji and Keystone waterproof cameras. Splash cameras can produce respectable results in shallow water and are ideal for swimming pool shots.

2 Sea & Sea MX10 camera with YS40 flash gun. An entry level system camera.

3 Sea & Sea Motormarine II-EX. A full system range finder camera with features similar to the Nikonos V.

4 Nikonos III – this manual model was manufactured during the 1970s and is still in high demand on the second hand market.

5 Nikonos V. The Nikonos V is the current range finder model with auto exposure and TTL flash facility.

6 Nikonos RS. The world's only amphibious SLR was manufactured between 1992 and 1996 and is now only likely to be available on the second hand market.

7 Sea & Sea SX 1000 housing. This is sold as a system complete with Sea & Sea's own manual focus SX 1000 camera.

8 Aquatica 90 housing for the auto focus Nikon F90/90X.
(photo courtesy of Benny Sutton, Underwater Images)

Above:
a Subal housing for Nikon F801/S.

b Seacam Minicam for the auto focus Nikon F801/S.
(photo courtesy of Benny Sutton, Underwater Images)

c Sea & Sea NX90 housing the auto focus Nikon F90/90X.

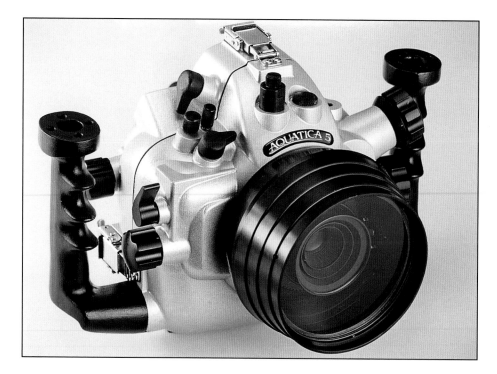

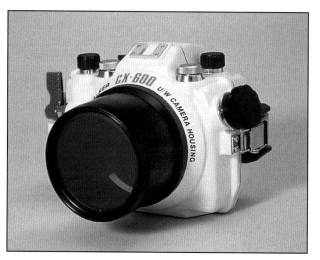

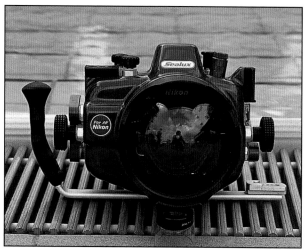

Left: Aquatica 5 housing for the latest professional camera from Nikon, the auto focus F5.

Below left: Sealux housing for the auto focus Nikon F90.

Below right: Sea & Sea CX-600 – Sea & Sea's latest compact housing for the auto focus Canon EOS 500N/ Rebel G series.
(photo courtesy of Sea & Sea.)

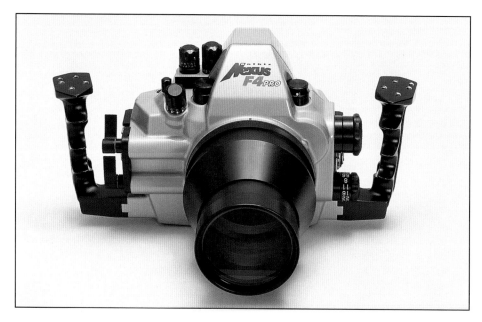

Nexus housing for the auto focus Nikon F4.
(photo courtesy of Anthis Inc.)

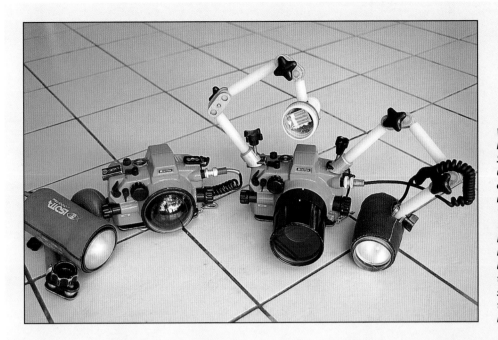

WHAT I USE
Nikon F801s housed in
Subal Miniflex housings
used with 16mm fish
eye, 20mm, 60mm
micro, 90mm macro,
105mm micro and
180mm macro lenses.
Flash guns include
models from Sea & Sea,
Isotecnic and Subatec
together with small
slave flash guns in
torch housings for
macro photography.

Housing a Land Camera

The third option may be considered if you already own a land single lens reflex camera (SLR – you view and focus through the lens), or you plan to take your photography very seriously from the start, or you want a system that will match the features of the attractive Nikonos RS but on a much tighter budget. The introduction of auto focus, auto wind compact SLR's in recent years has propagated a healthy market for housing manufacturers. If you are starting from scratch with a new or second hand auto focus SLR then you will have upwards of nine or ten different housings to choose from varying in price from £400 to £1800. If your camera is an older manual model then you may find that you are restricted to the second hand market, which can be surprisingly fertile and is also a good place to look for a bargain complete system built round an older manual camera.

Many novice and experienced photographers in the past may have been put off housed systems by their size and weight. Whilst this was a feature of the older systems, most of the latest generation of housings are extremely small having been designed as a 'glove fit' for a particular camera and they are therefore very light and manageable. These housings accommodate a huge range of lenses, many again available on the second hand market, and whilst the initial outlay for housing and camera is more than say for the Nikonos, it could be argued that you will start with a much more flexible system. The most popular cameras in use currently are the Nikon F601 / F801s / F50 / F70 and F90, and some of the Canon EOS series and the Minolta Dynax series.

The best approach, as with any option in life, is to try and see and handle as many of the choices as

Seacam Minicam Pro for the
auto focus Nikon F90/90X.
(photo courtesy of Benny
Sutton, Underwater Images)

possible and seek experienced opinion from practising underwater photographers. This means touring the specialist retailers and dive shops initially, or a good alternative for finding this mixture of talent and experience is to visit the British Society of Underwater Photographers who meet monthly in London, provide a regular news letter and have a very friendly and active membership (see appendix for details).

So now perhaps you are closer to choosing your camera. The next few chapters will discuss the basic functions of your camera, the differences between photography and the behaviour of light on land and underwater, flash guns, lenses and eventually how to take particular picture types. So follow this progression or skip those parts you are already familiar with and get to grips with the techniques you need.

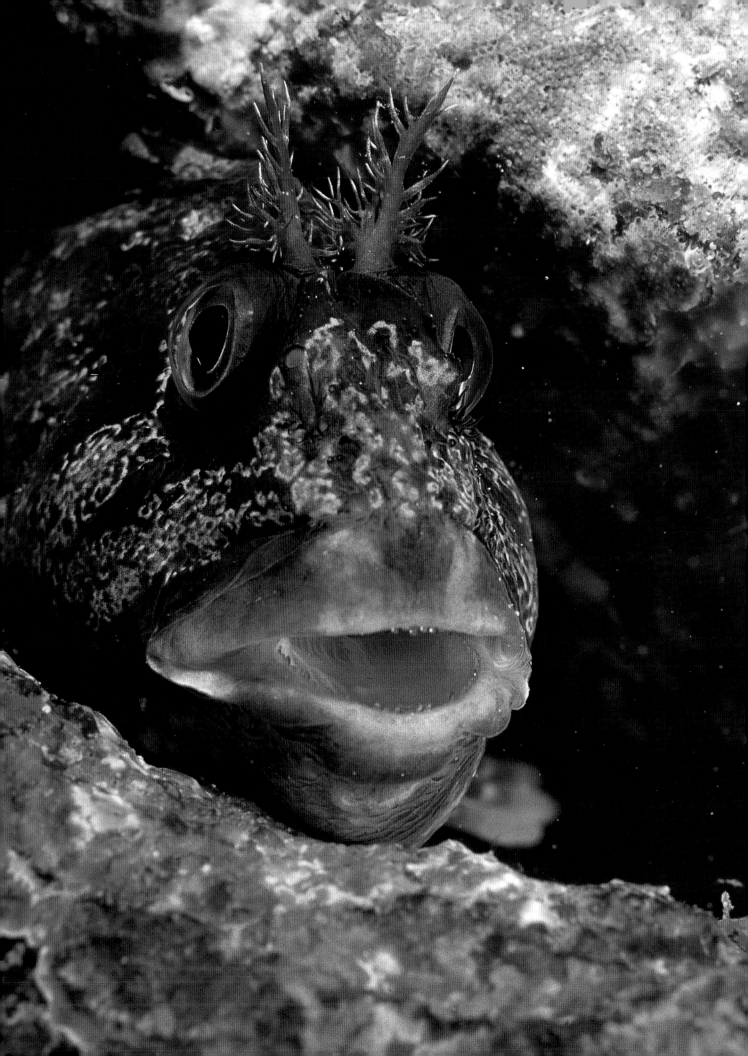

GETTING TO GRIPS WITH FUNDAMENTALS

I am sure we have all encountered underwater photographers at diving club meetings and overheard deep discussion of 'F Stops', 'Shutter Speeds', 'Depth of Field', 'Apertures' and a host of other terms which makes this activity so much like a black art. It is probable that many are put off trying photography simply by the thought of having to cope with all this information. Whilst it is helpful to understand a few fundamentals of photography, you are not required to become an expert to produce a good picture. This second chapter will seek to dispel the myths surrounding these mysterious terms by explaining each in layman's terms. If you are someone who enjoys or needs more detail or further explanation of these terms, then there is an almost endless variety of books on photographic techniques which will provide deeper discussion.

The Camera

Even the most expensive auto everything camera comprises four basic components to produce a picture: a light tight box with an adjustable hole in the front (the Aperture); a cover which closes the hole and can be removed and replaced within precisely timed duration's (the Shutter); a light sensitive material on which an image is formed (the Film); and a means of focusing the light entering the box (the Lens). The combined use of these components produces a picture the quality of which will depend on either the photographer's skill or the level of automation the camera provides! By quality in this context I mean only the accuracy of exposure and focusing in the final image. So, to make more sense of this, let's take each of these components and examine them in a little more detail:

Tompot blenny. Even in British waters we have some vividly coloured fish, some of which ooze with comic character like this Tompot blenny. This species is very inquisitive and patience will reward you with some striking poses.

Cornwall, UK, Nikon F801, 60mm f2.8 micro, Subal housing, Ektachrome Elite II 100, f22 1/250. Lighting from one Sea & Sea YS50TTL flash gun, with a YS30 set to slave to fill shadows.

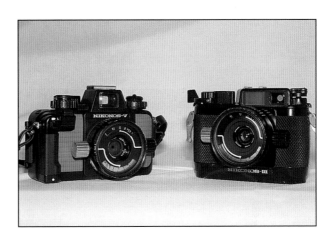

Nikonos III and V – the Nikonos V is the current range finder model with auto exposure and TTL flash facility.

Film

There are two types of 35mm film commonly used in underwater photography; Negative film in both colour and black and white from which a print is produced; and Reversal or Transparency film from which a slide or positive image is produced (you can also produce a print from your slides in a separate process).
The type of film you use is a personal choice but many underwater photographers stick to slide film for a variety of reasons – mostly cost, as you can process the image easily yourself, and the eternal hope of publication, as both magazines and books prefer slides to print from! The next choice to make is the speed of the film. This expression merely refers to the amount of light required to produce an image on the film, i.e. it's sensitivity to light. In the UK this sensitivity is expressed as an ASA (American Standards Association) rating and is quite easy to understand. A slow or low sensitivity film will have a low number (e.g. 25 ASA, 50 ASA), a medium speed film a mid range number (e.g. 100 ASA, 200 ASA) and a fast film a high number (e.g. 400 ASA, 1000 ASA). Slow films have a very high resolution (fine detail) and are therefore good for close-up work where a sharp image is required. As the film speed increases the

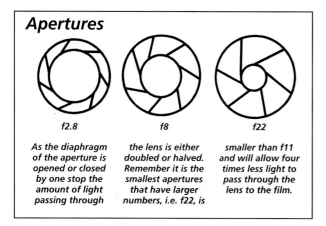

Apertures

f2.8 — *As the diaphragm of the aperture is opened or closed by one stop the amount of light passing through*

f8 — *the lens is either doubled or halved. Remember it is the smallest apertures that have larger numbers, i.e. f22, is*

f22 — *smaller than f11 and will allow four times less light to pass through the lens to the film.*

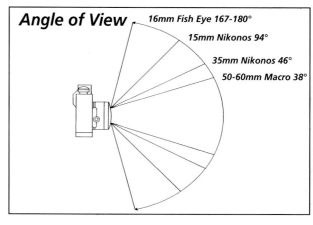

Angle of View

16mm Fish Eye 167-180°
15mm Nikonos 94°
35mm Nikonos 46°
50-60mm Macro 38°

Comparison of the angle of coverage underwater from different lenses.

resolution generally decreases and the image will get more grainy and less sharp. Many photographers will stick with 100ASA to begin with as it offers reasonably fine grain and is 'fast' enough for most light situations. Each increment in film speed is sometimes referred to as an exposure 'stop' and we will use this expression again when we discuss exposure later on.

Aperture

You will find the aperture or iris within the lens or individual lenses for your camera. Essentially it is an adjustable hole which allows light to pass through and expose the film. The size of the hole is adjusted in equal increments and is expressed in F Stops (that word again) or F Numbers. A typical range of F stops might be F22, F16, F11, F8, F5.6, F4, F2.8 which looks strange at first but it is easiest to remember that the larger the number the smaller the hole and conversely the smaller the number the larger the hole i.e. less or more light is allowed to pass through the lens. With each step up or down the scale you will either double or halve the amount of light passing through the aperture, e.g. F11 is twice the size of F16 and F5.6 is half the size of F4.

Shutter Speed

The shutter is located within the camera body between the aperture and the film. Its function is to control the length of time that the film is exposed to light passing through the aperture. Once again this is achieved in incremental steps expressed as fractions of a second. A typical range would include : 1/30th, 1/60th, 1/125th, 1/250th, 1/500th, 1/1000th and so on with some cameras reaching 1/4000 or even 1/8000th! Yet again these increments will double or halve the duration that the shutter opens and can be referred to as stops. The shutter speed that you will choose for a given subject will be affected by a variety of factors, however as a generalisation slow shutter speeds (e.g. 1/30th or 1/60th) are used for very slow moving or stationary subjects and fast shutter speeds (e.g. 1/500th or 1/1000th) are used to freeze the motion of a fast moving subject.

The Lens

The lens provides the method of focusing your image onto the film. How much the lens 'sees' is governed by its focal length which is measured in millimetres. Basically the shorter the focal length the more the lens sees, or the wider its angle of view, and the longer the focal length the narrower its angle of view.

As a rough guide, on a 35mm format (e.g. Nikonos) camera a 50mm lens is calculated to provide the same angle of view as the human eye. Lenses of 100mm or more are termed Telephoto lenses as they are able to focus on subjects at greater distances. There are variations to this basic rule, notably macro lenses which are lenses in the 50 to 200mm range specifically designed to photograph small subjects in close-up. Generally in underwater photography you need to get as close to your subject as possible to reduce the amount of water, and therefore the number of particles suspended in it, to an absolute minimum.

For this reason the majority of underwater photographs seen are either taken with a wide angle lens, which allows you to get close to large subjects, or with a close-up or macro lens which allows a close approach to a small subject. The effects that this water medium has on particular lens types will be discussed in detail in a following chapter. One other important term associated with lenses is 'Depth of Field'. This refers to the area in front of and behind your subject that will be in focus when you take a picture. The distance or depth of this area varies with both the aperture you choose and the focal length of lens in use.

The general rule of thumb is that small apertures give greater depth of field and that wide angle (i.e. short focal length) lenses have an inherently greater depth of field than telephoto or macro lenses (i.e. long focal lengths).

Depth of Field

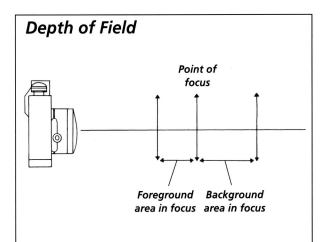

Point of focus

Foreground area in focus **Background area in focus**

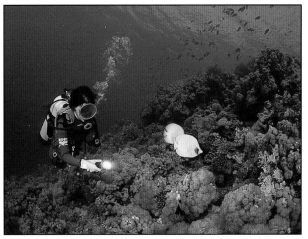

Depth of field refers to the area in front of and behind the subject on which the lens has focused which will also be in focus when the shutter is released. Depth of field is affected by the aperture in use and the focal length of the lens. Aperture: the smaller the aperture the greater the depth of field. Focal length: the shorter the focal length of the lens the greater the depth of field.

Diver with pair of masked butterfly fish. Red Sea, Nikon F801, 16mm f2.8 fish eye, Subal housing, Fujichrome Velvia, f8 @ 1/60. Lighting from one Isotecnic 33TTL flash gun set to manual on half power.

Exposure

The combined use of these fundamental camera components produces an exposure, that is the moment you press the shutter release and allow a certain amount of light, for a known duration onto film of a known sensitivity. So how do we work out what is the right mixture of settings to produce a correctly exposed image? The answer is by measuring the amount of light available at the time with a 'light meter' which will either be built into your camera or, in the case of manual cameras (e.g. Nikonos III), will be a separate unit. Once you have set your film speed on the camera or light meter you can then choose a shutter speed suitable for your subject and the meter will show you what aperture to use. This is known as using shutter priority selection. Alternatively select the aperture you want and the shutter speed is revealed which is called aperture priority selection.

Many modern computerised cameras will have a 'programmed' mode which will do everything for you, but it is useful to have a basic appreciation of how it is working. Given a constant level of lighting a number of different combinations of shutter speed and aperture will give the correct exposure dependant on your subject type and the effect you are looking for. This relationship between shutter speed and aperture is best demonstrated in the table below:

F 2.8 at 1/500th	F 8 at 1/60th
F 4 at 1/250th	F 11 at 1/30th
F 5.6 at 1/125th	F 16 at 1/15th

Light Meters

As mentioned earlier you will be measuring the light available either with an integral camera meter, or with a separate amphibious unit. Those built into the camera are generally TTL or 'Through The Lens' meters which assess the light actually passing through the lens onto the film surface in the camera. You will encounter three types of meter dependant on camera manufacturer and how well your camera is specified:

1. Centre Weighted – light is read from the centre of the film plane – the most common design and found on the Nikonos IVa, V and Sea & Sea Motormarine.

2. Matrix metering – the picture area is divided into several segments and light read from them is compared to give a correct exposure. This type of metering is available on the majority of auto focus SLR cameras suitable for housing and on the Nikonos RS.

3. Spot metering – light is read from a very small area in the centre of the picture area, similarly to centre weighted metering.

Many of the SLR cameras, including the RS, will offer the ability to switch between these three metering 'modes' giving the photographer the option of assessing which is most suitable for a particular shot.

Hopefully you are now beginning to make some sense of your camera's basic functions. Next we will investigate the problems associated with taking your camera underwater and how light behaves beneath the waves.

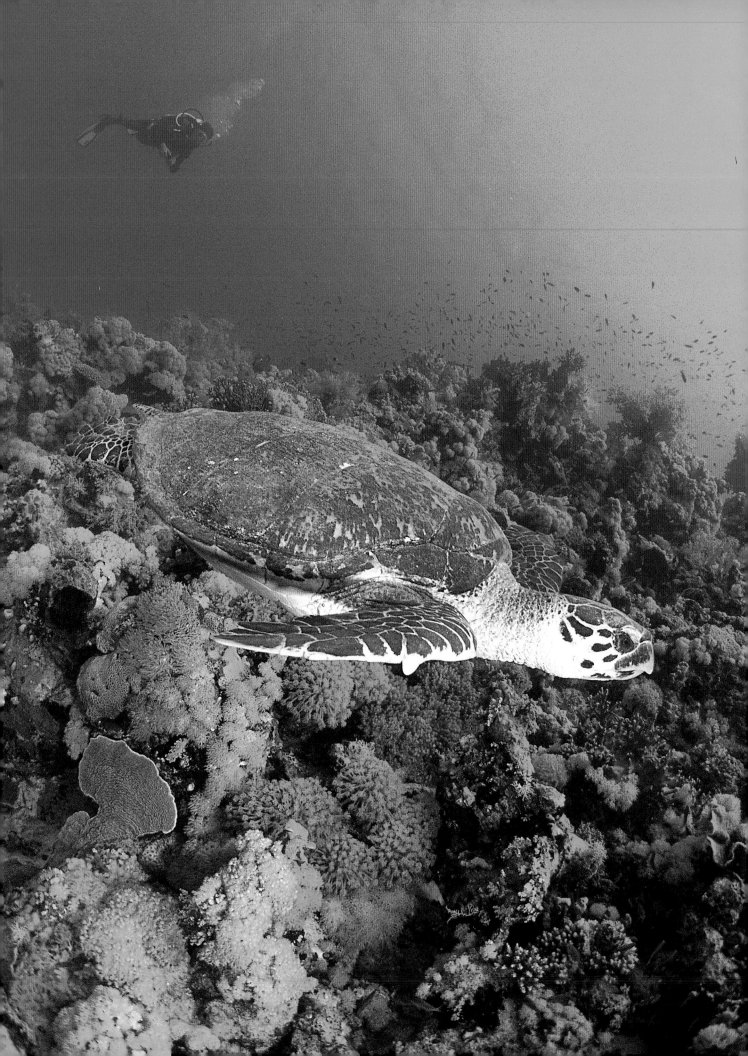

LIGHT IN THE SEA

Many budding underwater photographers start on a shoe string and perhaps can only afford to buy their camera and standard lens. Some better heeled aficionados may be wary of committing too much to this strange past-time and again only purchase the camera to begin. The one thing that they are likely to have in common is initial disappointment with their results – most of the photographs come back looking very blue or grey and grainy with poor definition and sometimes out of focus to boot. But they looked so good underwater and you are sure your exposure was spot on, so why did this happen?! In order to understand why, and how you can correct the problems, it is important to look at the way light behaves underwater.

It is easiest to understand these principles if we divide the behaviour into three major headings – Colour Absorption, Reflection and Scatter, and Refraction – and look at the ways to solve the problems.

Colour Absorption

Whether you dive in the waters around our coastline or in the clearest tropical waters, all divers will notice that as depth increases the colours around us appear to get more drab and grey or green. But if you switch your torch on suddenly you find that they blue/grey sponge in front of you is bright red! This is because white light or daylight is made up of several colours ranging from the warm end of the spectrum (reds and oranges) to the cool end (blues, green and grey) and water is a very efficient filter of light. It is however more efficient at the warm end of the spectrum and happily soaks up the red light by the time you reach 10 metres or so. This process continues the deeper you go until you are left with very little colour at all. Many of you will now say to yourselves " I'm sure I can recognise a red object at 10 metres!" and you would be correct in part. The human brain, being the

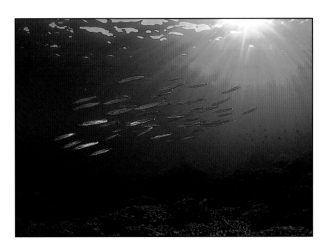

Barracuda shoal and sunburst. The quality of sunlight both early in the morning and late in the day can be particularly striking. This shot is taken in the Red Sea just before dusk when the sun is low and the combination of reflection and refraction produces *these attractive shafts of sunlight.*
Red Sea, Nikon F801, 16mm f2.8 fish eye, Subal housing, Ektachrome Elite II 100, f4 @ 1/125 to freeze the light shaft, fill flash lighting from one Subatec S100 manual flash gun on quarter power.

complex tool that it is, is able to compensate in part for this colour loss and allow you to still recognise these colours even if they are less vivid. Colour film however is balanced for use in daylight only and is unable to compensate and therefore records only what it sees. This rule applies not only to increasing depth but also to distance. So even in only a few feet of water, if you are too far from your subject the colours will be absorbed.

So what can we do? There are two options really, the first of which is to try and add back the missing red light by using a colour correction filter. This is done by adding a red filter of varying densities (grade CC30R is a good starting point) which will in fact not add red light but remove blue light. This however is only of use in water depths of 6 to 8 metres and it also reduces the amount of light reaching the film overall, thus affecting exposure. The second option, which is really an essential in underwater photography, is to provide an artificial source of light in the form of an electronic flash gun. This in effect provides the lost day light and restores the correct

Turtle and reef. This turtle is a resident of Jackson Reef in the Straits of Tiran. Although I had seen him many times, this was the first that he allowed a close approach with a wide angle lens.
Red Sea, Nikon F801, 16mm f2.8 fish eye, Subal housing, Ektachrome Elite II 100, f11 1/60. Lighting from one Sea & Sea YS120 flash gun set to manual on half power.

Colour absorption: Water selectively absorbs the colours from the warmer end of the spectrum the deeper you go. Although the colours at 2m without flash are reasonably easy to distinguish they are already beginning to look dull.
Red Sea, Nikon F801, 20mm f2.8, Subal housing, Ektachrome Elite II 100, f11 @ 1/60.

Colour absorption: Even at 2m the addition of flash has made a marked difference to the intensity of the colours.
Red Sea, Nikon F801, 20mm f2.8, Subal housing, Ektachrome Elite II 100, f11 @ 1/60, flash lighting from one Subatec S100 manual flash gun on half power.

Colour absorption: At a depth of 9m without flash the colours are very dull and the red end of the spectrum is almost gone. Although the human eye can compensate for this in part and recognise the warmer colours at this depth, film emulsion is not able to, as shown here.
Red Sea, Nikon F801, 20mm f2.8, Subal housing, Ektachrome Elite II 100, f5.6 @ 1/60.

Colour absorption: With the addition of flash at 9m the difference is much more striking. The reds and oranges are restored and the image is much more punchy.
Red Sea, Nikon F801, 20mm f2.8, Subal housing, Ektachrome Elite II 100, f11 @ 1/60, flash lighting from one Subatec S100 manual flash gun on half power.

colours for your film to record. However, light from a flash gun is affected by the same rules of distance underwater and consequently is only truly effective up to 2 metres or so if your gun is very powerful. Almost all the underwater photographs you see published have flash illumination and the use of flash is an important subject in its own right – more will follow in chapter 4!

Reflection and Scatter

Imagine a flat calm sunny day in a gin clear tropical sea. Given these conditions you might expect a photograph taken on the surface to have the same exposure settings as one taken just below the surface. However if you use your light meter you will find that you require 'more exposure' just below the surface and this exposure difference will increase with depth. There are two reasons for this, the first being due to reflection of some of the sun's light as it passes through the surface. On a flat calm day this may amount to a light loss of up to 25% and this figure will increase as the water surface becomes rougher and the waves present a variety of angles to reflect the light. The second reason is due to the scattering of light by suspended particles in the water. Even the clearest tropical water has countless minute particles in suspension which contrive to reflect light from their own surfaces and also degrade the definition of your image the further you move away from your subject. If you were to photograph a subject on the surface on a misty or foggy day the resulting image would lack definition and sharpness. Due to suspended matter

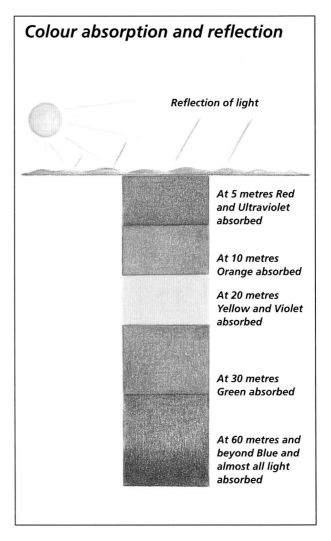

Colour absorption and reflection

Reflection of light

At 5 metres Red and Ultraviolet absorbed

At 10 metres Orange absorbed

At 20 metres Yellow and Violet absorbed

At 30 metres Green absorbed

At 60 metres and beyond Blue and almost all light absorbed

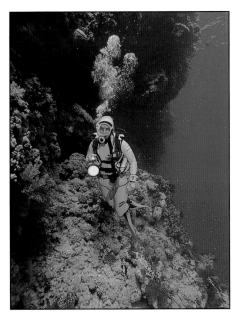

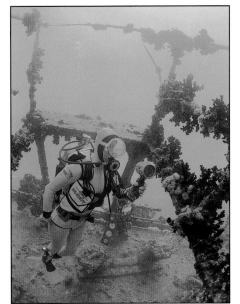

Far left: Diver on coral wall. This shot taken at a depth of 10m without flash in clear Red Sea waters shows how almost all the colour has disappeared. The diver's yellow suit is dull and has a blue cast to it and only the diver's lamp records its true colour. Red Sea, Nikon F801, 16mm f2.8 fish eye, Subal housing, Ektachrome Elite II 100, f8 @ 1/60

Left: Diver on the wreck of the Thistlegorm. In this shot the depth has increased to 24m in visibility of 25-30m. Now the diver's suit is even duller, although still obviously yellow, but the soft corals on the steel work which appear almost black are in fact bright red! Red Sea, Nikon F801, 16mm f2.8 fish eye, Subal housing, Ektachrome Elite II 100, f5.6 @ 1/60.

these conditions exist permanently underwater and is the reason why you must strive to get as close to your subject as possible, using wide angle or close/macro up lenses, to reduce the effects to a minimum.

Refraction

I am sure that we all remember that physics lesson at school when a pencil was stuck into a bowl of water and appeared to bend below the surface. This was due to refraction or the bending of light as it passes from one medium to another, in this case from air to water. Your first practical experience of refraction underwater is on your first dive when you reach for something and it isn't as close as you thought, or perhaps that crab shrunk on its way to the surface?! The bending of the light rays as they passed from the water through the face plate of your mask has magnified what you are seeing by about 25% thus making an object appear to be closer as well as larger.

Refraction also occurs when light passes from water through a flat port in front of your camera lens and has exactly the same effect. The magnification is also reducing the angle of view that your lens has on land (i.e. you will get less in your picture than with the same lens on land) and with wide angle lenses refraction will also cause a variety of optical distortions at the edge of the picture. With longer focal length lenses we can live with this and in fact it can be an advantage when using close-up and macro lenses as you gain that additional magnification. When focusing underwater it is not a problem as the lens sees exactly as you do through your face mask. So with your Nikonos you simply set your lens for the estimated 'apparent distance' (correct estimation of course takes practice!) or if you are using an SLR in a housing you will be able to see through the lens when the subject is in focus.

Diver on the wreck of the Thistlegorm. The same wreck and same dive, but this time with the addition of flash and the difference is stunning. The diver's suit is much brighter and those soft corals are revealed in their true livery of bright red.

Red Sea, Nikon F801, 16mm f2.8 fish eye, Subal housing, Ektachrome Elite II 100, f8 @ 1/60. Lighting from one Isotecnic 33TTL on manual at half power.

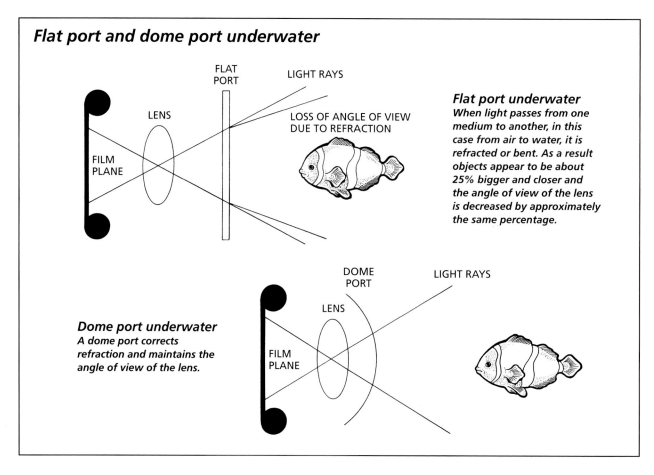

Flat port and dome port underwater

FLAT PORT

LIGHT RAYS

LENS

FILM PLANE

LOSS OF ANGLE OF VIEW DUE TO REFRACTION

Flat port underwater
When light passes from one medium to another, in this case from air to water, it is refracted or bent. As a result objects appear to be about 25% bigger and closer and the angle of view of the lens is decreased by approximately the same percentage.

DOME PORT

LIGHT RAYS

LENS

FILM PLANE

Dome port underwater
A dome port corrects refraction and maintains the angle of view of the lens.

The real problems occur when using lenses with a focal length of 28mm or less ('wide angle' lenses) and the optical distortions become unacceptable. The simplest solution to this is to use a dome port in front of the lens which presents a curved surface to the light rays and prevents them from being bent as they pass from the water to the air. This maintains the angle of view of the lens and also corrects the distortions. The only drawback of a dome is that it acts as a lens in itself and creates an image much closer to the camera than the subject itself, sometimes only a few inches away. This is known as the virtual image and its distance is governed by the diameter of the dome in use (distance = 2x diameter of the dome). The wide angle lens you choose must therefore be able to focus close enough to define this image, if it does not then you will have to fit a dioptre or close-up lens in order to enable the lens to focus on it.

There are other methods of producing corrective ports but these are much more expensive and you are unlikely to encounter them on commercially available amateur equipment.

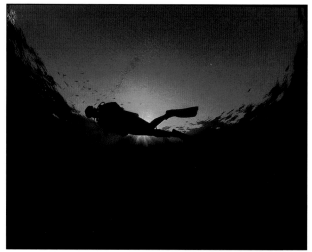

Diver silhouette with Snells window. When conditions are calm and the sun is very low the majority of the sun's rays are reflected and refracted from the surface causing this unique optical phenomenon. Once spotted you must position yourself to capture the arc created, which disappears quickly as the sun rises or falls. An extreme wide angle lens, especially a fish eye, will exaggerate this effect.
Red Sea, Nikon F801, 16mm f2.8 fish eye, Subal housing, Ektachrome Elite II 100, f5.6 @ 1/125.

Parallax

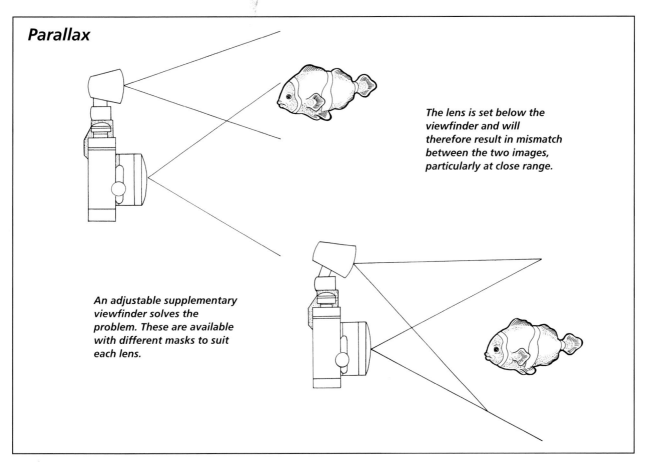

The lens is set below the viewfinder and will therefore result in mismatch between the two images, particularly at close range.

An adjustable supplementary viewfinder solves the problem. These are available with different masks to suit each lens.

Parallax

This problem is worth mentioning here, although it is more directly related to the optical arrangement of the range finder cameras rather than the optical effects of water. Because the viewfinder on the Nikonos or Motormarine is separate from and above the axis of the lens there is a mismatch between what you see and what the lens sees. This problem becomes exacerbated the closer you come to your subject (see diagrams).

Some integral and fixed supplementary viewfinders have bright line markings within them to indicate the picture area at different camera to subject distances which alleviates the problem. The best solution I have used is the adjustable range or distance design of supplementary viewfinder which allows you to dial in the distance from your subject which in turn adjusts the angle on the viewfinder. These are often supplied with different masks to match the picture area of the lens in use. This accessory is almost an essential investment and will make life very much easier, but only if you remember to change the setting when you adjust the focus!

Hopefully the mist is now beginning to clear on some of the basic principles of underwater photography and you will be itching to get wet and have a go. Next we will look at the need for artificial light, the various flash gun options available and the differences between them.

Flat port on a Subal Miniflex housing.

Dome ports.

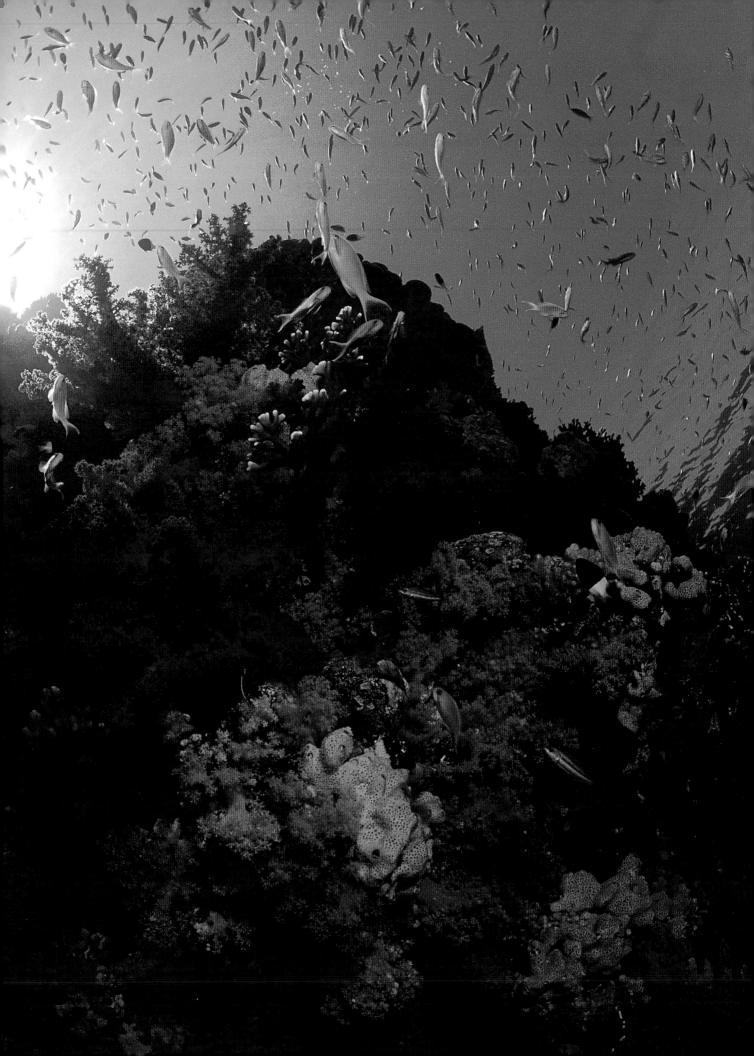

SEEING THE LIGHT

As we discussed in the previous chapter, if you begin your photography without an underwater flash gun (or strobe) you will very quickly become aware of the limitations of using the available or natural light except in very shallow and very clear water. Most published underwater images use artificial light to illuminate all or part of the image which is why the colours are vivid and punchy.
So what do you need to know about flash guns before deciding which is best for your camera system or for the type of photography you are planning?
As with previous subjects there is some terminology and a few basics to grasp first which are important even if you plan to use a fully automated system:

Synchronisation Speeds

This term refers to the fastest shutter speed which you may use with your flash gun. The actual shutter speed will vary between cameras and will generally range from 1/60th of a second to 1/250th of a second, although there are now cameras which boast 1/2000th and even 1/4000th. When a flash gun is fired the duration of the burst of light is very short, perhaps 1/1000th of a second or less. In order to expose the film frame fully the shutter must be fully open when the flash gun fires, otherwise you will only successfully expose part of the film frame. Most of us will actually get the chance to see this phenomenon when we inevitably forget to set the correct shutter speed for a dive! The synchronisation speed for your camera will be dictated by the design and type of the shutter mechanism, e.g. for a Nikonos III 1/60th; Nikonos IVa and V 1/90th; or a housed Nikon F90X up to 1/250th. It is possible and sometimes preferable to use a slower shutter speed (e.g. 1/30 or 1/15) than the maximum dedicated speed when balancing ambient and flash in a low light situation with a slow film speed, perhaps inside a wreck.

Soft corals on reef wall. A classic portrait of soft corals for which the Red Sea is so well known. The fish add interest and make a pleasing contrast against the blue water.

Red Sea, Nikon F801, 16mm f2.8 fish eye, Subal housing, Ektachrome Elite II 100, f11 @ 1/60. Lighting from one Sea & Sea YS 120 flash gun set to manual on half power.

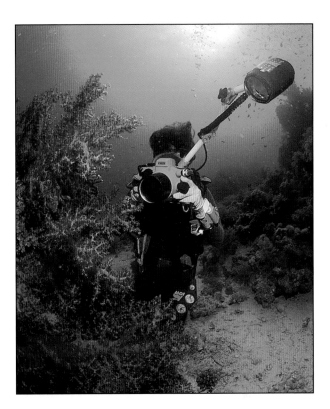

A photographer using a single strobe. For macro shots a second low power strobe is effective in filling in harsh shadows sometimes caused by using a single strobe to light the subject.

Beam Angle

This term refers to the spread of light from your flash gun which will dictate what type of lens or photography it is suitable for. Narrow beam strobes generally have a spread of 60 to 70 degrees making them suitable for macro and close-up or medium wide angle work with say a 28mm lens. The reflector design of these flash guns is generally oblong in shape and consequently the beam shape tends to follow this. Wide beam or wide angle strobes are more powerful and generally physically larger. The beam spread will be in the order of 90 to 110 degrees and the reflector and flash tube design is usually circular which gives a much more even spread of light.

1

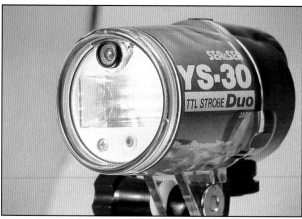

2

3

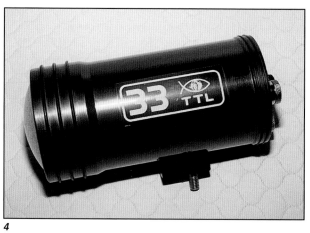

4

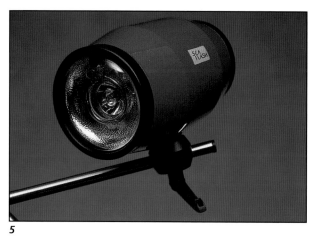

5

6

7

8

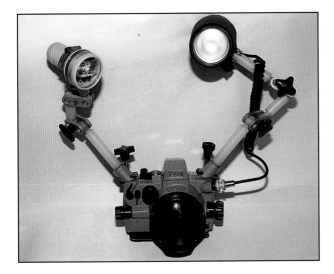

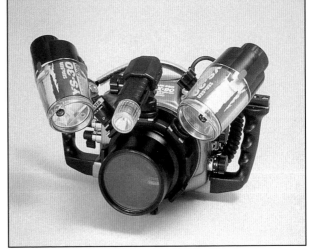

Above left: Twin strobe set up – one Sea & Sea YS50 TTL and a small land slave housed in a torch housing to fill in shadows.

Above right: Twin strobe set up – Sea & Sea NX90 housing with two YS30 TTL strobes.

One strobe is connected to the camera, the second will slave in TTL mode to the "key" or "primary" strobe. With small strobes such as these it is possible to mount them on brackets directly to the port as shown here.
(photo courtesy of Sea & Sea)

These units are specifically designed for use with wide and superwide angle lenses although they can be used for close-up and macro work. The difference in price is sometimes significant and your initial choice will be based on the size of your wallet or the type of photography that you plan to do.

Guide Numbers

The power or light output of flash guns is normally expressed as a guide number for a given film speed. This information is important even if you intend using a fully automated TTL flash gun as it is from this figure that the effective range of the strobe at certain apertures is calculated. The guide number quoted is generally calculated for underwater use, but occasionally the land figure is given this must be adjusted as the power of the gun will be reduced when taken underwater due to light absorption.
In order to arrive at the underwater guide number it is necessary to use a 'filter factor' which, dependant on the flash gun, varies between 1/3 to 1/2 of the land guide number. So, to understand this a little better we will assume that you own a manual flash gun with a

Left: A selection of flashguns
1 *Sea & Sea YS120.*
2 *Sea & Sea YS30.*
3 *Nikonos SB102.*
4 *Isotecnic 33TTL.*
5 *Seacam Sea Flash.*
6 *A secondhand Sea & Sea YS50.*
7 *A selection of new and used manual and TTL flash guns.*
8 *Home-engineered housing for a Nikon SB24.*

land guide number of 24 in metres with a film speed of 100ASA. The term 'in metres' simply refers to the fact that distance to the subject is measured in metres. The calculation to find the correct aperture at 1 metre is as follows:
Underwater Guide Number = 24 divided by $^1/_2$ = GN12
Aperture at 1 metre using 100ASA = 12 divided by 1 = F12 (i.e. F11 is closest)
This may look complicated at first but once you have established your underwater guide number through a test film in a swimming pool you can compile a table of distances and apertures for the film speeds you use, e.g.:
0.25m = F22; 0.5m = F16; 1m = F11; 1.5m = f8; 2m = F5.6
(The division is rarely exact and the actual aperture will vary with water conditions. As the term implies, the apertures calculated are used as a 'guide' for the correct exposure and it is advisable to bracket around these settings – see below for definition).
If you are using an automatic or TTL flash gun then this calculation may not appear necessary but it does help to establish the range within which your subject must fall for the gun to give you a correct exposure. Most if not all TTL guns come with a table giving the effective range with a given aperture and film speed combination. Even though some manufacturers quote their guide numbers as 'underwater corrected' it has been my experience that they are seldom entirely accurate and it is always wise to conduct a test.
So with the basics behind us what flash gun options are there to choose from?

Manual Flash Guns

Manual flash guns require you to calculate the aperture required for a given exposure using the guide number system described above. This method gives an approximate exposure which you would normally 'bracket' around, i.e. take a further exposure at the aperture setting above and below the indicated setting. This is a reliable method and you will soon be

UK Germany housing for a land TTL flash gun, e.g. Nikon SB24/25/26.

able to assess correct exposures for particular subject types and thereby save film.

There are not many manual only flash guns manufactured now, although most TTL guns have a manual setting and there is a healthy second hand market. Many of the high power wide angle manual flash guns have more than one power setting which makes them very flexible especially in situations which require a balanced light effect.

Auto Flash Guns

Automatic flash guns were the mid way technology between manual and TTL guns. They provide automatic flash control with a fixed range of apertures by measuring the light reflected from your subject via a remote sensor rather than through the lens (as with TTL). The sensor is best located on top of the camera as close to the lens as possible where it will 'meter' the light reaching the film more accurately. These systems will give reasonable results under the right conditions but cope best with subjects which fill the frame and have even contrast. Most auto guns also offer manual settings, sometimes with adjustable power, so you can switch to the guide number system when required. As far as I am aware there are no auto flash guns currently available (for underwater use) as most manufacturers now produce TTL and manual guns only, so it may be best to look for a second hand example if you decide to take this route.

TTL Flash Guns

The introduction of the first TTL guns with the Nikonos V led many photographers, especially those just beginning, to expect a system which would produce 36 perfectly exposed shots from every film.

However, it soon became apparent that this was only true for certain subject types and compositions. The limitations are derived from the metering system which is centre weighted (the reflected light is only metered from the centre of the picture) and exposes for the average, dominant subject. So, for example macro or close-up subjects which fill the frame and are of reasonably even contrast will be correctly exposed, assuming that the aperture used is within the exposure range of the flash. Conversely, small dark subjects on a sandy or bright bottom or a silver fish against a blue water background could be grossly under or over exposed. There is also a problem with the classic close focus wide angle shot, with the main, well lit, subject in the lower foreground and perhaps a diver and sunburst in the background. Again, the meter cannot cope as the flash lit subject is off centre and it is therefore the mid background which is exposed for and the foreground subject is more often than not over exposed.

If you are using an auto focus land camera in a housing you will probably have a 'matrix' metering system. This divides the frame into several segments and measures light in each separately to arrive at a more accurate exposure. On some cameras the TTL flash meter is also matrix based and therefore, in theory, will give you accurate exposure across the frame regardless of the differences in contrast. However to achieve this you must use the dedicated land flash gun for your particular camera, which means building or purchasing another housing for the flash gun (see below). This can give more predictable results with wide angle lenses, but I have found it not to be infallible. Some European amphibious flash gun manufacturers claim to be using dedicated TTL modules for particular cameras which will give this

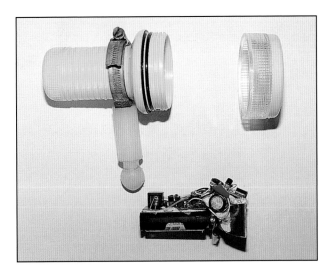

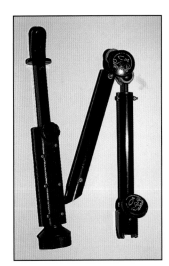

Right: Oceanic and Sea & Sea flash arms.

Below: Sea & Sea Sea Arm V system and base plates.

Above: Small land slave flash gun re-configured to fit in a torch housing. These low powered slave guns are **ideal for macro and close-up photography to fill in harsh shadows.**

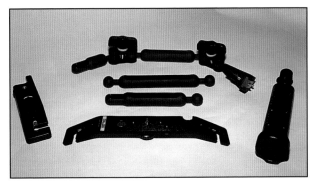

compatibility, although I have not had the opportunity to try all of them. Nikon also supply the SB104 for the Nikonos RS which in theory provides this function and it is apparently compatible with, for example, a Nikon F801s or F90X in a housing.

Land Flash Guns

Not so long ago there were few amphibious guns available and many photographers resorted to housing land guns in either home produced housings or those that were commercially available. Many still believe in this principle if only for reasons of economy and there are countless land guns available, both manual and TTL, which are suitable for housing. Before deciding which gun to house you should look at the various shapes and sizes available to determine the size and design of housing required. Then choose the gun which has sufficient power for your needs and in the case of TTL, is compatible with your Nikonos or land camera. Anyone who is reasonably skilled with their hands can construct a housing from perspex or aluminium tube and the cost of having perspex ports with 'O' ring seats turned up by a local engineer is normally reasonable. Controls (if needed), cable glands and synchronisation cable with Nikonos plug are all available as separate items from specialist dealers (see appendix). Alternatively, there are a number of commercially available flash housings available from the major camera housing manufacturers which range from simple tubular designs to more complex cast aluminium housings with a multitude of controls. Most of these are designed for use with specific camera dedicated land guns and so are likely to appeal only to users of that particular camera system.

Flash Gun Arms

Whatever type of flash gun you own, one essential piece of ancillary equipment is a rigid or flexible arm to attach the gun to the camera and allow you to position it accurately to illuminate your subject. The choice of design is very broad and every photographer will have his own opinion on the perfect combination but two opinions will rarely match! Some prefer the minimalist approach of a simple handle on the flash and use only hand held techniques to position it, which can work well with a compact system like the Nikonos or Motormarine. Larger systems normally require two hands and everything from rigid telescopic to ball jointed and multi jointed flexible arms are available, although one common feature is normally a means of releasing the arm reasonably quickly for hand held shots when necessary. Only experience will tell you which is best for your own needs and most photographers go through two or three designs before settling with one. My own preference is for ball joint arms which I have had engineered in a lightweight nylon rod but these will not suit everybody.

One important design point to examine is the means of attaching the arm to the housing or camera. This needs to be sturdy as the arm is inevitably used to lift the system out of the water by some helpful soul when you return to a dive boat. I have witnessed many times the parting of arm and system as it is

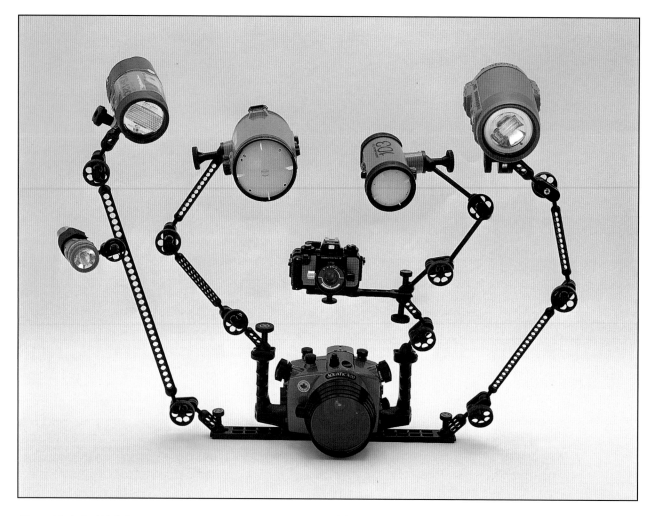

Above: Technical Lighting Control (TLC) arms. A flexible and well engineered system to fit almost any flash gun. (photo courtesy of Benny Sutton, Underwater Images)

lifted which results in the camera or housing crashing to the deck, stretching the synchronisation lead beyond its limit or hitting the waiting photographer on the head!

The Choice is Yours

Your final choice of flash gun will initially be dictated by the camera system you own, followed, inevitably, by the size of your budget. There is a healthy second hand market both through private sales and the specialist dealers, but do try to see as many of the combinations available and talk to fellow photographers who are perhaps using a similar set up. Once again, the British Society of Underwater Photographers meetings are an ideal venue for picking experienced brains if you have none in your own diving club. The next chapter will look at the way you can use and manage natural and artificial light underwater once you have made that choice.

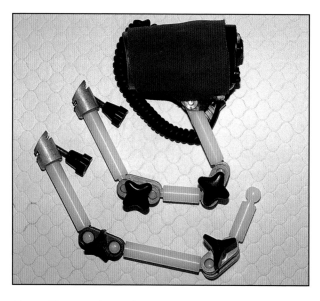

Above: Home engineered ball joint flash arms.

Right: The summer months brings a frenzy of mating activity to the Red Sea. Hanging beneath a huge shoal of red snappers I watched jacks in their court-ship dance, during which the male turns jet black.

Red Sea, Nikon F801, 16mm f2.8 fish eye, Subal housing, Ektachrome Elite II 100, f11 @ 1/60. Lighting from one Sea & Sea YS120 flash gun set to manual on half power.

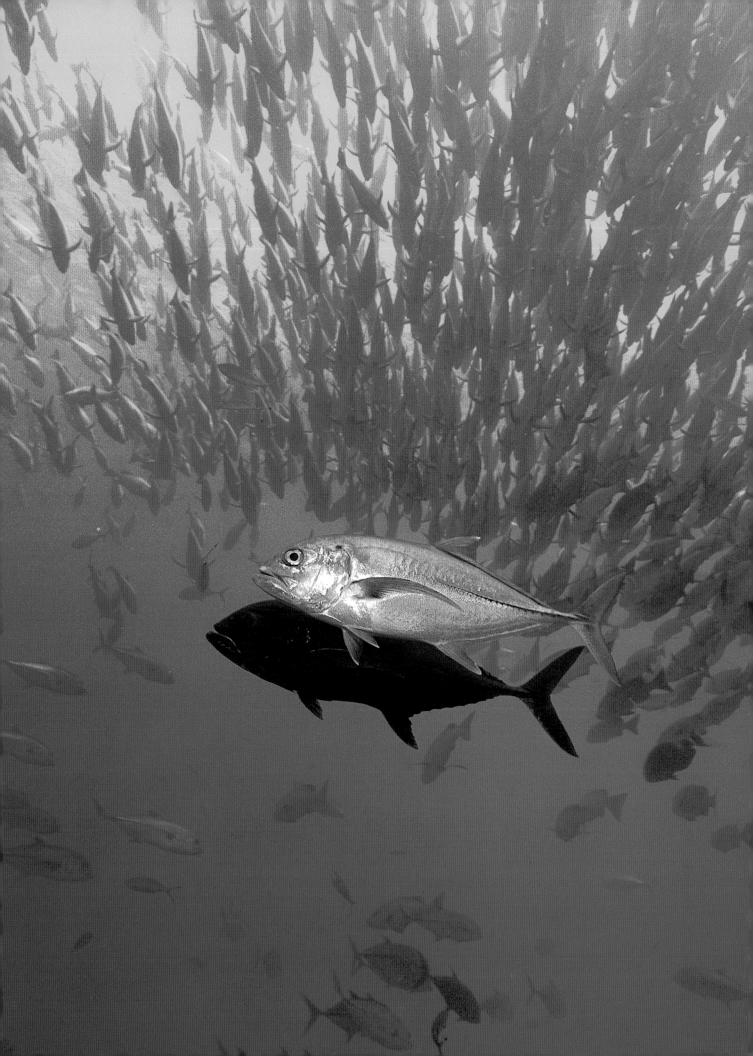

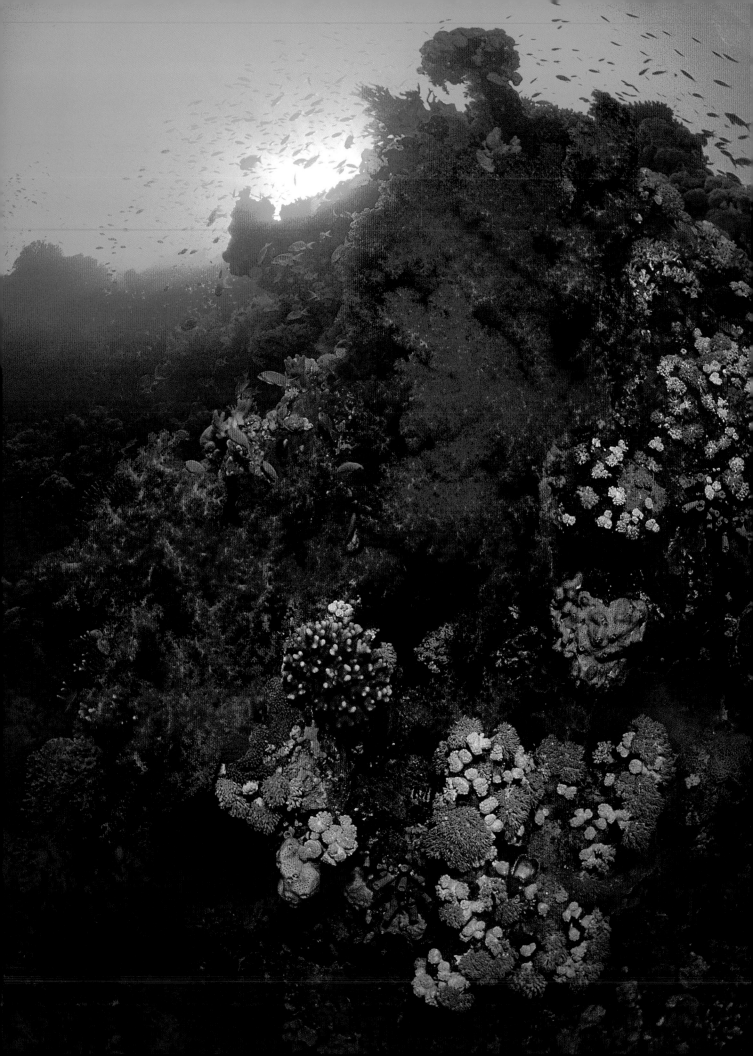

MANAGING LIGHT

Underwater Techniques

The management of natural and artificial light is the key to any good photograph. When you take your camera underwater it becomes even more critical to the outcome of your images and your first few forays can prove to be disappointing. However, if you understand why the results are not quite what you anticipated then these mistakes can become an education and the basis for improvement. The list of techniques discussed in this chapter is by no means exhaustive and often photographers will mix them or deliberately try breaking the rules to experiment with different effects. But to begin with it is best to try one technique at a time until you become proficient, which will enable you to gauge your improvement and produce much more successful images. Another point to mention here is film – do not be afraid to use it as it is the cheapest part of the equation – consider the cost of all your equipment and the cost of reaching your diving destination, film is very cheap by comparison! Do not be tempted to try and come back with 36 different shots, you must learn to cover a subject from a variety of different angles using differing settings and then examine the results afterwards for the most successful results.

Natural Light

Taking a natural light, or ambient light, photograph should in theory be the easiest technique but is often the most disappointing. Whether you use a separate light meter or the one built into your camera, finding the correct exposure settings is only half the battle. As mentioned in a previous chapter, colours are absorbed by depth and through distance to your subject. So you must stay shallow and get close to your subject and perhaps use a colour correction filter if you have one. The next important consideration when looking for your subject is contrast. Try to find

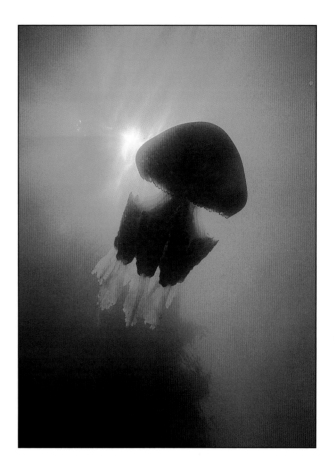

Rhizostoma jellyfish silhouette. To produce good silhouettes you must remember to meter the light just to one side of the sun burst on the surface so that the subject will not appear too dark, especially if it is not entirely within the sunburst. The sun is then *slightly over exposed but the main subject will be a well defined silhouette and, in this case, a little light filtering through the body of the jellyfish.*
Cornwall UK, Nikon F2, 24mm f2.8, Hugyfot housing, Ektachrome 100, f16 @ 1/60.

subjects which have a good colour contrast with their surroundings, such as bright fish, corals or a diver in a bright suit. Once you have settled on the subject you must consider the position that you are going to take the picture from. Because of the problems of poor colour contrast with natural light photographs the better images are often the ones which demonstrate good separation between the subject and its surroundings. This is almost always be achieved by

Soft corals on reef wall. A classic portrait of soft corals for which the Red Sea is so well known. Static subjects like this give you time to perfect your composition and exposure.

Red Sea, Nikon F801, 16mm f2.8 fish eye, Subal housing, Ektachrome Elite II 100, f11 @ 1/60. Lighting from one Sea & Sea YS 120 flash gun set to manual on half power.

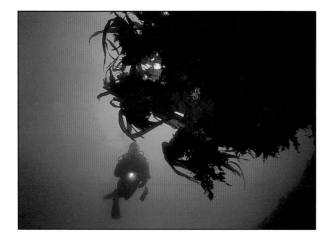

Diver and kelp silhouette. To produce good silhouettes you must remember to meter the light just to one side of the sun burst on the surface so that the subject will not appear too dark, especially if it is not entirely within the sunburst. The sun is then slightly over exposed but the main subject will be a well defined silhouette. In this shot there is just a touch of flash to illuminate the underside of the rock below the kelp and the diver's torch adds that feeling of exploration. *Cornwall, UK, Nikon F801, 16mm f2.8 fish eye, Subal housing, Ektachrome Elite II 100, f5.6 @ 1/125 with fill flash lighting from one Subatec S100 manual flash gun on quarter power.*

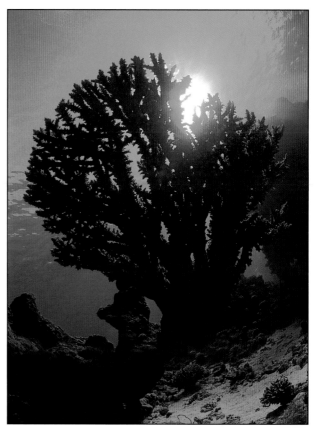

Staghorn coral silhouette. *Red Sea, Nikon F801, 16mm f2.8 fish eye, Subal housing, Ektachrome Elite II 100, f16 @ 1/125.*

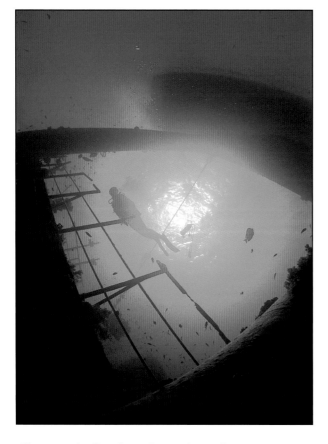

Silhouette of a diver framed by bridge and superstructure on the wreck of the Giannis 'D' in the Red Sea. *Red Sea, Nikon F801, 16mm f2.8 fish eye, Subal housing, Ektachrome Elite II 100, f16 @ 1/125.*

getting down low relative to the subject so that you can get some open water or light behind it, although you can also see the same effect if you choose a bright sandy bottom for the background.

At this point you must consider the exposure. Be aware of what your camera or light meter is measuring. If the light behind the subject is very bright then you could end up producing a silhouette (which may be what you want!) if you take the reading with your upward camera angle. In these circumstances you should take a reading directly from the subject or from an area which has similar light or contrast, perhaps a horizontal reading against the mid water. Under these circumstances it is better to use your camera on manual (if it is fully automated) so that the exposure is 'locked' when you re-compose and shoot, otherwise the automatic function will simply reset the exposure for the bright background. Most of the latest auto focus cameras have what is known as 'matrix metering' which does not measure light from a single point in the frame, but takes an average of the contrasts from several points and produces a balanced exposure, which in theory means

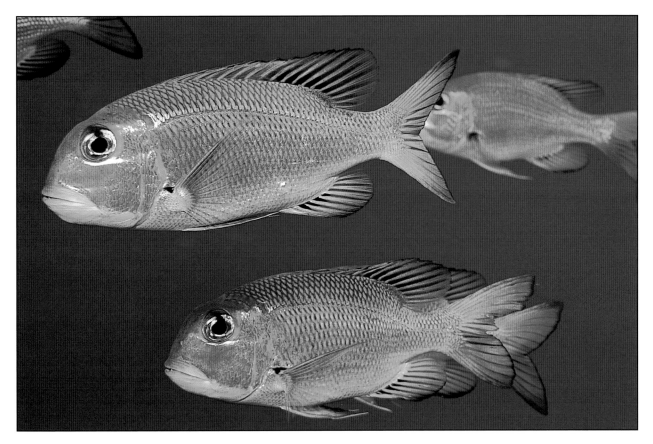

that you can meter, compose and shoot as you see the picture. Some systems and lens combinations work well others are not so adept, only experimentation with your own equipment will tell.

Once you have arrived at what you anticipate to be the correct exposure you should then 'bracket' your shots. This means taking a shot one 'stop' either side of the ideal settings to ensure that at least one frame will be correctly exposed, e.g. if the correct reading is F11 @ 1/60th then take shots at F8, F11 and F16 @ 1/60th. The most successful natural light shots are often taken with a wide angle lens which allows you to get close even if your subject is large. However it is possible to produce excellent results with say the Nikonos 35mm or 28mm lens once you are familiar with their limitations. I would not advise attempting close-up or macro shots with natural light as, although it is possible in theory, a very wide aperture and long exposure would needed which would result in an unacceptable depth of field and potential camera shake.

Artificial Light

We have already discussed the use of guide numbers for calculating the correct exposure or TTL/Auto range of your flash gun. Once you have calculated the aperture required you must consider where you are going to position the strobe. This is important for two reasons – firstly the effect you are seeking in your image, e.g. do you want it to look 'natural' with

Balanced light: Sheepshead snappers. You can balance the daylight and natural light exposure either by setting the aperture for the metered natural light exposure and relying on the camera TTL flash control, or by matching the output of your manual flash gun by reducing the power or moving it further away from the subject.
Red Sea, Nikon F801, 60mm f2.8 micro, Subal housing, Ektachrome Fujichrome Velvia, f8 @ 1/60. Main lighting from one Sea & Sea YS50TTL with small slave flash to fill shadows.

simulated sunlight from above – and secondly you need to minimise 'backscatter'. This term refers to reflection of light from the particles which are suspended in the water between your camera and your subject. If you position your flash gun close to the camera lens and point it straight at the subject then a lot of the light will be reflected back at the lens by these particles producing a snowstorm effect in your final image. So the trick is to position the flash gun above the subject and at an oblique angle, approximately 45 degrees, thus ensuring that any reflected light from the particles is directed at the flash and not the lens. This is of course not a rule cast in stone and may be varied dependant on prevailing conditions and will become less critical the closer you get to your subject, as in macro photography.

Two other factors to be aware of when photographing from a distance is that firstly you are calculating your exposure on the distance from your subject to your flash gun, not from the camera to the subject. So be aware of this when positioning your

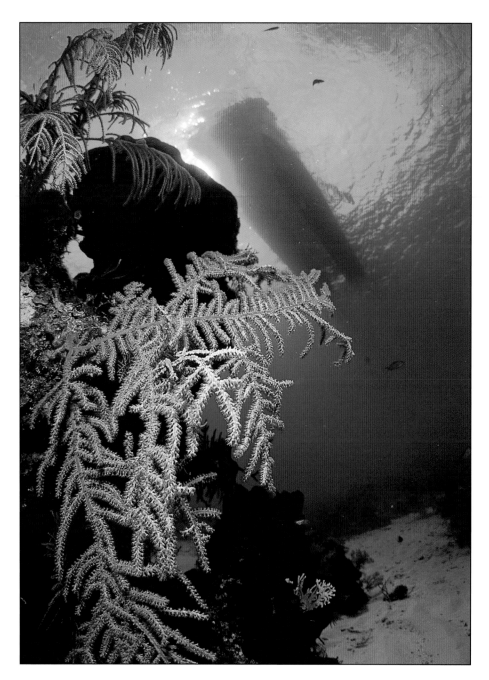

Above: Plumose anemones. Balanced lighting techniques can be used with equal success in temperate waters also, the only difference will be in the colour of the background, in this case green.
Cornwall, UK, Nikon F2, 28mm f2.8, Hugyfot housing, Kodachrome 64, f5.6 @ 1/60. Lighting from one Subatec S100 manual flash gun on quarter power.

Balanced light: Gorgonian coral with boat and sun in background. You can balance the daylight and natural light exposure either by setting the aperture for the metered natural light exposure and relying on the camera TTL flash control, or by matching the output of your manual flash gun by reducing the power or moving it further away from *the subject. Use of a smaller aperture has been possible in this image as I balanced the exposure with the sun on the surface.*
Turks and Caicos, Caribbean Sea, Nikon F801, 16mm f2.8 fish eye, Subal housing, Ektachrome Elite II 100, f16 @ 1/60. Lighting from one Subatec S100 manual flash gun on half power.

strobe otherwise you can under or over expose the image. Secondly you must bear in mind the effects of refraction and aim the strobe at the actual position of the subject and not the apparent one. This problem becomes more evident when using a narrow beam strobe at a distance of 1m or more, and only practice will help your aim to become more automatic. Once again bracket your exposures, vary the composition and the strobe position and examine the results. It often helps to make notes of settings on a scratch board so that you can identify the results with the optimum settings.

Twin Strobes

Two flash guns I hear you cry! Surely using one is problematic enough! This need not be so and whilst countless professional quality photographs are taken

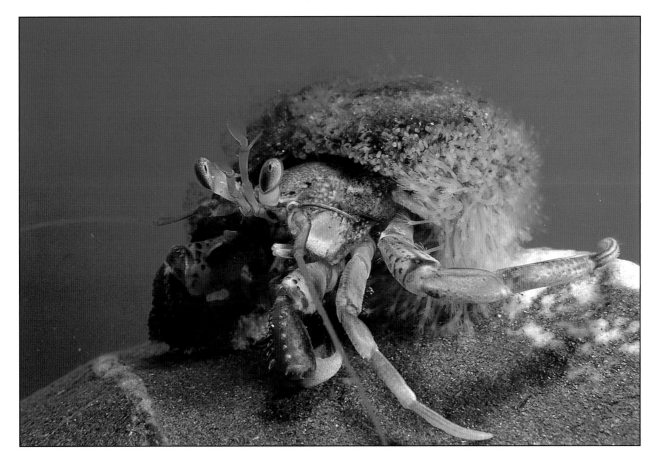

***Back lighting: Hermit crab.
This hermit crab has been
backlit with a third flash gun
with a blue filter behind the
subject. Getting the
exposure correct with back
lighting is difficult initially –
much depends on the power
of the flash gun and in this
case the density of the filter
in use. Only trial and error
will produce the correct
exposure. This is a***
***particularly useful technique
for British waters as it
appears to be a balanced
light shot with a tropical
blue water.***
*Cornwall, UK, Nikon F801,
60mm f2.8 micro, Subal
housing, Fujichrome Velvia,
f16 @ 1/60. Lighting from one
Sea & Sea YS50TTL flash gun,
a small slave to fill shadows
and a third flash with blue filter
back lighting the subject.*

with one strobe there are circumstances where two
strobes will produce a much improved image. Some
photographers will use two strobes with a wide angle
lens especially if neither strobe has a beam angle wide
enough to cover the lens in use. Personally I always
use two strobe for macro photography where there is
rarely any natural light in the exposure and therefore
the lighting is much harsher. If, for example, you are
photographing a fish in close-up lighting from one
side or directly above is likely to cause harsh shadows
alongside or under the fish. However, the addition of
a second light source will reduce the shadows and
give a more natural feel to the image.

There are two ways of adding a second strobe to
the equation. The first is by using a 'slave flash gun'
which requires no connection to the camera and is
triggered by a sensor when the main or 'key' strobe
is fired by the camera. It is preferable to have a lower

output from the slave so that it does not affect the
exposure calculation, i.e. the exposure calculation is
always based on the more powerful light source, and
this will also give natural soft shadowing in the image.
Some flash guns have a slave setting on them, some
also come with adjustable power output on slave,
whilst others are sold as slave only strobes. A recent
addition to the market are strobes which will slave in
TTL without a connection to the camera. One method
is to use a TTL slave sensor which attaches to the flash
instead of the synchronisation cord – this system is
available from Ikelite to suit their own strobes.
The second option which comes from Sea & Sea is the
neat YS30 strobe which will slave in TTL to any other
TTL flash via its built in sensor. Another alternative to
consider is buying a cheap manual land slave gun (try
Jessops photo stores at £8-10) and housing it in an
underwater torch housing or a home made housing.
Even if you buy a new torch at £12-15 you still end up
with a very cheap slave flash gun. These low powered
slaves are ideal for macro photography where just a
squirt of light is required close-up, but they are not
powerful enough for distances of more
than 30cm (1ft).

The second option is to have two flash guns fired
simultaneously by the camera. Various twin leads and
twin lead connectors are available from Nikon, for the
Nikonos V and RS, and other manufacturers such as
Sea & Sea which will also offer TTL exposure control
to both strobes. However, you may find that both

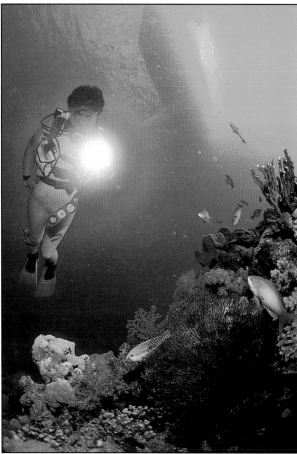

Above left: Backscatter is caused by the light from your flash striking the particles suspended in the water and being reflected back towards the lens creating this snowstorm effect. If the visibility is not too bad then the effect can be reduced by lighting the subject from above and from an oblique angle so that light is reflected back in the direction of the flash gun and not the lens.
Cornwall UK, Nikon F801, 16mm f2.8 fish eye, Subal housing, Ektachrome Elite II 100, f16 @ 1/60. Lighting from one Subatec S100 manual flash gun on half power.

Above right: Although the visibility was not good when this shot was taken, the level of backscatter has been reduced by: a) getting closer to the subject by using a wide angle lens, and b) by lighting the subject from above and from an oblique angle so that light reflected back by the suspended particles goes in the direction of the flash gun and not the lens. Particles can still be seen in the water, however, particularly in the beam of the slave torch.
Cornwall UK, Nikon F801, 20mm f2.8 , Subal housing, Ektachrome Elite II 100, f11 @ 1/60. Lighting from one Isotecnic 33TTL flash gun.

Left: Even in the clearest tropical waters there are suspended particles waiting to ruin a perfectly good shot. In this image the diver's slave torch has illuminated the particles in the water. This could have been avoided by ensuring that
the slave had been directed more sideways towards the reef.
Red Sea, Nikon F801, 16mm f2.8 fish eye, Subal housing, Ektachrome Elite II 100, f16 @ 1/60. Lighting from one Subatec S100 manual flash gun on half power.

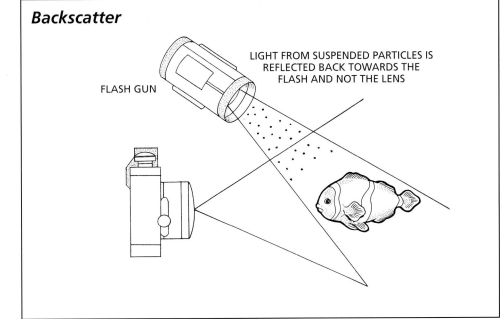

Backscatter

FLASH GUN

LIGHT FROM SUSPENDED PARTICLES IS
REFLECTED BACK TOWARDS THE
FLASH AND NOT THE LENS

*By keeping your flash
above the lens axis and
aiming it at the subject
at 45°, backscatter (light
reflected from
suspended particles) will
be minimised.*

flash guns in use have to be identical or at least from the same manufacturer otherwise there can be problems with trigger voltages and quench signals. If you decide to take this route then it is wise to seek advice from a specialist supplier or the manufacturer before you commit yourself.

Balanced Lighting

Some of the most pleasing and natural looking images taken underwater use the technique of balanced or mixed lighting. Simply defined it means balancing the output of your flash gun with the exposure required for a natural light shot. This will add back the true colours to the main subject in the foreground of the shot whilst maintaining a naturally lit blue background behind the main subject. But how is it done? The answer is there are two options once again.

The first option is for those using a manual system. First you take a light reading for the background exposure which for example gives you a reading of F8 @ 1/60th. Then you must calculate the flash to main subject distance which we will assume is at 30cm (1ft) and will be F11. So now we have to reduce the output of the flash to match the exposure of F8. If you have adjustable power settings on your flash gun then it is simply a matter of turning the power down one stop. If you don't then you must physically hold the strobe back behind the camera to a distance which will give an exposure of F8, in this case probably 45cm (1.5ft) or so. Be aware of the direction you are aiming the strobe as it is easy to miss the subject when it is not in your direct line of sight. This technique requires some practice until you are truly familiar with the power output of your strobe but the results are worthwhile.

The second option is to use the TTL facility on your camera if you are lucky enough to have it. Using this method you meter the background and set the aperture for the natural light exposure (do not forget to set the shutter speed for flash synchronisation!). Then check that the aperture chosen is within the TTL range for the distance to your subject. If so take the shot and the camera's meter will quench the flash output when the correct balanced exposure has been made. This works very well for most systems when the subject is in the centre or dominates the frame. If your subject is off centre and the contrast is poor the TTL system may overexpose the shot by exposing for the background. Only experience will give you an indication of when your particular system is likely to fail and then you must resort to the manual method.

Back Lighting

Another interesting and effective technique to experiment with is back lighting with your flash gun. As the term suggests this means placing the light source behind the subject and can be varied by using one or two strobes. A single strobe will give you a strong silhouette effect, whilst placing your slave or key strobe behind the subject will soften this to a greater or lesser degree dependant on the output of the individual units. Two things to watch out for – first, when placing the strobe behind the subject double the normal strobe to subject distance as you are halving the light path by pointing the strobe at the lens and, secondly, try to position the strobe at an oblique angle to the subject to avoid illuminating suspended particles, i.e. backscatter in reverse. Backlighting can be used to achieve unusual and creative effects particularly if used with coloured or special effect filters. Achieving perfect exposures is

Diver framed by coral formation: Exposure: a) one stop over exposed, b) correct exposure, and c) one stop under exposed.

a

b

c

Above: Diver positioning flash. When photographing subjects up to 1m away you can ensure that your flash gun is positioned correctly by holding the camera in front of you with the lens directed at your face and then aiming the flash at your eyes.

Right: Diver hand holding flash. Sometimes a flash arm system is not quite flexible enough and it is necessary to hand hold the flash perhaps to light a larger area, reduce the strength of the light reaching the subject or to light a subject in an awkward position.

a

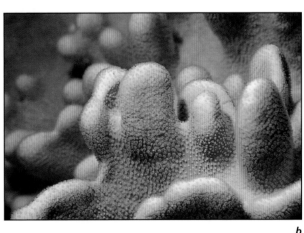

b

Above: Hard coral. A single flash (a) at an oblique angle can cause harsh shadows in some subjects. By using a second flash gun (b) you can fill in these shadows and create a more natural looking image.

Right: Refraction. The apparent distance of a subject can cause you to aim your flash incorrectly. Always aim at the actual position.

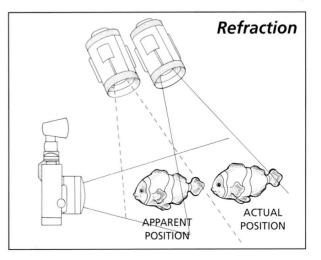

Refraction

APPARENT POSITION

ACTUAL POSITION

often a matter of trial and error, but when it all comes together backlit images can be very striking.

Every photographer develops their own interpretation of perfect lighting and the perfect lighting set up for their own camera system and style of photography. Once you have mastered these basic techniques you will be in a position to experiment and develop your own preferences and perhaps come up with a truly unique lighting technique!

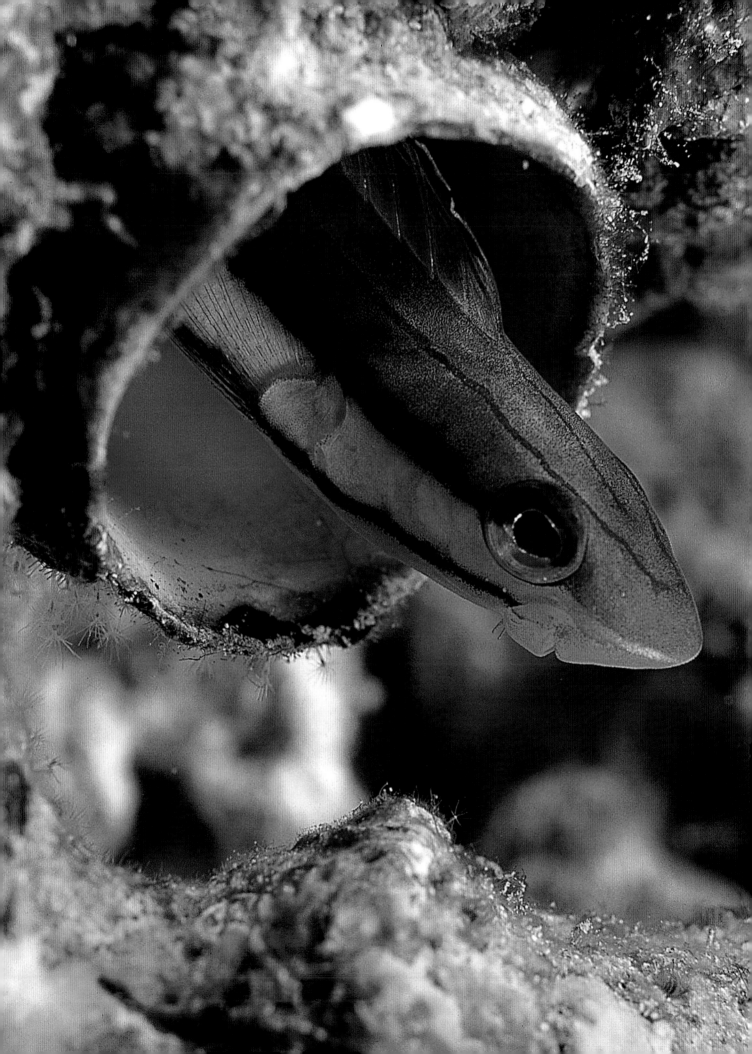

CLOSE ENCOUNTERS

Close-up and Macro Photography

During your first few forays into underwater photography it is sometimes beneficial to stick to one technique until you have mastered it and feel happy with the results you are producing. Many budding photographers choose macro or close-up techniques to begin with as, in the case of Nikonos and Sea and Sea camera systems, it offers fixed focus and aperture settings and easy composition using a wire framer which indicates the picture area. But what exactly is macro and close-up photography and is it just a beginners technique? The answer to the latter is most definitely no and you will find that many of the most stunning competition winning pictures have been taken using the methods discussed below.

So where do we draw the line between a macro photograph and a close-up photograph? The definitions are all related to the reproduction ratio of your subject on the film, i.e. how big it appears in the final picture. The other deciding factor for me is the distance that you are from the subject when the picture is taken. For close-up my range would be from 5 inches to 12 inches and for macro 1.5 inches to five inches. Definitions of reproduction ratios also vary, but mine would be 1:4 to 1:10 for close-up and 2:1 to 1:4 for macro. To help you understand these figures some examples are shown below:

2:1 = A twice life size image on the film

1:1 = A life size image on the film

1:2 = A half life size image on the film

1:3 = A one third life size image on the film

And so on to 1:10

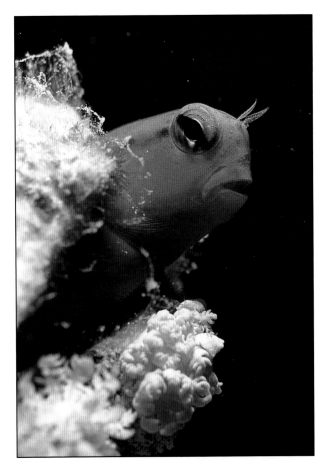

Grey mimic blenny in a dead clam shell. Territorial fish make ideal macro subjects as they will rarely move from their home and are very inquisitive. Wait patiently and eventually the fish will pop its head out for a look, making it a perfect subject for extension tubes.
Red Sea, Nikon F801, 60mm micro f2.8, Subal housing, Fujichrome Velvia, f16 @ 1/125 @ 1:1. Main lighting from one Sea & Sea YS50TTL with small slave flash to fill shadows.

The equipment required to take these type of photographs varies dependant on the type of camera system you own, but can be broken down into four groups: Extension tubes; Add on or Supplementary close-up lenses; Macro or close focusing lenses, and Zoom lenses with a macro setting. These are described in the following pages:

Sabre toothed blenny in a dead tube worm cast.
Red Sea, Nikon F801, 60mm micro f2.8, Subal housing, Fujichrome Velvia, f16 @ 1/125 @ 1:2. Main lighting from one Sea & Sea YS50TTL with small slave flash to fill shadows.

**Horned nudibranch.
Nudibranchs make ideal
macro subjects not least due
to their striking colours.
Being very slow moving they
provide ample opportunity
to compose each shot and
bracket exposures.**
*Red Sea, Nikon F801, 60mm
micro f2.8, Subal housing,
Fujichrome Velvia, f16 @ 1/125
@ 1:1. Main lighting from one
Sea & Sea YS50TTL with small
slave flash to fill shadows.*

Yellow tipped nudibranch.
*Cornwall, UK, Nikon F801,
60mm micro f2.8, Subal
housing, Fujichrome Velvia,
f16 @ 1/125 @ 1:2. Main
lighting from one Sea & Sea
YS50TTL with small slave
flash to fill shadows.*

Yellow spotted nudibranch.
*Red Sea, Nikon F801, 60mm
micro f2.8, Subal housing,
Fujichrome Velvia, f16 @ 1/125
@ 1:2. Main lighting from one
Sea & Sea YS50TTL with small
slave flash to fill shadows.*

Cuttle fish eye. Marine creatures with good camouflage will often allow you to get very close, possibly convinced that you cannot see them! Use these opportunities to concentrate on specific features or patterns, don't be afraid to use film whilst you experiment.
Cornwall, UK, Nikon F801, 60mm micro f2.8, Subal housing, Fujichrome Velvia, f16 @ 1/125 @ 1:1. Main lighting from one Sea & Sea YS50TTL with small slave flash to fill shadows.

Extension Tubes

These are light tight (and for the Nikonos water tight) tubes which fit between the lens and the camera body increasing the distance between the lens and the focal plane of the camera, which has the effect of reducing the focusing distance of the lens. Extension tubes are available for the Nikonos and for housed camera systems and are normally used with the 'standard' focal length lens, e.g. 35mm to 50mm. They come in varying sizes, normally bought as a set of three, and basically the longer the tube the greater the magnification ratio available. Those that are manufactured for the Nikonos come with a set of framers or prods which attach to the tube or the lens which give you a guide to the picture area and the exact focused distance. The focus and aperture are pre-set and generally you have only the flash position and distance to worry about. With a housed camera obviously the framer is unnecessary as you focus through the lens, but you will still be restricted to a single stand off distance. Although extension tubes give you increased magnification the downside is that the depth of field is also greatly reduced, particularly in the 1:1 or 2:1 ratio where it can be less than 12mm (half an inch). So positioning your subject in the framer is very important and selection of the smallest aperture available is essential to maximise the depth of field.

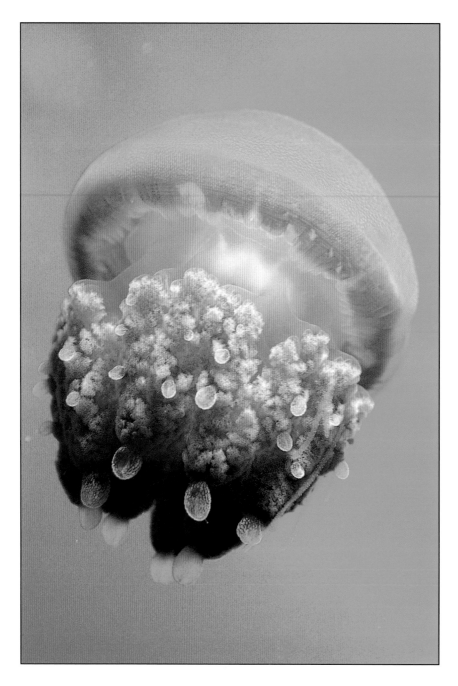

Left: Small jelly fish in shallow water. You can often find small or juvenile jelly fish in the water column at the start or end of your dive. These slow moving creatures offer an ideal opportunity to play with exposure and composition – vary your orientation from vertical to horizontal and choose both a dark (small aperture) background or as in this case a balanced light background against the bright surface.
Red Sea, Nikon F801, 90mm macro f2.8, Subal housing, Fujichrome Velvia, f8 @ 1/30 @ 1:3. Main lighting from one Sea & Sea YS50TTL with small slave flash to fill shadows.

Right: Cleaner shrimp on sea cucumber. With a little research you can discover where to look for certain macro subjects. These shrimps are found on sea cucumbers, starfish, urchins and some larger nudibranchs such as the spanish dancer. They are sometimes difficult to photograph due to their twitchy movements, so be patient.
Red Sea, Nikon F801, 90mm macro f2.8, Subal housing, Fujichrome Velvia, f16 @ 1/125 @ 1:2. Main lighting from one Sea & Sea YS50TTL with small slave flash to fill shadows.

Supplementary Close-up Lenses

These are optical 'magnifying' lenses which fit to the front of your standard lens and allow you to get closer to your subject. They are available for the Nikonos, the Sea & Sea range and housed land cameras. Those for the amphibious cameras are generally supplied with frame or prods, similar to an extension tube, to aid focusing and assessment of picture area and they are generally used with a pre-set focused distance and aperture. These also have the effect of reducing depth of field but not to such a great degree as an extension tube. Nikon make an excellent kit which comes with three frame sizes for the 35mm, 28mm and 80mm lenses, but there are alternatives from several other manufacturers. One of their great advantages is that they can be fitted and removed underwater which

means, unlike the extension tube, you need not be committed to one type of photography for your dive.

If you are using a housed system then you will be able to choose the strength of close-up lens which will screw onto the front of your lens. These are termed 'dioptres' and their strength is expressed numerically as +1, +2, +3 etc. Fitting one will allow you to get closer to your subject, the stronger the lens the greater the magnification and therefore the closer you can get. Once fitted you will lose some of the focusing range of your lens, at the infinity end, how much is dependant on the strength of dioptre and the focal length of the lens in use.

You will also see a reduction in the depth of field especially at close focus.

Lion fish eye. Some subjects, especially fish, will only let you come so close. To achieve a shot like this requires a macro lens with a longer focal length allowing the same magnification from a greater distance.

Red Sea, Nikon F801, 180mm macro f5.6, Subal housing, Fujichrome Velvia, f11 @ 1/60 @ 1:2. Main lighting from one Sea & Sea YS50TTL with small slave flash to fill shadows.

Macro Lenses

Macro lenses are specialist close focusing lenses only available for single lens reflex cameras which means only housed systems or, if you are well heeled financially, for the Nikonos RS. These lenses come in various focal lengths generally in the range of 50mm to 60mm, 90mm to 105mm and 180mm to 200mm. They are able to focus from their infinity setting all the way to a macro setting of 1:1 or 1:2. The different focal lengths allow you to choose to be closer or further away from your subject at full magnification, e.g. you will be closer to your subject at a reproduction ratio of 1:2 with a 50mm lens than with a 180mm lens. These lenses are extremely flexible and I would say an invaluable tool for a housed system. They allow the photographer to choose between a fish portrait and a tiny coral polyp all in the same dive and for many photographers they are the 'standard' lens.

Zoom Lenses

This is a choice only available currently to photographers using housed systems. There is a huge range of 'standard zooms' to choose from generally in the range of 28mm-105mm and many of these offer a 'macro' setting at the telephoto end of the lens. This in fact is generally not a true macro although some do feature a reproduction ratio of 1:3. This is a fixed setting so in some respects is a little like using an extension tube, but of course you have the advantage of being able to switch to the other focal lengths available on the lens. This is now a very popular choice with beginners who choose a housed system as it gives great flexibility as a standard lens as it covers several focal lengths. However, when choosing a lens do make sure that the zooming ring control and macro setting are on the same control ring (some require a switch to be operated), so that you can zoom in and out of macro, and that the ring is correctly positioned on the lens for your housing.

Tips and Wrinkles

Although a close-up or macro set up can produce very pleasing results from your first attempt, there are one or two guiding points which can help to improve composition and increase your success rate.

*Long nosed hawkfish.
These fish, which live
predominantly on gorgonian
fan corals and black coral,
are sometimes shy but do
have a pattern to their
movements. Watch for a
few minutes to find the
points the fish settles on,
then focus on this point for
the shot. A longer focal
length macro lens is best
(90-105mm) to avoid
spooking the fish.*
Red Sea, Nikon F801, 90mm
macro f2.8, Subal housing,
Fujichrome Velvia, f11 @ 1/60 @
1:2. Main lighting from one Sea
& Sea YS50TTL with small slave
flash to fill shadows.

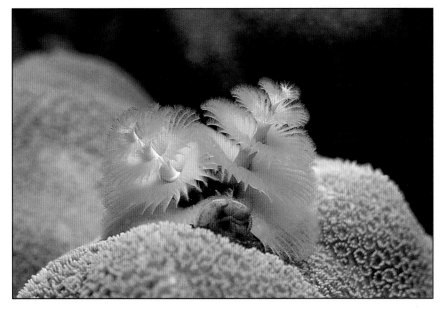

*Christmas tree tube worms.
This is a classic tropical water
macro subject and very easy
to photograph with a little
patience. They are very
sensitive to movement and
shadow, so set up, stay still
and take each shot as the
worm emerges.*
Nikonos III, 1:2 extension tube,
Fujichrome Velvia, f16 @ 1/60.
Lighting from a single Sea & Sea
YS50 manual flash gun.

*Lemon goby in acropora
coral. This very small (3cm)
species is particularly shy
and will hide immediately
in the branches of the coral
if you come too close.
To achieve a shot like this
therefore requires a macro
lens with a longer focal
length allowing the same
magnification from a
greater distance.*
Red Sea, Nikon F801, 180mm
macro f5.6, Subal housing,
Fujichrome Velvia, f11 @ 1/60 @
1:2. Main lighting from one Sea
& Sea YS50TTL with small slave
flash to fill shadows.

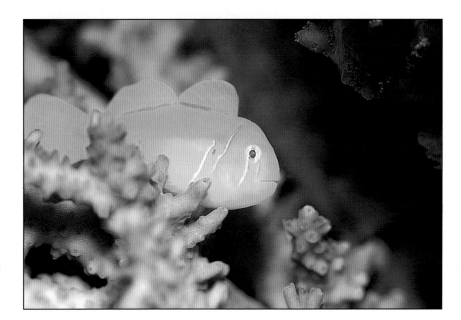

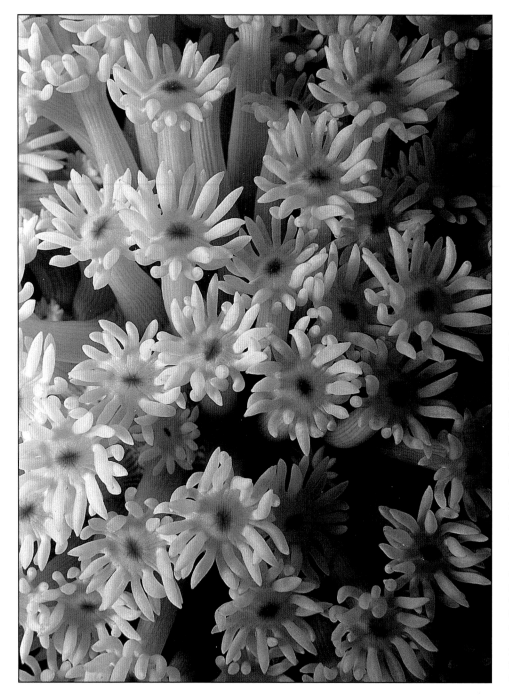

Left: Detail of soft coral polyps. When using macro be aware of interesting patterns or shapes in complete subjects, these often make attractive and striking abstract compositions.
Red Sea, Nikon F801, 60mm micro f2.8, Subal housing, Fujichrome Velvia, f16 @ 1/60 @ 1:1. Main lighting from one Sea & Sea YS50TTL with small slave flash to fill shadows.

Right: Detail of red gorgonian sea fan.
Red Sea, Nikon F801, 60mm micro f2.8, Subal housing, Fujichrome Velvia, f16 @ 1/125 @ 1:2. Main lighting from one Sea & Sea YS50TTL with small slave flash to fill shadows.

Nikonos and Sea & Sea

Be sure to read your instructions completely and pay special attention to the fixed focus setting which may vary from minimum to infinity dependant on manufacturer.

Remember that the framer size is larger than the picture area and therefore if you subject fills it completely parts of it will be cut off in the final picture. Experiment with different compositions until you are sure where the limits of your picture area are.

When composing your picture try to view the orientation of the subject from directly over the top of the camera and through the framer This will give you a better feel for what the lens will be seeing and avoid those 'flat' macro shots which lack depth.

Many photographers keep their flash position static over the top of the subject which in most cases will simulate reasonably natural lighting. However to compose some subjects it may be necessary to remove the flash from the camera or you may simply wish to try a creative lighting angle. When moving the flash be aware of the position of the framer as it is very easy to cast a shadow over the subject which will not be obvious until you see the processed image.

In order to retain maximum depth of field you will want to use minimum aperture or as close to it as possible. But when using extension tubes remember that you have increased the light path to the film and therefore the 'effective' aperture will be smaller than the setting on the lens. This means that the flash must

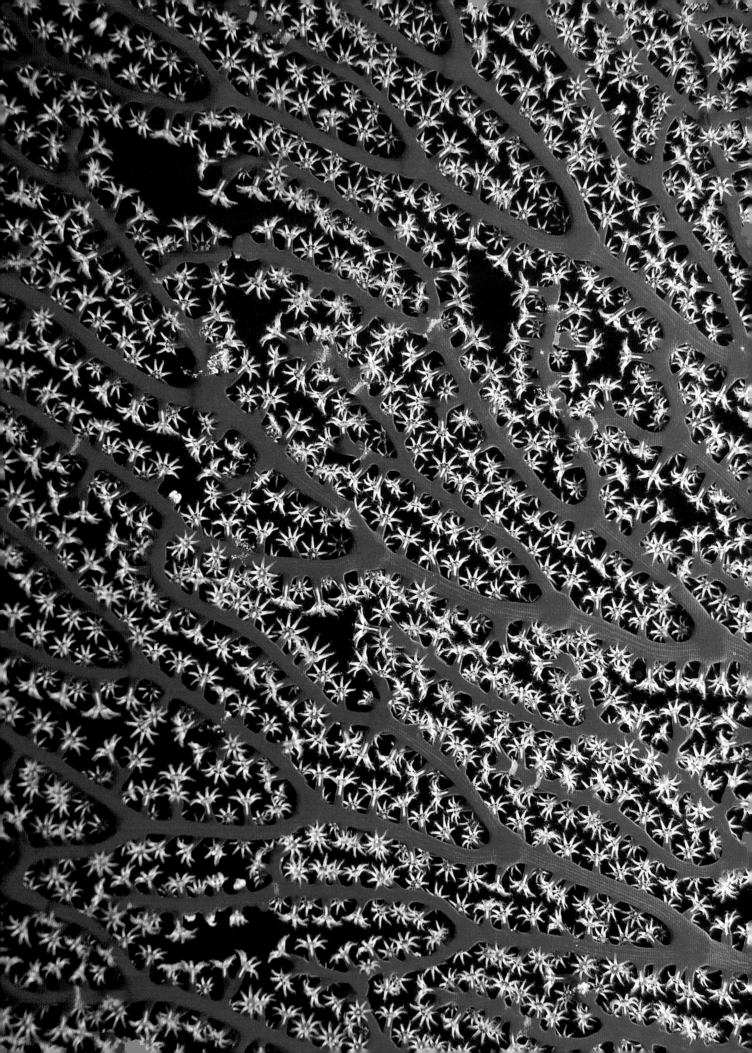

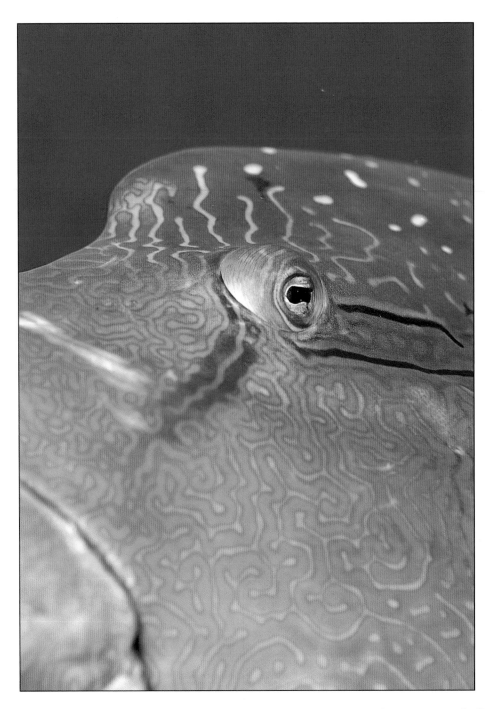

Napoleon wrasse eye.
Even if your subject is too
large for the lens you are
using, look for unusual ways
to photograph details.
This shot was taken as the
fish passed overhead giving
the opportunity to contrast
the body with the blue
background of the water.
Red Sea, Nikon F801, 90mm
macro f2.8, Subal housing,
Fujichrome Velvia, f11 @ 1/60 @
1:5. Main lighting from one Sea
& Sea YS50TTL with small slave
flash to fill shadows.

come closer to the subject to maintain a correct exposure. Even if you are using TTL exposure (you may be out of range) it is wise to 'bracket' exposures by moving the flash closer and further away from the subject which will vary the intensity of light.

Try using a second small slave flash opposite your main or key light. This will add depth to your pictures and also remove harsh shadows caused by single overhead lighting. As long as the slave has a lower power output than the key light it will not affect exposure.

Try placing some bait on or close to your framer to attract small shy fish into the picture area. However, be careful of including suspended pieces of food in the picture.

Housed Systems and Nikonos RS

If you are using a manual focusing system then it is sometimes better to prefocus the lens and then move into your subject and gently rock in and out until the focus is sharp and composition correct. If you are photographing fish it is sometimes better to observe the movements of your subject initially and let the fish become accustomed to your presence. You can then prefocus on a point where you expect the fish to pass or settle and take the shot when the fish is in frame and in focus.

If you are using an auto focus system you will find that when you are photographing at high magnifications (i.e. close to your subject) the lens will often 'hunt' from the point of focus to infinity and

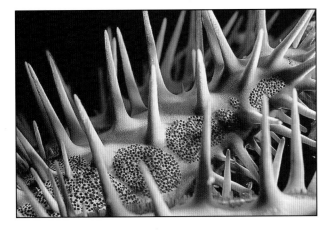

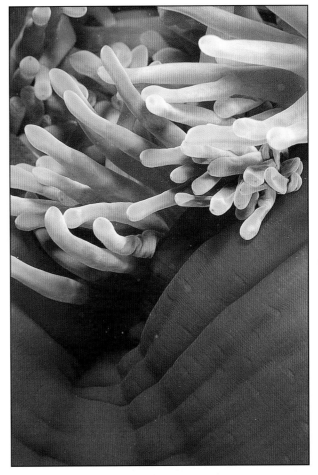

Above: Detail of spines on a crown of thorns starfish. Another example of using macro to produce attractive and striking abstract compositions.
Red Sea, Nikon F801, 60mm micro f2.8, Subal housing, Fujichrome Velvia, f16 @ 1/60 @ 1:1. Main lighting from one Sea & Sea YS50TTL with small slave flash to fill shadows.

Right: Detail of carpet anemone mantle.
Red Sea, Nikon F801, 90mm micro f2.8, Subal housing, Ektachrome 64, f16 @ 1/60 @ 1:2. Main lighting from one Sea & Sea YS50TTL with small slave flash to fill shadows.

Below: Detail of the dorsal spines of a scorpion fish.
Minorca, Mediterranean Sea, Nikon F801, 60mm micro f2.8, Subal housing, Ektachrome Elite II 100, f16 @ 1/60 @ 1:1. Main lighting from one Sea & Sea YS50TTL with small slave flash to fill shadows.

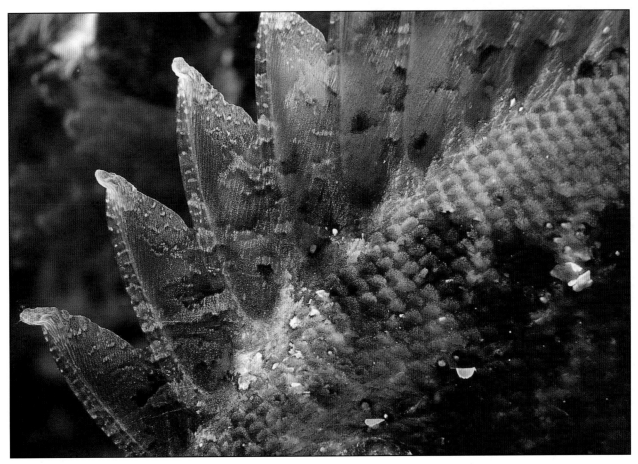

Wrong! Your macro framer is not to be used as a prod to pin your subject down whilst the picture is taken. Before approaching a subject ensure that you have trimmed your buoyancy correctly so that you are not sinking or having to fin hard to stay in position.

Right! When positioning yourself for macro photography either ensure that you have neutral buoyancy or find a subject next to a sandy area which will allow you to position yourself on the seabed without damaging the reef. Do not rest your framer on the subject, as it will either distress the animal or damage delicate reef organisms.

back again. This can be due to a lack of contrast in the subject or your movements of the camera, which are exaggerated at high magnifications, which move the focusing area off the subject slightly. This can be extremely irritating and I often resort to manual focus when this happens. Another way out of it is to focus on a contrasty subject and lock the focus by keeping the shutter release slightly depressed or using auto-focus lock if available. You can then re-compose and take your picture.

When using macro lenses, especially with manual flash, bear in mind that when you extend the lens to get close to your subject the aperture that you have set may not be the 'effective' aperture you are using. As you extend the lens you increase the light path through the lens to the aperture and to the film plane and therefore some light is lost (as with Nikonos extension tubes above). This is sometimes a problem even with TTL flash, so whether you are using TTL or manual you may need to move the flash a little closer to get the correct exposure. Many auto focus cameras

will display this phenomenon as you extend the lens, e.g. you will see the aperture displayed jump up one or two stops from the lens setting.

When composing a picture bear in mind that you are viewing the scene at full aperture and therefore at minimum depth of field. Often what appears to be just out of focus through the viewfinder may be sharp in the final image.

Be conscious of you flash positioning and try using a twin flash set up if you have a small slave. Look for subjects which stand up from their surroundings and allow you to get a low angle of view and separate your subject from its background giving it more impact.

Close up and macro photography are without doubt one of the best techniques to start with, producing pleasing results immediately. However, there is a large gap between a correctly exposed macro/close-up photograph and one which stands out as being artistically and technically well composed and only practice and familiarity with your particular system will move your results into this league.

Orange sea horse. Sea horses are one of the most appealing macro subjects you could hope for but are exceedingly difficult to spot. If you find one do not waste the opportunity – shoot the whole roll of film if necessary, varying exposure and lighting to ensure a good shot.
Bonaire, Caribbean Sea, Nikon F801, 105mm micro f2.8 , Subal housing, Ektachrome Elite II 100, f8 @ 1/60. Lighting from one Sea & Sea YS 120 TTL with a small slave to fill shadows.

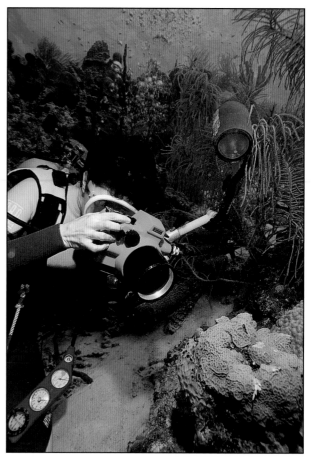

Above: Diver using Sea & Sea Motormarine II and macro kit. Extension tubes and close-up lenses with framers are ideal for static subjects or approachable marine life with easy access around the subject.

Right: Diver using housed macro system. When a subject is less accessible or will not tolerate a framer in close proximity then a macro lens on an SLR is the only way to get the shot.

Left: Oceanic Products extension tubes and Nikonos III.

Above: Sea & Sea Extension tubes for the Nikonos.

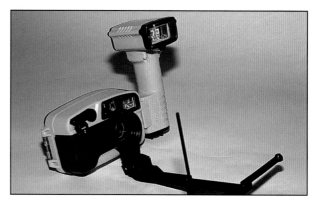

Left: Sea & Sea Motormarine II-EX with macro lenses and framers.

Above: Sea & Sea MX10 camera with macro lens and framer fitted.

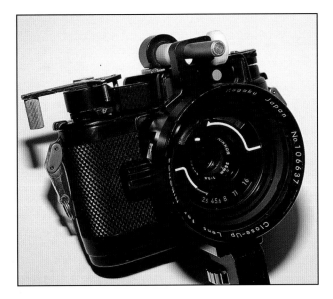

Left: Nikonos III with Nikonos close-up lens fitted.

Above: Nikonos Close Up Kit shown with frame for the 80mm lens.

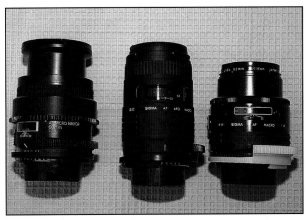

Above: Ocean Optics close-up lens and prods for use with the Nikonos 35mm and 28mm lenses.

Right: Nikonos Close Up Kit shown with framers for the 35mm, 28mm and 80mm lenses.

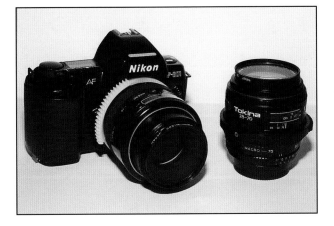

Close up diopters.

Above left: Nikon F801 with Sigma 90mm macro lens fitted. Alongside is a Tokina 28-72mm zoom lens with a macro setting of 1:4.

Above right: Three macro lenses for a housed Nikon auto focus camera. From the left: 60mm f2.8 micro Nikkor, 180mm f5.6 Sigma and 90mm f2.8.

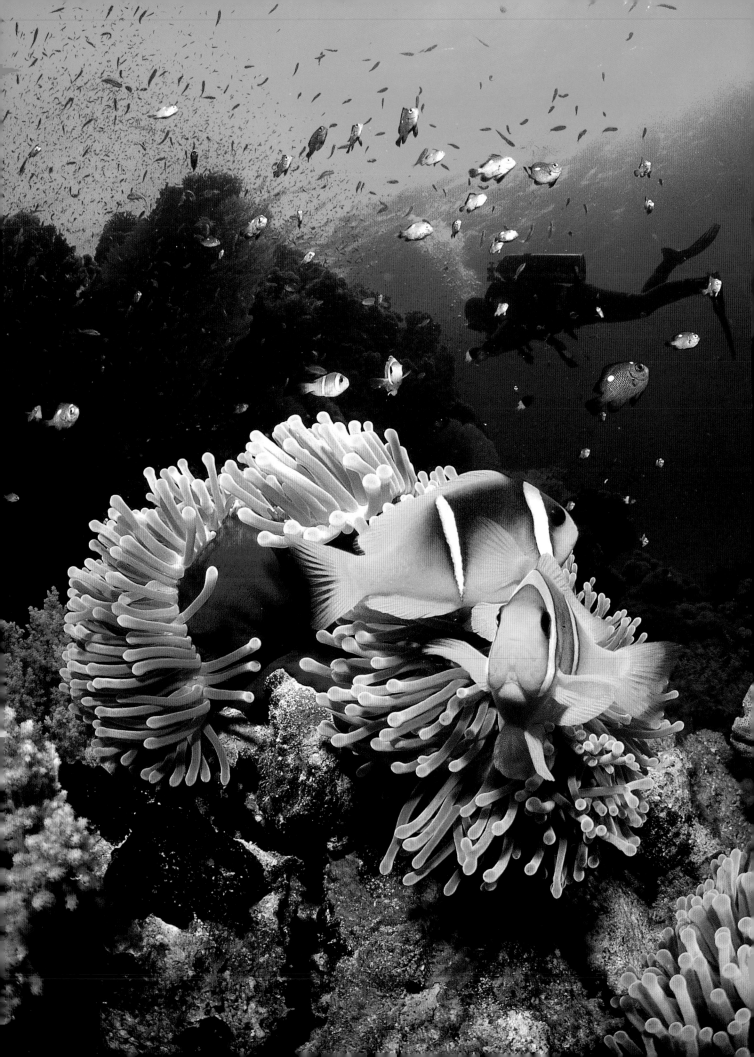

TAKING A WIDER VIEW

Wide Angle Photography

There is one golden rule in underwater photography; get as close as possible to your subject in order to minimise the effects of the water between your lens and your subject. This is an obvious technique when you are taking macro or close-up photographs, but how do you achieve those stunning panoramic views which adorn the diving press without sacrificing image sharpness and colour? The solution is to use extreme wide angle lenses which allow you to get very close to your subject and still get panoramic view in your picture. Extreme wide angle lenses are those with a focal length of 20mm or less for the 35mm format and there is now quite an extensive range to choose from for the Nikonos, RS and Sea & Sea user as well as those dedicated to housed land cameras.

Lenses with short focal lengths have an inherently good depth of field at most apertures – this in simple terms means that more of the picture area both in front and behind the subject on which you have focused will also be in focus. The shorter the focal length and smaller the aperture the better the depth of field becomes. The extreme of this phenomenon can be seen in 'fish eye' lenses which at medium apertures can provide a depth of field from a few inches from the lens to infinity! Ultra wide angle lenses have an angle of view which ranges from 80-85° for a 20mm for a Nikonos to a massive 160-180° for a fish eye which means you can get very close to your subject and still collect that panorama behind it. At this point it will help to highlight the various focal lengths available, the angle of view they provide and the differences between the land lenses and those for the Nikonos. Because Nikonos lenses are water corrected the optics differ from their land cousins which means that the angle of view will be slightly less than for a land lens with the same focal length:

Nikonos Lenses

FOCAL LENGTH	ANGLE OF VIEW
12mm Fish Eye	167°
15mm	95°
18mm	88°
20mm	85°
20-35mm zoom (RS)	85°
13mm Fish Eye (RS)	167°

Land Lenses

FOCAL LENGTH	ANGLE OF VIEW
6-8mm Fish Eye	220-180°
16mm Fish Eye	170-180°
14-15mm Rectilinear	110-115°
18mm	100°
20mm	96°

By comparing these tables you can appreciate the differences and perhaps notice that there are also one or two oddities in the range of land lenses. For instance why should a 15mm lens have a narrower angle of view than a 16mm fish eye? The reason for this is that a fish eye lens is largely uncorrected for distortion and will display a very curved image anywhere outside the centre of the frame – the object is simply to get as much in the picture as possible. A rectilinear 15mm lens is fully corrected in order to maximise the angle of view whilst minimising the apparent distortion at the edge of the frame – this is why the angle of view is reduced. There are also two types of fish eye lenses – full frame and circular. Full frame means simply that the resulting image fills the 35mm frame and this is generally the choice of most photographers as the weird circular image produced by the very short focal lengths is for specialist application only.

All extreme wide angle lenses will display some distortion and this is most obvious when photographing subjects where straight lines dominate. Fortunately underwater there are very few straight lines so this is not generally a problem but

Clown fish and carpet anemone. This anemone was perched on the top of a pillar of coral allowing me to get close and low under it. An unusual subject for close focus wide angle, this image bursts with movement from *the clown fish and the small accompanying domino fish.* Red Sea, Nikon F801, 16mm f2.8 fish eye, Subal housing, Ektachrome Elite II 100, f16 @ 1/125 to freeze the suns rays. Lighting from one Isotecnic 33TTL set to manual half power.

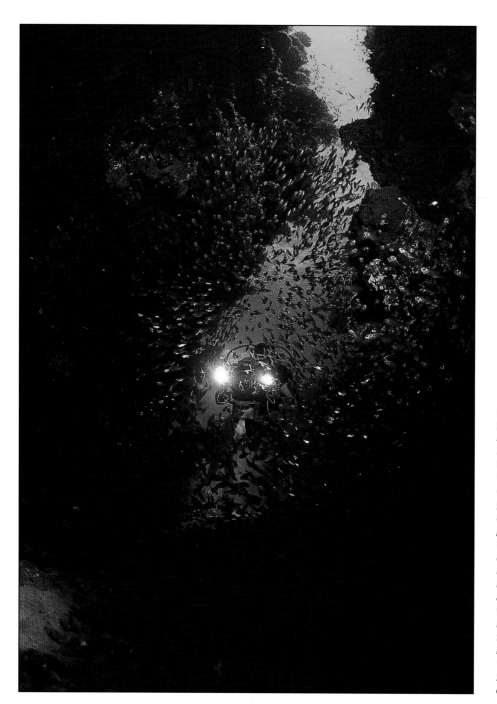

Diver swimming through a gulley filled with glassfish. A wide angle picture should be able to impart to the viewer a feeling of being there. This image shows a diver swimming towards the glassfish shoal which are about to part and let him pass. The addition of the video camera with its lights also tells the viewer there is movement and action in the image. A touch of flash has added sparkle to the fish without over exposing them. Red Sea, Nikon F801, 16mm f2.8 fish eye, Subal housing, Ektachrome Elite II 100, f8 @ 1/60. Lighting from one Subatec S100 manual flash gun on quarter power.

you need to be aware when photographing wrecks and even divers. Another problem that can arise when photographing divers is that of 'forced perspective'. This occurs when perhaps a hand, foot or face is closer to the lens than the rest of the diver's body and it appears large and distorted. So you need to be careful how you position a diver when you are working very close to avoid this.

Nikonos Systems

If you are a Nikonos user your choice is reasonably simple. Basically you have to choose the focal length you want and then decide whether you want a prime lens or a supplementary – this choice is mostly dictated by budget! However there is now a third option which is to use a land lens in a lens housing which fits to the Nikonos and is available from Aquatica. These housings are suitable for a whole range of lenses from fish eye to medium wide and offer full control over aperture and focusing. If you follow this route then some of the comments for housings which follow may apply dependant on which lens you plan to use.

Using a prime lens will always produce technically superior photographs to the supplementary lenses, but unless you are very fastidious in your appraisal of your results you will probably not notice a huge difference. One thing which is essential for all combinations is a good quality optical viewfinder

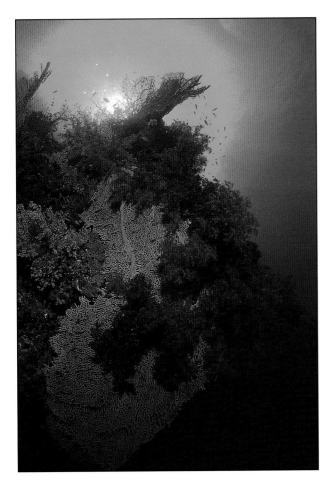

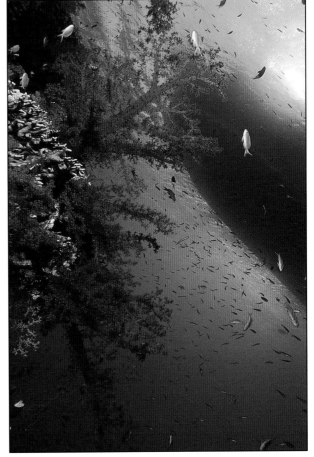

***Sea fan with soft corals.
This sea fan was at least 2m
in diameter, so required a
fish eye lens to get close and
still leave room in the frame
for some background detail.
Although the subject
distance is less than a metre
it is far too large to light
entirely by flash. A light
meter reading was taken for
the blue water above the
main subject and the flash
power adjusted to match***

***and balance the light. With
a large subject like this TTL
may work if you are close
enough, so it's worth a try,
but it is always safer to
bracket a couple of manual
exposures just in case.***
*Red Sea, Nikon F801, 16mm
f2.8 fish eye, Subal housing,
Ektachrome Elite II 100,
f11 @ 1/60. Lighting from one
Isotecnic 33TTL on manual
half power.*

***Purple soft coral on sheer
reef wall with boat above.
When diving on a reef wall
look for subjects growing
out into the water column
which allow you to get close
and compose an upward
angle without contacting the
reef. A boat on the surface is
always a useful background
and adds depth and that
feeling of exploration
to the image.***

*Red Sea, Nikon F801, 20mm
f2.8 , Subal housing, Fujichrome
Velvia, f11 @ 1/60. Lighting
from one Subatec S100 manual
flash gun on half power.*

which is matched to the coverage of your lens.
Some have a focused distance adjustment which sets
the viewfinder to correct for parallax (the mismatch
between what the lens sees and what the viewfinder
sees) which generally work well. Others are rigid and
pre-set for a distance of perhaps a metre but may
provide bright line graduations in the viewfinder for
other distances. Most lenses are supplied with a
viewfinder or the manufacturer provides one as an
extra – if this is the case look around at the options as
the viewfinder from another manufacturer may be
of a better design.

Currently there are only two supplementary wide
angle lenses available of which I am aware. One is the
Subawider manufactured by Subatec of Switzerland
and the second is the WCL 16 from Sea & Sea.

Sadly the Subawider is no longer imported into the
UK but there is a healthy second hand market or you
could order direct from Subatec. The Sea & Sea WCL
16 is widely available and both lenses are very similar
in operation and performance. They are designed to
be used in conjunction with the standard Nikonos
35mm lens and increase the angle of view to
approximately 94°, similar to the Nikonos 15mm
prime lens. This conversion affects the focus scale of
the 35mm lens (small stickers are provided to convert)
and also increases depth of field significantly. Apart
from the reduced cost, the great advantage of these
lenses is that you can change them underwater which
enables you to use both close-up and wide angle on
the same dive. Over the years other manufacturers
have produced similar supplementary lenses which

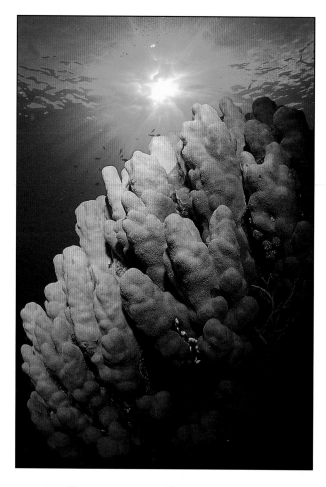

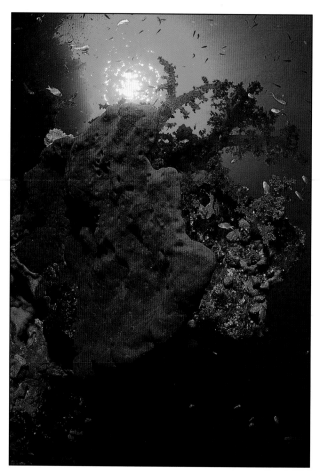

occasionally crop up second hand. They include:-
Vizmaster; Novatek; Aquacraft; Green Things; Seacor
and perhaps one or two others. If you find one of
these it would be prudent to try before you buy as
some were a lot better than others!

The lens options for the Nikonos are best shown as
a table as follows:

Focal Length	Manufacturer	Angle of View
12mm Fish Eye	Sea & Sea	167°
15mm	Nikonos/Sea & Sea	95°
17/18mm	Sea & Sea	88°
20mm	Nikonos/Sea & Sea	85°
15mm Supplementary	Subatec/Sea & Sea	95°
Aqualens Lens Housing	Aquatica	Fish eye to 28mm

All the prime lens options are for underwater use
only as the small domes used on these lenses require
particularly strong correction to focus under water.

Lenses for the Nikonos RS were only manufactured
by Nikon and as shown in the first table there are two
available (most likely only on the second hand market
now): 13mm fish eye and 20 to 35mm zoom.
Both are superb auto focus optics but are in the same
price league as the RS camera body! However, if the
price is not a problem then this system is worthy of
serious consideration.

Above left: Pillar corals and sunburst. Be aware of interesting shapes and compositions when you are searching for wide angle subjects. I had been patiently stalking a shoal of barracuda and when they finally swam off (I missed the shot!) I then concentrated on composing this stand of coral.
By moving the camera you can create a more dramatic diagonal composition from a fairly uniform subject.
Red Sea, Nikon F801, 16mm f2.8 fish eye, Subal housing, Ektachrome Elite II 100, f11 @ 1/60. Lighting from one Subatec S100 manual flash gun on half power.

Above right: Red elephant ear sponge with soft corals. Bright colours in wide angle images are a very important tool for adding impact, so don't discard seemingly uninteresting subjects without considering their colour potential. This sponge with its fringe of soft coral looked a dull greeny colour at 18m, which indicated to me that it was probably bright red, which proved to be the case on the processed film.
Red Sea, Nikon F801, 16mm f2.8 fish eye, Subal housing, Ektachrome Elite II 100, f11 @ 1/60. Lighting from one Subatec S100 manual flash gun on half power.

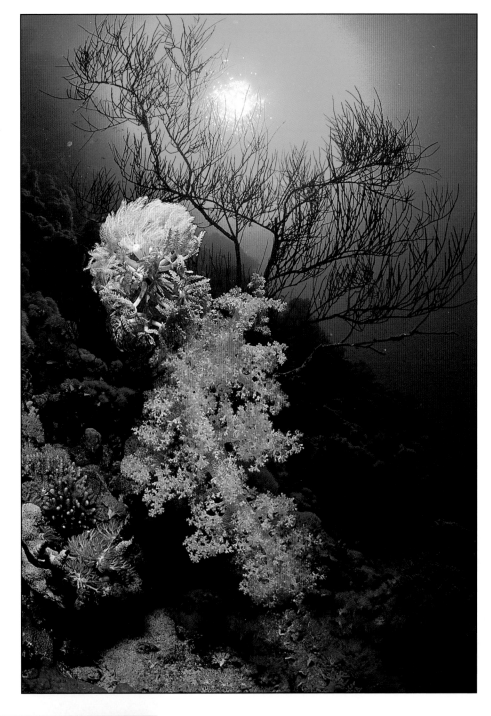

Soft corals growing on a tree of black coral.
This is a classic close focus wide angle composition. The location of the black coral on a steep reef slope has allowed a very close approach and an extreme upward angle, enabling the use of a small aperture, to balance with the sunlight, for additional depth of field.
Red Sea, Nikon F801, 16mm f2.8 fish eye, Subal housing, Ektachrome Elite II 100, f16 @ 1/60. Lighting from one Subatec S100 manual flash gun on half power.

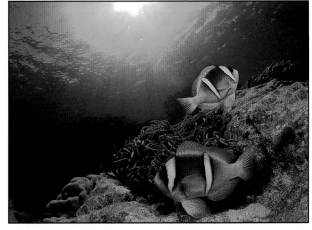

Clown fish and anemone. Try not to get obsessed with the vertical format for close focus wide angle shots. There are plenty of subjects which suit the horizontal format especially in shallow water. This anemone complete with two clown fish was found on the top of a rock which allowed a close **approach. Late afternoon sun provided the added bonus of shafts of sunlight.**
Red Sea, Nikon F801, 16mm f2.8 fish eye, Subal housing, Ektachrome Elite II 100, f16 @ 1/125 to freeze the suns rays. Lighting from one Subatec S100 manual flash gun on half power.

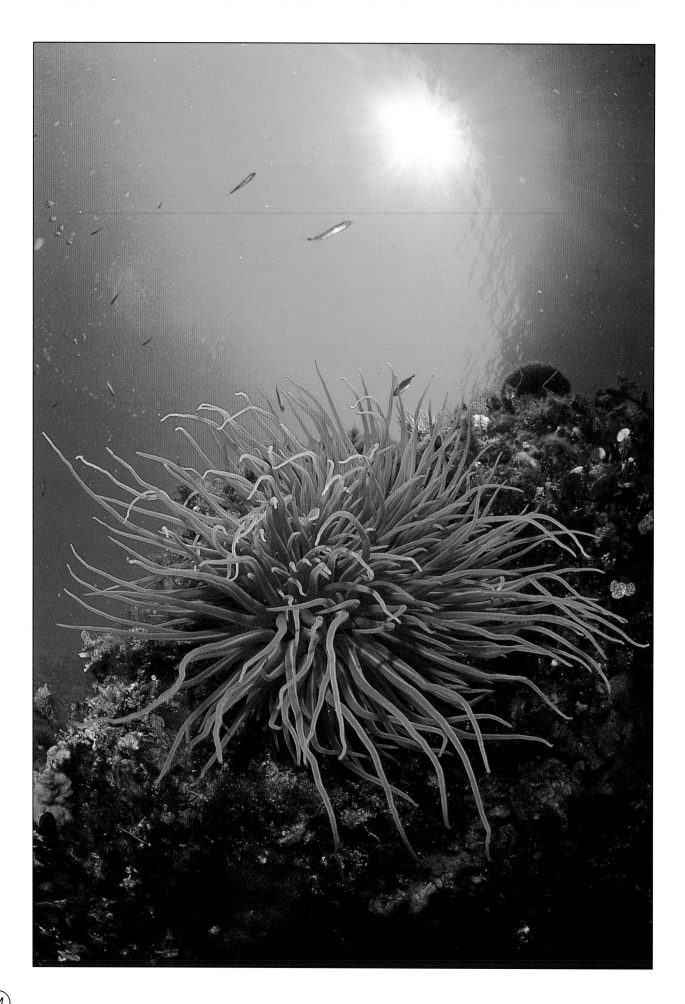

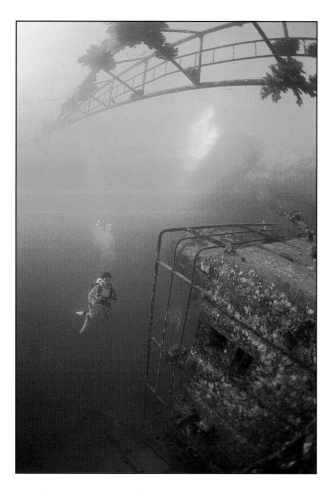

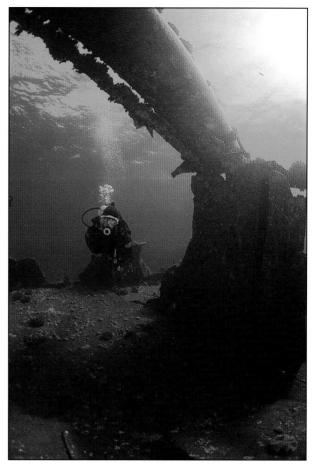

Wreck of the Giannis 'D', Red Sea. This image demonstrates the importance of keeping straight lines in the centre of the frame when using a fish eye or extreme wide angle lens. The framework of the mast reaching toward the surface has become curved and bent, whereas the **bridge hand rails in the centre have not and this has spoilt an otherwise attractive shot.** *Red Sea, Nikon F801, 16mm f2.8 fish eye, Subal housing, Ektachrome Elite II 100, f8 @ 1/60. Lighting from one Subatec S100 manual flash gun on half power.*

Diver on the wreck of the Krisoula 'K', Red Sea. The diver is swimming under the main mast which has collapsed across the main deck. The shape of the mast is acceptable in the centre of the frame but begins to bend towards the camera in the top left hand corner. Some degree of distortion in wreck **photography is inevitable, what is acceptable is purely down to the personal assessment of the photographer.** *Red Sea, Nikon F801, 16mm f2.8 fish eye, Subal housing, Ektachrome Elite II 100, f8 @ 1/60. Lighting from one Subatec S100 manual flash gun on half power.*

Left: Snakelocks anemone. This small anemone was perfectly placed on the edge of an overhanging rock in about 4m of water, allowing me to get right under it and as close as 10-12cm. The early morning sun added the sparkle, but in this type of situation you must be careful with your regulator exhaust, **which can disturb the subject or leave bubbles on the surface – definitely a no-no, so hold your breath!** *Corsica, Mediterranean Sea, Nikon F801, 16mm f2.8 fish eye, Subal housing, Ektachrome Elite II 100, f16 @ 1/125 to freeze the suns rays. Lighting from one Isotecnic 33TTL set to manual half power.*

Housed Camera Systems

When choosing a lens for your housed system options will often be limited by what your housing will accept. Some housings have quite a deep bulkhead onto which the various ports will mount, which may restrict the use of some fish eye lenses due to 'vignetting' or cut off at the picture edges (i.e. the lens 'sees' the inside of the housing). Lenses from different manufacturers can vary dramatically in their dimensions so don't give up on your first try as another may be long enough to clear the edge of the housing. The next step is to match the right dome port to your lens to correct it for underwater use. Most manufacturers produce dome ports for specific wide angle lenses but it is wise to consider the

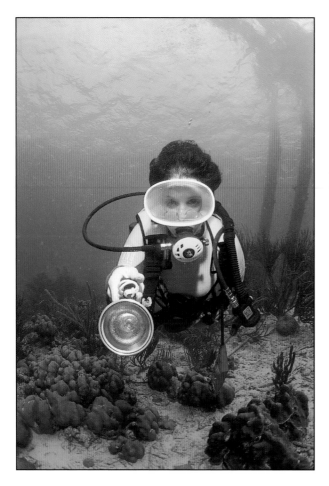

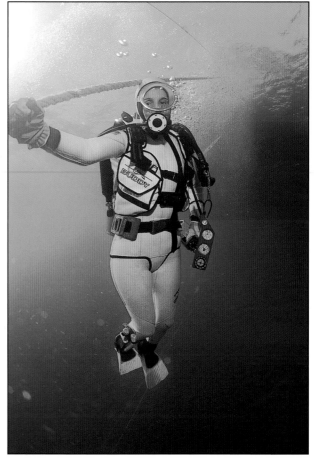

compatibility of the port you are choosing with other wide angle lenses to avoid duplication. For example if you are buying for a 20mm lens but plan to buy a fish eye in the future it may be wise to buy the fish eye port which will probably serve both lenses.

Another point to consider when choosing a lens/port combination is whether or not your lens will require a close-up dioptre to enable it to focus when under water. When your lens is behind the dome underwater it is focusing on a 'virtual' image created by the dome which is much closer than the actual subject. The distance to this image is a product of the size of dome in use (generally the virtual image lies at a distance twice the diameter of the dome) and unless your particular lens will focus down to this distance you will need to add a dioptre. This becomes more exaggerated as the dome size is reduced and therefore the lens requires more correction. Although all this sounds extremely complicated, most of the manufacturers will have calculated this for you for various lens combinations, so there is no need for brain strain unless you plan to make your own domes, but that is quite another story!

Above left:
Forced perspective: This shot demonstrates the distortion that results from having a diver too close to a fish eye lens. The torch and diver's hand appear unnaturally large.
Red Sea, Nikon F801, 16mm f2.8 fish eye, Subal housing, Ektachrome Elite II 100, f16 @ 1/60. Lighting from one Subatec S100 manual flash gun on half power.

Above right:
Forced perspective: Again there is distortion from having a diver too close to a fish eye lens. The diver's hand appears unnaturally large and the arm looks far too long.
Red Sea, Nikon F801, 16mm f2.8 fish eye, Subal housing, Ektachrome Elite II 100, f11 @ 1/60. Lighting from one Subatec S100 manual flash gun on half power.

Tips and Wrinkles

Metering

When using a TTL meter bear in mind that these lenses collect an awful lot of light especially if the sun is in the picture. This applies especially to the fish eye lenses and you can very easily end up metering for the brightest part of the picture which is not necessarily the main subject area. Some housed systems offer matrix metering with dedicated lenses and this can cope with the problem a little better in most circumstances. However, I personally prefer to use centre weighted (the Nikonos IV/V has this) or spot

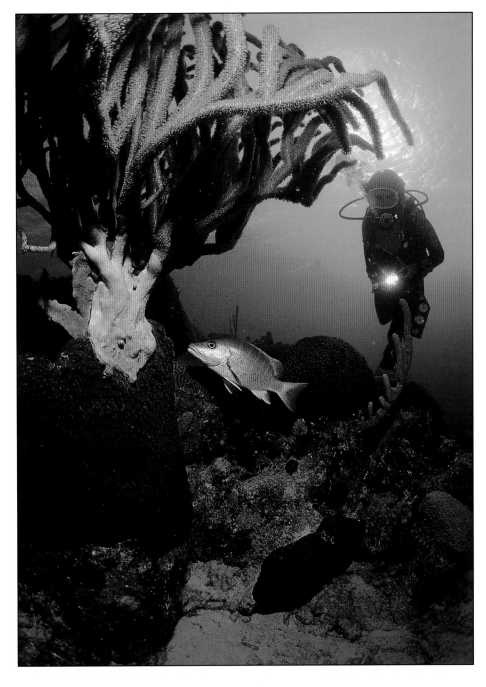

Gorgonian corals and snapper. The sandy areas at the top of Caribbean reefs offer plenty of opportunities to get close to your subject and maintain a low approach without damaging the surrounding reef. This allows you to position the subject against an open water background and perhaps include the sun or a diver.
Bonaire, Caribbean Sea, Nikon F801, 16mm f2.8 fish eye, Subal housing, Ektachrome Elite II 100, f8 @ 1/60. Lighting from one Isotecnic 33TTL set to manual half power.

metering which enables you to meter the critical area of picture more accurately. Another option is to use a separate amphibious light meter which generally have a narrow angle of view.

Flash Coverage

We have already discussed flash choice in an earlier chapter but it is worth making a couple of points here. Undoubtedly it is better to use a powerful wide angle flash with these lenses if you can afford one. This is perhaps more important for the fish eye lenses which will always exceed the angle of your flash. However, many wide angle photographs are taken using the 'balanced lighting' technique where you are only using flash to fill in the colours in the foreground.

In these circumstances it is possible to use narrower beam flashes especially if the subject you wish to light fills only a part of the frame and is close to the lens. This takes practice and patience! One other point to be wary of, especially with fish eye lenses, is flash position. It is very easy not to notice that your flash is either to close to the edge of the picture or even included at the top or corner. Many otherwise perfect pictures are ruined by the bright glare of the flash in one corner or even the perfectly exposed image of half your flash! Be wary and ensure that the flash is well behind the lens especially if you are hand holding the flash gun.

Left: Nikonos V with Nikkor 15mm lens and viewfinder.

Above: Sea & Sea Nikonos lenses. 16mm Super wide conversion Lens, 20mm lens, 15mm lens and 12mm fish eye lens.

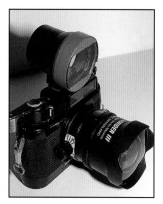

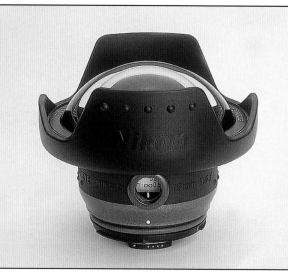

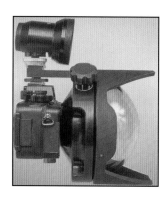

Above: Subatec Subawider III supplementary wide angle lens fitted to a Nikonos III.

Above: Aqua Vision Systems Aqualens lens housing for Nikonos.

Left: Nikkor 13mm fish eye lens for the Nikonos RS.

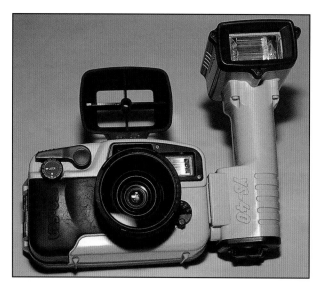

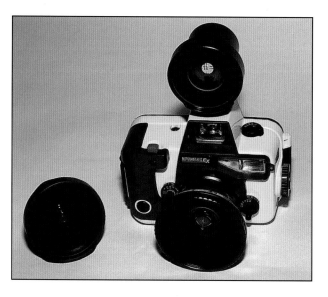

Sea & Sea MX-10 with 20mm Wide Conversion Lens and sports finder.

Sea & Sea Motormarine II-EX with 16mm and 20mm Wide Conversion Lenses and optical viewfinder.

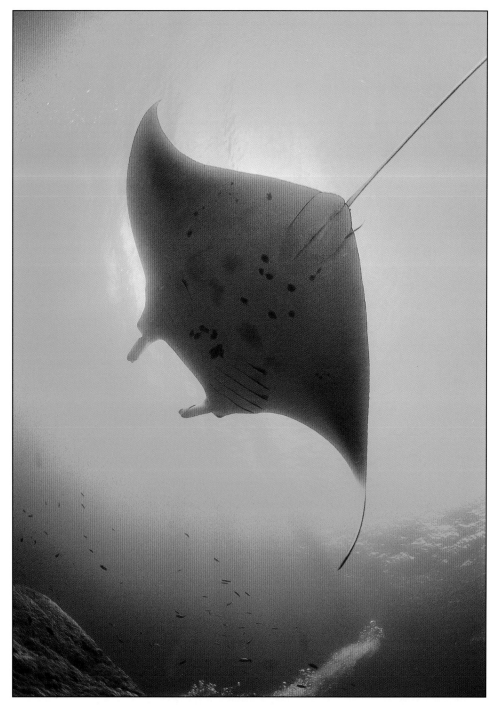

Manta ray. There are some big marine creatures which will allow a very close approach if you are cautious and you will need a superwide angle lens to get the whole subject in the picture. Mantas are generally encountered on the move unless you are lucky enough to find a cleaning station. This shot was taken on a shallow reef in the Maldives in a current of 1.5 knots!! No problem for the mantas but exceptionally hard work with a camera!
Maldive Islands, Indian Ocean, Nikon F801, 16mm f2.8 fish eye, Subal housing, Ektachrome Elite II 100, f8 @ 1/60. Lighting from one Sea & Sea YS 120 set to manual half power.

TTL Flash Exposure

With the exception of one or two housed camera options all TTL flash metering is centre weighted. This means that when the flash is fired the exposure is metered from the centre of your picture area. Therefore, if your main subject does not dominate the centre of the picture you are unlikely to get a correct exposure particularly if you are trying to balance the flash with the natural light. This problem is most acute with the classic close focus wide angle situation where the flash lit subject is in the lower half of the frame and the background is largely distant or open water. In situations like this it is best to use manual exposure

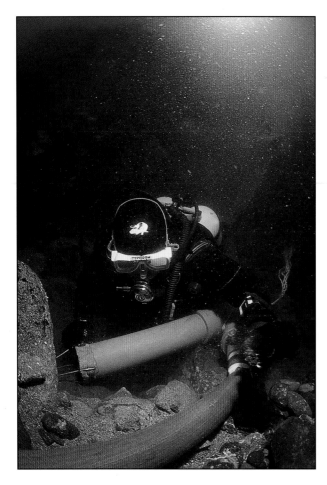

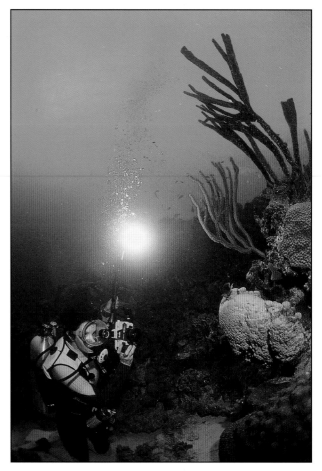

and bracket to ensure at least one good shot. TTL does work perfectly well with wide angle lenses but you must be conscious of the limitations of the metering system.

Using Depth of Field

Some extreme wide angle lenses will focus right down to 4-6 inches whilst others may have a minimum focus of only 12-18 inches. If yours is one of the latter don't despair as by careful use of apertures you can improve the close focus capacity of your lens.
For this you must be familiar with the depth of field your lens produces at certain apertures. This is normally easy with a Nikonos lens which displays a depth of field scale with each aperture setting but with housed systems you may need to experiment and make up a small table. Then you will find that under the right exposure conditions you can select an aperture which may give you a depth of field from 6 inches to 10 or 20 feet for those stunning close focus wide angle shots.

Wide angle photography can produce some of the most exciting underwater images. However, the lenses, flash guns and ancillaries are not cheap and the techniques may take time to master. But it is worth persevering with your savings and then the techniques to produce those powerful, colourful shots with the sun bursting through!

Above left: Flash in the picture: This shot of a diver using an air lift has been spoilt by the inclusion of the flash in the top of the picture. This is easy to do when using wide angle lenses, particularly with a Nikonos which does not have through the lens viewing.

*Above right: Diver taking a close focus wide angle shot. In order to balance the exposure of the subject close to the lens with that for the background, it is often necessary to hand hold the flash back in order to reduce the strength of the light reaching the subject.
If you have a manual gun with several power settings you can merely turn down the power and leave the flash attached to the camera. TTL often does not work well with close focus wide angle compositions so it is best to bracket your exposures on a manual setting.
Cornwall, UK, Nikonos V, 15mm f2.8, Ektachrome Elite II 100, f11 @ 1/60. Lighting from one Subatec S100 manual flash gun on half power.*

Right: Diver using Sea & Sea Motormarine II-EX with 20mm wide angle supplementary lens and optical viewfinder.

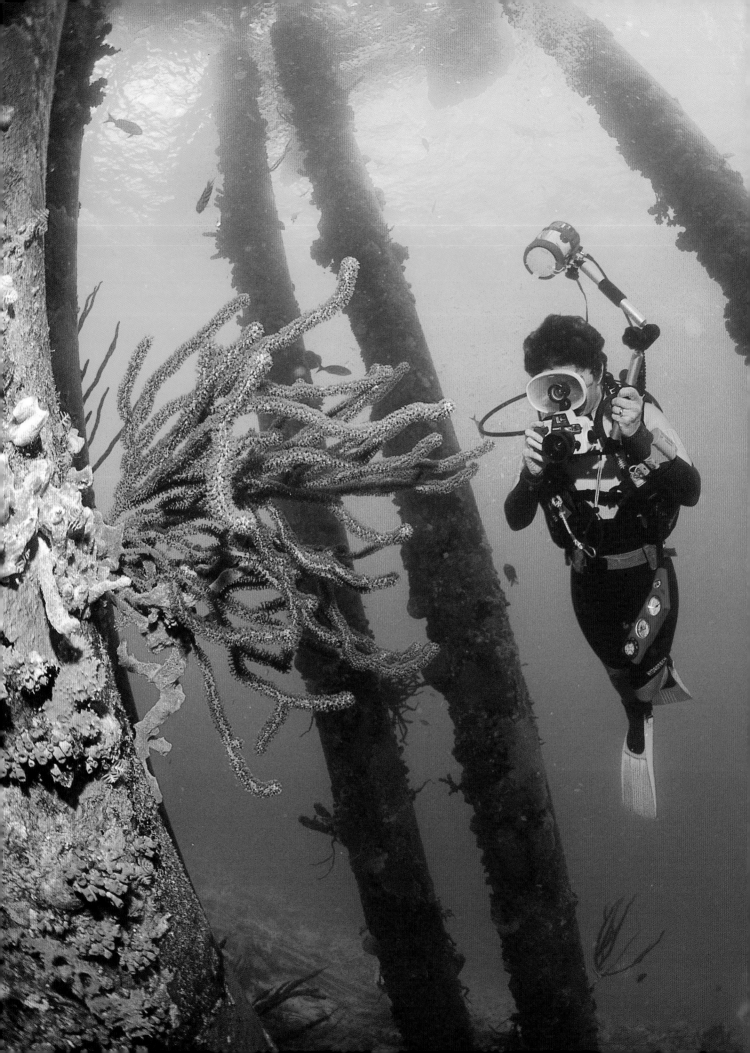

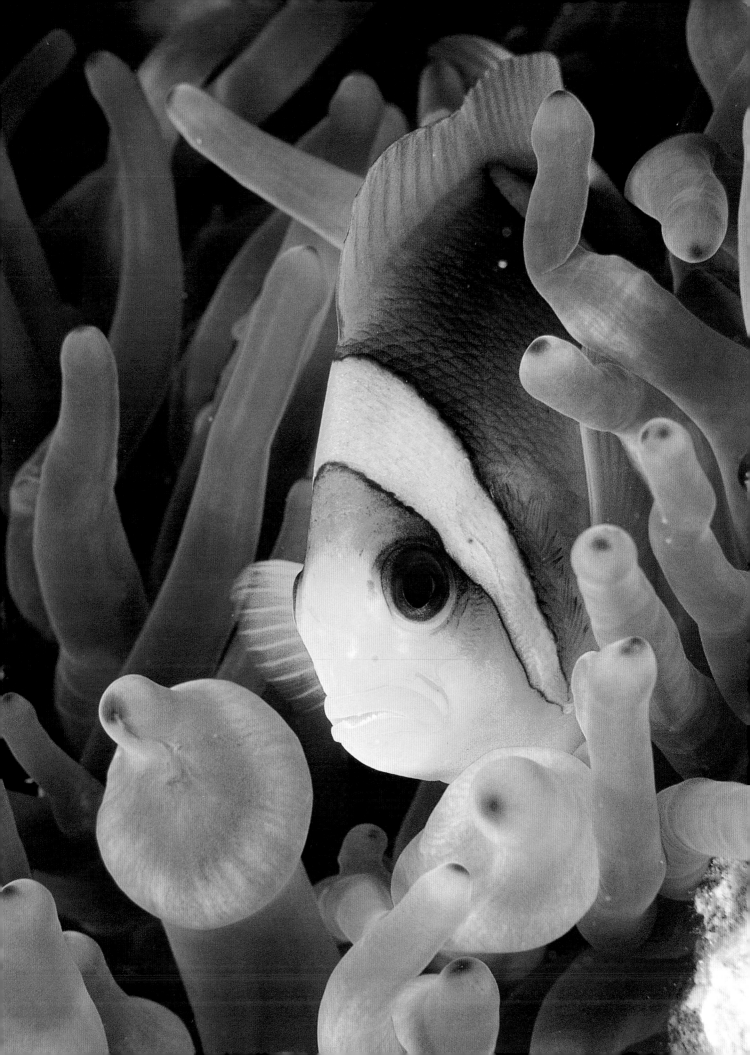

GETTING COMPOSED

If you take time to study some of the many books available describing the techniques required for successful land photography you will inevitably encounter detailed descriptions of the rules of composition and how they need to be followed to produce a technically perfect and pleasing photograph. But do these apparently complex rules apply to underwater photography? Although the thought of applying them is both baffling and daunting to most at first, there are many similarities between land and underwater techniques and by using some of the basic rules you can improve the composition and impact of your photographs.

Many successful underwater photographers do not consciously follow the rules of composition but merely apply a horizontal or vertical format to a subject and arrange the picture instinctively. However, most, at one time or another, will have admired and imitated the images of other photographers who have followed these rules to some degree and therefore end up applying them subconsciously to produce similar results. So, let's examine a few of the basic rules which can be useful underwater, but remember they are only guides and we should not become obsessed with composing according to the rules as very often an image which breaks them all can be your most successful!

The Rule of Thirds

This is one of the first basic rules which is taught to students studying photography and is supposed to have been used by all the great classic photographers. Essentially it divides the image into nine equal sections by drawing three imaginary horizontal and three

Right: The basic rule of thirds division of the 35mm format.

vertical lines through the frame. The theory behind this is that it encourages the photographer to position key elements of the image within or at the intersection of these areas thus avoiding a central focal point and a boring or empty composition.

Your first thought might be "how do you apply this to a fish which fills the frame?". With a subject such as this you would divide the key elements of the fish to suit. For instance, the most important feature of the fish will be its face or eye and mouth and these would be composed say in the lower third of the frame to lead the viewers eye over the subject. By using the rule of thirds you can achieve a better sense of balance in an image and realise immediately if you have any glaringly empty areas or dead 'negative space' before you release the shutter.

Leading the Eye

The key to the art of successful composition is the lead the viewer's eye to the focal point of the image. This may be the face of a fish or marine animal, an anemone or coral or a diver examining or searching for marine life. Whatever it is, the viewer must be able to immediately realise where the focal point is and what the photograph is trying to convey. This can be achieved by following some additional basic rules which in effect are overlaid onto the rule of thirds.

One of the most powerful tools in composition is

Clown fish in anemone. Clown fish are an irresistible tropical subject which all photographers will want to photograph on their first visit to a coral reef. Although at first they appear to be an easy subject as they stay with the host anemone, they are in fact difficult to compose quickly due to their constant skittish movements.

This is a classic vertical composition with the fish positioned diagonally in the frame with the eye positioned on the centre third area.
Red Sea, Nikon F801, 60mm f2.8 micro, Subal housing, Fujichrome Velvia, f16 @ 1/60. Main lighting from Sea & Sea YS50TTL flash gun with a small slave to fill shadows.

the diagonal line running through an image which pulls the viewer's eye towards the focal point. This point can anywhere along the line as the viewer's eye will naturally be led across the image and discover this point. So, to examine the example of the fish once again, you can position the fish diagonally in the image, passing through two or more of the 'rule of third zones' leading the viewer's attention towards the head or eye of the fish in say the lower right or left section of the image. If the image were a close-up of the head of the same fish then perhaps you would position the eye and mouth on an imaginary diagonal line to balance the photograph. Once you grasp this fundamental tool you will realise how often it is used by other photographers, whether it is the line of the reef, the shape of a wreck, the position of a diver or the shape of an invertebrate animal. Sometimes the use of diagonals can be truly striking and obvious, whilst others are more subtle but none the less powerful. So when you have decided on your subject, try moving the camera to place it on a diagonal line and see how it changes the appearance of an image.

As you begin to consider composition more fully you will realise that it is often a mixture of techniques which produce the most striking images. Perspective control or applying a sense of depth and scale to an image is a technique which operates well on the diagonal principle described above. In order to avoid the appearance of a 'flat' image it is important to

Tiny commensal goby on branch of soft coral. In this horizontal composition both the main elements (fish and soft coral branch) are placed on a diagonal line with the fish's head placed in the bottom left hand third of the picture. Both these elements **lead the viewer's eye across the image from top to bottom.**
Red Sea, Nikon F801, 60mm f2.8 micro, Subal housing, Ektachrome 64, f16 @ 1/250. Main lighting from Sea & Sea YS50TTL flash gun with a small slave to fill shadows.

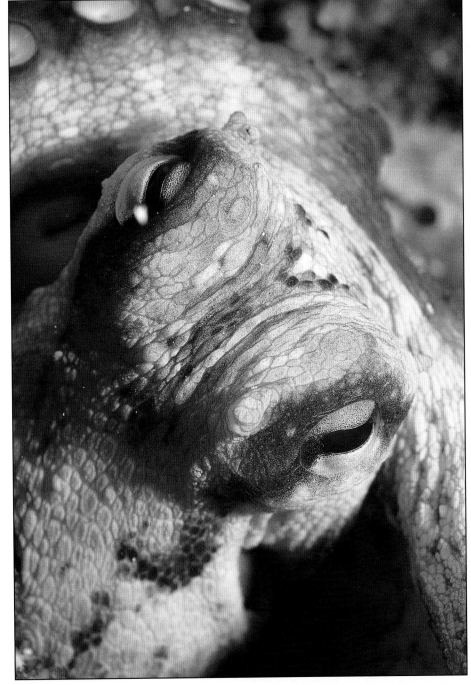

Octopus eyes. This octopus was just peering out of his hole and as I looked through the viewfinder I realised that there were two diagonals running through the image – that of the eyes in one direction and the body in the other. Positioning the eyes across the centre third of the frame provided the best balance.

Minorca, Mediterranean Sea, Nikon F801, 60mm f2.8 micro, Subal housing, Fujichrome Velvia, f16 @ 1/60. Main lighting from Sea & Sea YS50TTL flash gun with a small slave to fill shadows.

consider the positioning of your subject and the background or negative space around it. Using the fish example again, if the animal is positioned diagonally moving towards the camera instead of side on or flat, then an impression of depth or length is achieved with perhaps the added impression of movement towards the camera. This can be enhanced by choosing a background which contrasts well with the main subject so that it stands out against it. Look also for opportunities to get below your subject to gain an upward view against open water towards the surface which creates good contrast and that impression of distance behind it.

Perspective is a particularly important consideration in wide angle photography which is used to transport the viewer into the feel of the underwater world. You can use the diagonal line of the reef or a wreck to lead the eye away into the distance perhaps towards the sun bursting through on the surface to create a feeling of depth. Scale can be demonstrated by either having a small subject in the foreground, which is dwarfed by the background, or by including something larger in the distant background such as a diver or a dive boat on the surface. You can see that sometimes these elements are doing more than one job and it is often the subtle combination of techniques which is most successful in transmitting that feeling of 'being there' to the viewer.

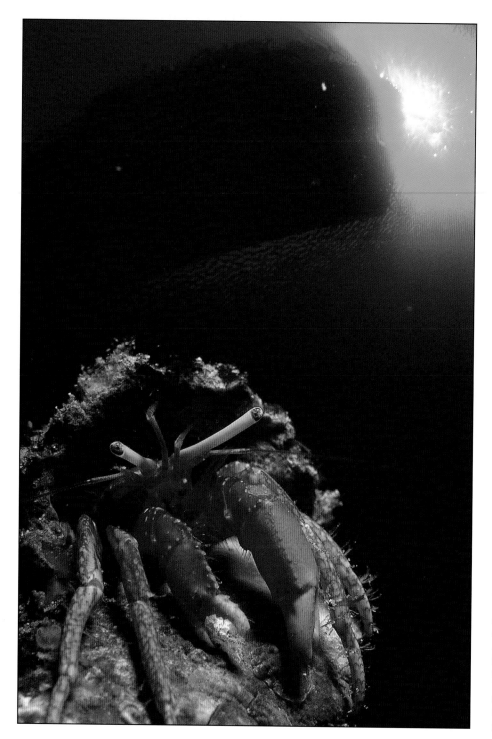

Hermit crab and boat – double exposure. Even when taking manipulative or creative shots you can apply the rules of composition. In this image the hermit crab and boat with sunburst have been positioned in opposing thirds top and bottom with an implied diagonal line between them.
Red Sea, Nikon F801, 60mm f2.8 micro and 16mm 2.8 fish eye, Subal housing, Fujichrome Velvia, f22 @ 1/250 for both exposures. Lighting for the crab from one Sea & Sea YS50TTL flash gun on manual.

When you are including a diver in the image it is normally best to have he/she doing something or looking at some other subject in the image. Positioning of the diver and eye contact is discussed in more detail in Chapter 10, but bear in mind that you can apply the rules of composition to the location of your diver in the image to enhance the balance and to direct attention toward the main subject. For example, your diver can be swimming into the picture on a diagonal towards the subject perhaps shining a torch at it or, if it is a closer view, the divers eyes can be directed across the image from one 'thirds zone' to another towards the main subject.

Right: Napoleon wrasse. When I encountered this fish I had been looking for macro subjects with my 90mm lens. However, this fish persisted in its curiosity so I concentrated on photographing details of its body with some unusual compositions. Even though this image is taken from above the fish, it has still **been possible to introduce a diagonal composition which is perhaps more interesting and appealing than positioning the fish straight up and down in the frame.**
Red Sea, Nikon F801, 90mm f2.8 macro, Subal housing, Fujichrome Velvia, f16 @ 1/60. Main lighting from Sea & Sea YS50TTL flash gun with a small slave to fill shadows.

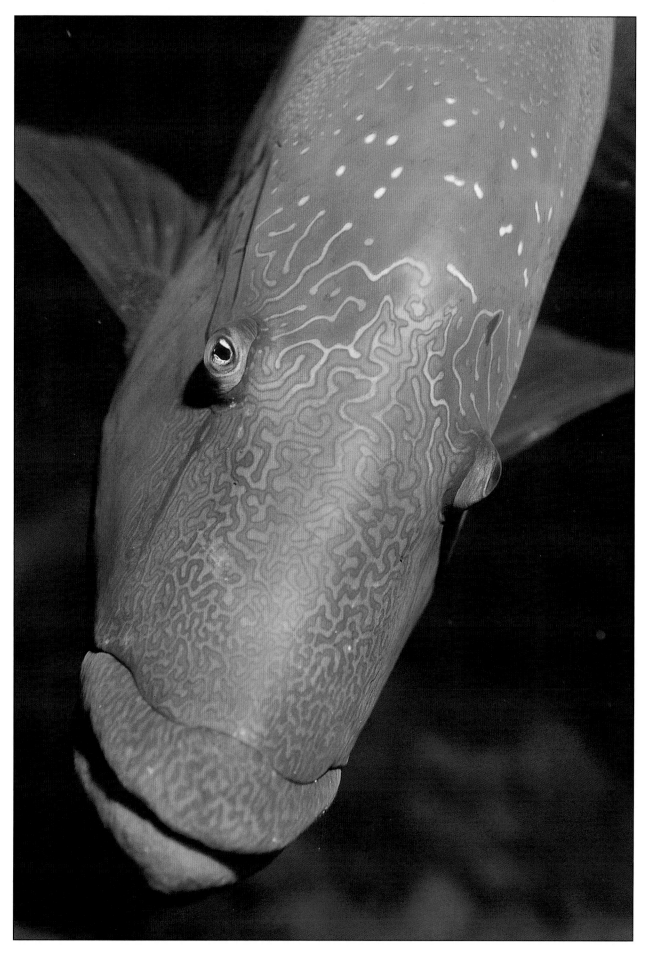

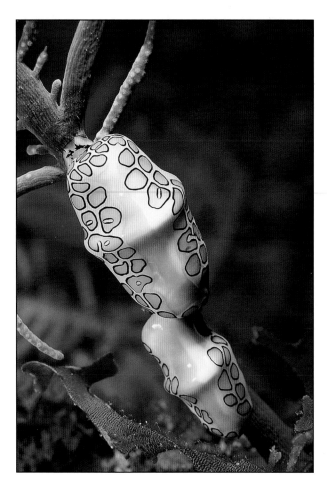

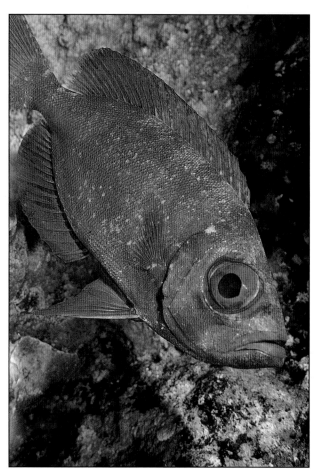

Flamingo tongue cowries.
These molluscs are almost
always found on the
branches of purple sea fans
in the Caribbean.
The branches of the
gorgonian are perfect for
diagonal compositions and
to find two together was
pure luck. Remember to
twist the camera to vary the
composition and try
both horizontal and
vertical formats.
Turks and Caicos, Caribbean
Sea, Nikon F801, 60mm f2.8
micro, Subal housing,
Fujichrome Velvia, f16 @ 1/60.
Main lighting from Sea & Sea
YS50TTL flash gun with a small
slave to fill shadows.

Breaking the Rules

The old adage that "rules are made to be broken" is
no less true in underwater photography than in any
other discipline. Many of the most memorable images
ignore them completely, so you must not become a
slave to the rules of composition. A fine example of
this is the forced perspective style of image which
makes a foreground subject appear much larger than
it actually is. This can be achieved by using the 'close
focus wide angle' technique or by using a double
exposure which combines two images and produces
an unreal scale say between a nudibranch and a diver.

With experience you will learn to imagine the
image you are viewing through the viewfinder as the
finished picture and examine its compositional
elements. By changing your position and twisting or
moving the camera or just changing the format from

Big eye squirrel fish. These
fish are very common in the
tropics and are found under
overhangs or in caves during
daylight hours. They are
comfortable with a close
approach and are therefore a
good subject to practise and
vary your composition on.
The fish in this image is
positioned on the diagonal
line with the eye positioned
in the bottom right hand
third producing a well
balanced composition.
Red Sea, Nikon F801, 60mm
f2.8 micro, Subal housing,
Fujichrome Velvia, f16 @ 1/60.
Main lighting from Sea & Sea
YS50TTL flash gun with a small
slave to fill shadows.

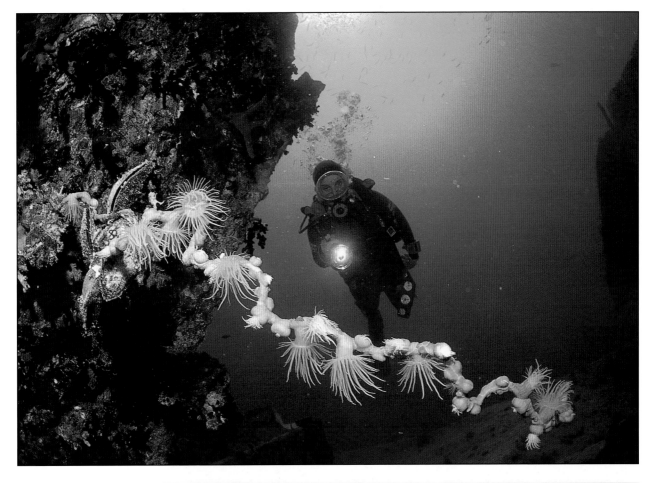

Above: Commensal anemones on a sea whip with diver, wreck of the Thistlegorm. When it was first re-discovered the Thistlegorm was a magical dive for photographers as every possible part of the wreck was encrusted with reef life. Sadly the huge increase in the number of divers and repeated moorings by visiting dive boats has destroyed much of this life except in a few isolated pockets. This sea whip complete with anemones was growing out from the side of the bridge section allowing an upward angle and a diagonal composition of the foreground subject. The diver has been placed in the centre thirds area of the image which balances all the elements well.

Red Sea, Nikon F801, 16mm f2.8 fish eye, Subal housing, Ektachrome Elite II 100, f8 @ 1/60. Lighting from one Subatec S100 manual flash gun on half power.

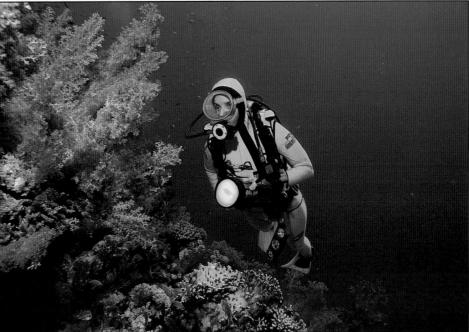

Diver on reef wall. This reef followed a gentle slope but looked far more dramatic if the diagonal was increased by twisting the camera. The diver has been positioned adjacent to the reef line in a position to reflect this composition. If the diver had been hanging horizontally or swimming down toward the reef this image would have lost its balanced composition.

Red Sea, Nikon F801, 16mm f2.8 fish eye, Subal housing, Ektachrome Elite II 100, f8 @ 1/60. Lighting from one Subatec S100 manual flash gun on half power.

horizontal to vertical, you can vary the composition until it is arranged in a pleasing or striking manner before you release the shutter. The final and most successful result may not follow all the rules so don't rely on them too much. As with all techniques in underwater photography you must be prepared to spend time and film experimenting with various subjects to determine the different effects that can be achieved. Eventually the art of composition will then become second nature and you will give it less thought as you develop your own style and learn to recognise subjects and picture opportunities which will bring immediate success.

Pyjama nudibranch double exposure. This shot demonstrates that even when using creative techniques the rules of composition can be applied. The macro element of this double exposure is a pyjama nudibranch which is positioned on a diagonal line across the lower three thirds of the frame.
The background comprises

a silhouette of a table coral with the sun bursting through. The top edge of the coral arcs through the top thirds of the image with the sunburst placed centrally.
Red Sea, Nikon F801, 60mm f2.8 micro and 16mm f2.8 fish eye, Subal housing, Ektachrome Elite II 100, f8 @ 1/60. Lighting for the foreground exposure from one Sea & Sea YS50TTL set to manual with a snoot.

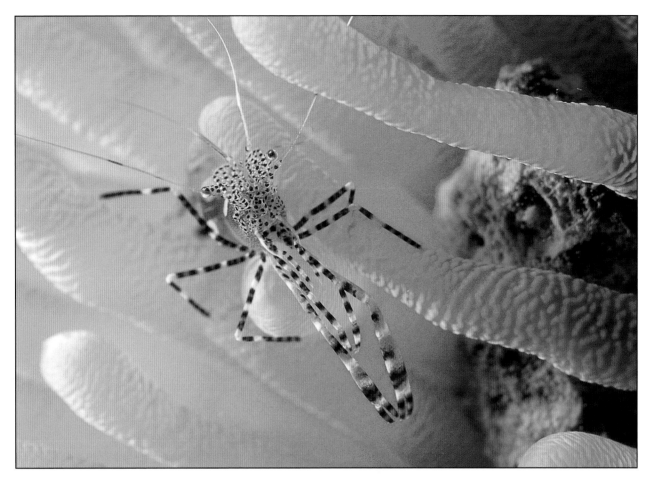

Above: Ghost shrimp in anemone. These shrimps can be found in almost every anemone you look at in Caribbean waters.
They can be quite difficult to compose with the anemone's tentacles as they constantly jump about. This image has the anemone tentacles positioned diagonally with the shrimp placed toward the central third intersection.
Bonaire, Caribbean Sea, Nikon F801, 105mm micro f2.8 , Subal housing, Ektachrome Elite II 100, 16 @ 1/60. Lighting from one Sea & Sea YS50 TTL flash gun with a small slave to fill shadows.

Right: Finger sponges and diver. Another classic composition using a static subject and the line of the reef. This type of subject is perfect for practising your composition techniques. Vary your angle of view, format and the positioning of each element to see how the changes affect the appearance of the image.

Bonaire, Caribbean Sea, Nikon F801, 16mm f2.8 fish eye, Subal housing, Ektachrome Elite II 100, f11 @ 1/60. Lighting from one Isotecnic 33TTL set to manual half power.

FISH FACTS & PHOTOGRAPHY

Together with diver or model photography, one of the most popular subjects for many photographers will undoubtedly be fish. For many beginning underwater photography their first desire is to bring back pictures of the fish they encounter on their dive, and more often than not this is where the first of many frustrations set in.

Although fish are one of the most numerous subjects available to the photographer they can also be the most unco-operative, wary and just plain difficult to compose and photograph well. Although fish are never an easy subject you can ease the path to pleasing images by the correct choice of equipment and techniques and perhaps a large portion of patience!

Equipment Choice

You can take fish photographs with almost any lens available to the Nikonos and Sea & Sea systems or housed SLR's. However, the detailed closer shots which many photographers seek are mostly taken with lenses which are able to frame the subject tightly, in other words those with a longer focal length. For the Nikonos user this means the standard 35mm lens (which is equivalent to 45-50mm underwater) or less often the 80mm, which is notoriously difficult to use due to its minimal depth of field, and the fixed standard lens for the Sea & Sea Motor Marine. Some small, territorial species of fish can be approached with close-up lenses and framers or extension tubes, but on the whole fish are very wary of any object approaching them. Those who use the RS or housed camera systems are at an advantage as the macro lenses in the range of 50mm to 105mm are ideal for fish photography. These lenses have a focusing range which will provide the options of framing the entire subject, head portraits and then right down to small details such as the eyes.

Flash illumination is almost essential in fish photography, unless you are photographing large species in very shallow water or you are looking for silhouettes of single or shoaling fish. Many fish, even in British waters, have striking colouration and film will just not record this detail without the help of artificial light. Some of the best fish photographs use

Above: Masked butterfly fish. These fish are common throughout the Indo/Pacific region and are easily spotted in their mated pairs (although they can be found shoaling in the spring months) patrolling their portion of the reef. They are normally quite co-operative and will make repeated passes in front of your camera if you are patient. A small aperture and fast shutter speed has darkened the background to add impact to this portrait. Red Sea, Nikon F801, 90mm f2.8 macro, Subal housing, Ektachrome 64, 1a: f16 @ 1/250. Main lighting from Sea & Sea YS50TTL flash gun with a small slave to fill shadows.

Opposite: Small marbled grouper. Each time I edged closer to this grouper it would open its mouth once or twice in perhaps a threatening gesture. Taking the shot at this moment from a low angle adds impact to the image with the feeling that the fish is almost talking down to you! Red Sea, Nikon F801, 90mm f2.8 macro, Subal housing, Ektachrome 64, f11 @ 1/60. Main lighting from Sea & Sea YS50TTL flash gun with a small slave to fill shadows.

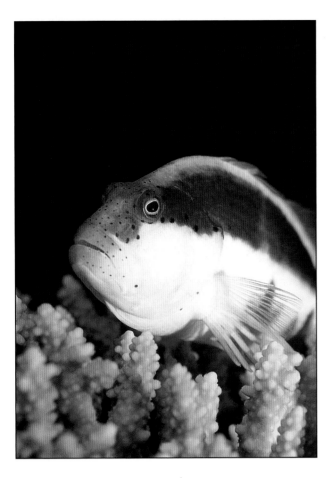

Above: Spotted hawk fish. These fish are very territorial and are found perching on top of coral formations watching over their domain for a meal. Although they may initially swim off as you approach, settle down and wait patiently and the fish will eventually return to its perch for a closer inspection. Positioning yourself below the fish enables you to separate it from the distracting background of the coral. Varying your exposure from totally flash lit to one more balanced with the ambient light changes the mood of the image significantly.
Red Sea, Nikon F801, 90mm f2.8 macro, Subal housing, Ektachrome 64, 1a: f16 @ 1/250, 1b: f8 @ 1/60. Main lighting from Sea & Sea YS50TTL flash gun with a small slave to fill shadows.

Left: Moray eels are often thought to be aggressive as they pump water through their gills by repeatedly opening and closing their mouths. In reality, as long as they are not antagonised, they are very docile and inquisitive. This portrait is made more unusual by the fact that the eel had its face buried in the sand just as I approached, which has provided a striking contrast with the dark colour of its skin.
Red Sea, Nikon F801, 90mm f2.8 macro, Subal housing, Ektachrome 64, f11 @ 1/60. Main lighting from Sea & Sea YS50TTL flash gun with a small slave to fill shadows.

'balanced' lighting techniques to show the subject and its environment and the correct use of flash is essential here to make the fish stand out from its background and add back that colour and detail. Narrow beam strobes are ideal for these subjects, although you can of course use a wide angle strobe just as effectively. Single flash configuration is adequate in most cases although care must be taken not to cause harsh shadows especially when the subject is close to the seabed. I prefer to use a small low powered slave to fill in shadows, which are often created by the subject itself turning sharply at the moment the shutter opens. This is not necessarily an expensive option as small cheap land guns can easily be housed in a torch housing (see chapter 4) or you can even use a piece of white card or perspex on an arm to reflect light back towards the subject, as many land photographers do. TTL flash works well with most fish subjects, especially when they dominate the frame. However, be wary of silvery fish with very reflective scales as this can often fool the TTL system leading to underexposure. You can often tell from the duration of the flash if you are in danger of under or overexposing in TTL and if you have any doubts it is best to switch to manual and bracket.

Techniques for Nikonos and Sea & Sea

The standard 35mm lens for the Nikonos and Motor Marine is excellent for fish photography, although like

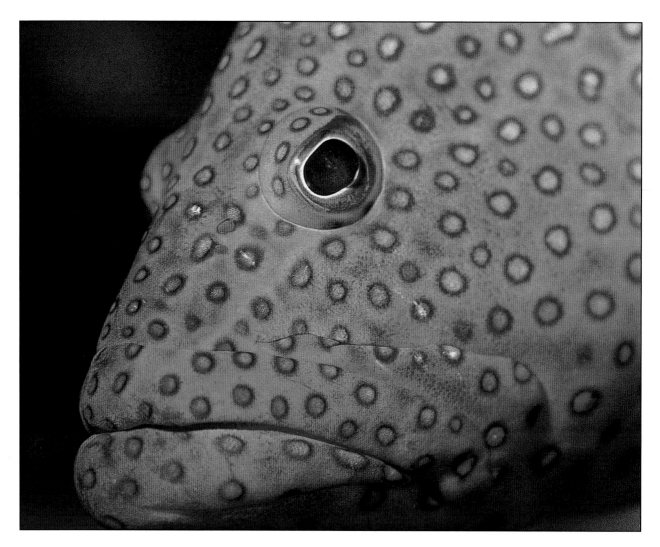

its housed land 50-60mm cousins, it does have a narrow depth of field, especially in the mid to low range apertures. The most effective way of using this lens for a potentially moving subject is by optimising the setting of the aperture and point of focus to provide the most flexible depth of field. With the lens pre-set in this way you can concentrate on the subject and make an exposure as soon as you are confident that the fish is within the selected depth of field which will produce a sharp well focused result. Using this method will give you far more successful results than merely focusing for a particular subject distance and guesstimating your stand off – you may strike lucky with depth of field this way but sod's law states that the fish will swim forward from the point of focus when the greatest depth of field will lie behind it! So study the setting on your lens and watch how the aperture setting changes the depth of field and then set your point of focus within it so that you have a good working range of sharp focus. For Motor Marine users there are depth of field tables in the users handbook.

The other point to bear in mind is framing your subject. There are two variables dependant on you distance from the subject – parallax and field of view.

Above: Blue spotted coral trout. These fish are very common on Indo/Pacific reefs but, although they are territorial, can be very difficult to get close to for a tight portrait. This shot has been taken with a 180mm macro lens which enabled me to fill the frame from a distance of perhaps 60cm so that the fish did not feel I was threatening its private space.
Red Sea, Nikon F801, 180mm f5.6 macro, Subal housing, Ektachrome 64, f8 @ 1/250. Main lighting from Sea & Sea YS50TTL flash gun with a small slave to fill shadows.

Right: Long nosed hawkfish in soft coral. These little fish are normally found on gorgonian fan corals where they are particularly difficult to spot. I found this one by accident whilst taking a wide angle shot of the soft coral and luckily also had a macro system with me with film left in it. The fish was convinced of its camouflage and let me make a very close approach with my 60mm lens. Red Sea, Nikon F801, 60mm f2.8 micro, Subal housing, Fujichrome Velvia, f11 @ 1/60. Main lighting from Sea & Sea YS50TTL flash gun with a small slave to fill shadows.

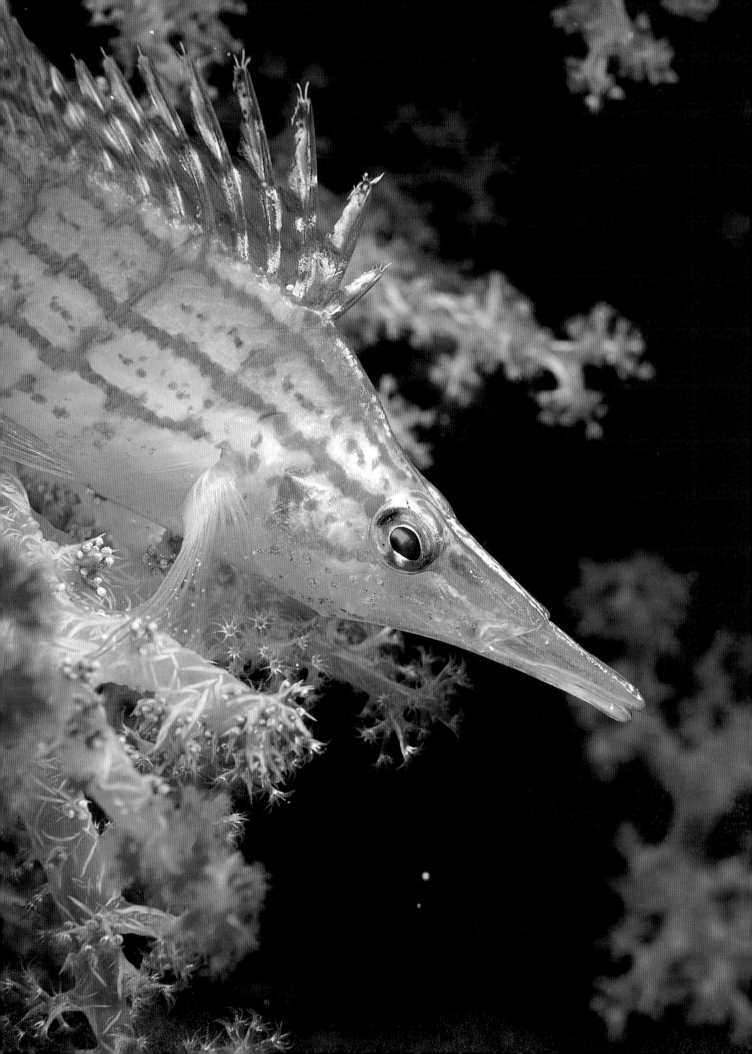

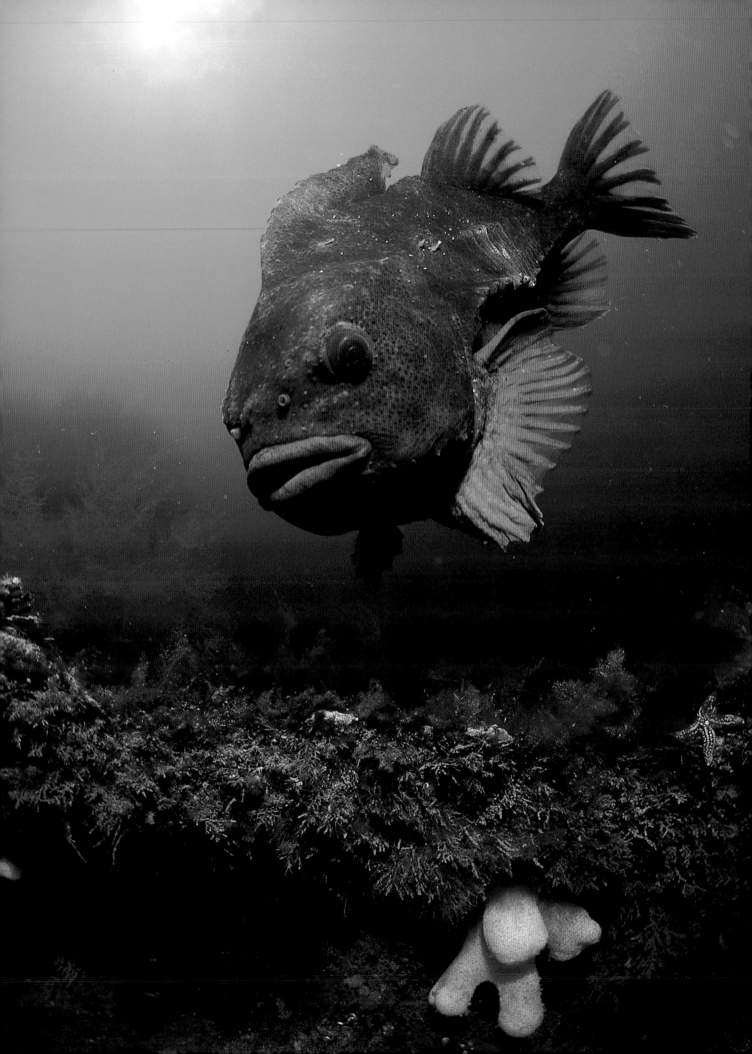

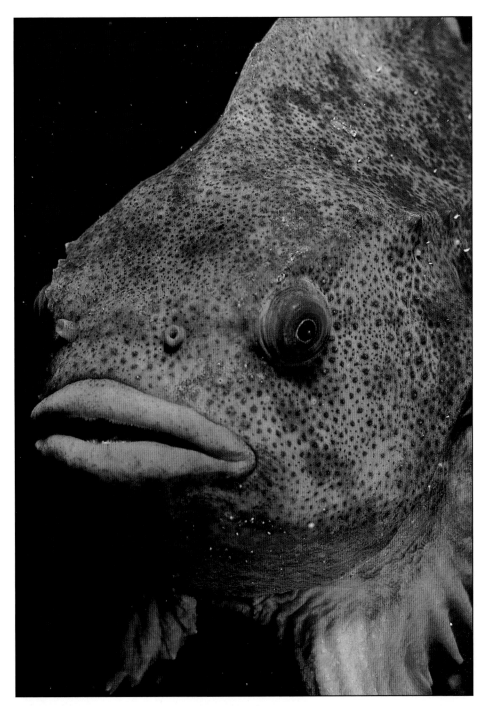

Lumpsucker portrait.
Even in temperate waters there are some very odd looking and boldly coloured fish. This male lumpsucker is in his springtime breeding livery and was found oxygenating his mate's egg mass on the side of a small wreck. Being intent on his task he all but ignored me.
Cornwall, UK, Nikon F801, 60mm f2.8 micro, Subal housing, Fujichrome Velvia, f11 @ 1/250. Main lighting from Sea & Sea YS50TTL flash gun with a small slave to fill shadows.

Left: Lumpsucker.
Although lenses with a focal length of 35-100mm are best suited to fish photography, every now and then an opportunity arises to try breaking the rules. I made three dives in one day with this lumpsucker, knowing that he would stay with his egg mass, on the side of a small wreck, which he was busy oxygenating.
On the first dive I noticed him circling his 'nest' periodically to chase off marauding wrasse and thought this might provide an opportunity to picture him in his environment lit by some springtime sunshine. So I shot a roll with my 16mm fish eye lens which produced some very pleasing compositions one of which went on to win a placing in the Wildlife Photographer of the Year competition.
Cornwall, UK, Nikon F801, 16mm f2.8 fish eye, Subal housing, Fujichrome Velvia, f5.6 @ 1/60. Lighting from one Subatec S100 manual flash gun on quarter power.

The most reliable way to work with these is to use a good quality parallax adjustable optical viewfinder. These are available from Nikon, Sea & Sea and Ikelite and often on the second hand market from now defunct manufacturers like Novatek and Seacore. Using an optical viewfinder takes a lot of the guesswork out of what will appear in the final image (as long as you remember to set the focused distance!) but you should experiment a little to determine how accurate yours is – there is nothing more infuriating than to cut off your subject's tail in the final image having been confident you had it all in the viewfinder!

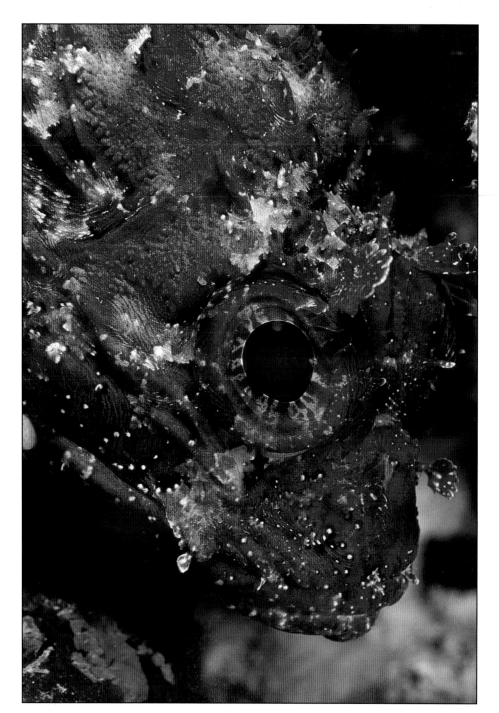

Sea scorpion, Minorca, Spain.
If you cannot afford to travel
often for your photography
you might assume that there
are no exotic fish in your
home waters. These three
shots demonstrate that there
are similar species to be
found in temperate, warm
and tropical waters.
All were shot with much the
same composition and with
the same equipment and, if
the locations were
incorrectly labelled in the
captions, could you be sure
of their origin?
Minorca, Spain, Nikon F801,
60mm f2.8 micro, Subal
housing, Fujichrome Velvia, f11
@ 1/60. Main lighting from Sea
& Sea YS50TTL flash gun with
a small slave to fill shadows.

SLR Techniques

As mentioned above, the macro lenses are the most
flexible choice, although you can quite happily use
any lens in the range 35mm to 105mm or perhaps a
28-70mm zoom lens. The great advantage is that you
see exactly what is in the picture before you release
the shutter and you know when it is in focus.
Remember that you are viewing at full aperture, so
the depth of field will appear narrower than it will be
in the final exposure. Auto focus cameras really come
into their own with fish photography as they will take
on all the hard work of focusing on your moving
subject and leave you to concentrate on the

composition of your shot. You must be wary of exactly
where the focus sensor is in the frame, as it is
essential to ensure that the eye of the fish is sharp
and this may entail locking the focus whilst you
recompose. Sometimes a fish may be too fast or
twitchy for your auto focus system, especially in close-
up, and the lens may then hunt to infinity and back
again whilst it tries to lock on the subject. Under these
circumstances it can often be better to switch to
manual focus – if you do not have a manual focus
option on your housing then use focus lock. You will
develop your own preferred technique if you are using
a totally manual focus system, but most will find that
it is very difficult to focus quick enough on a moving

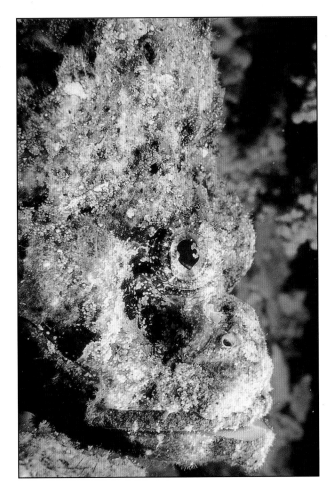

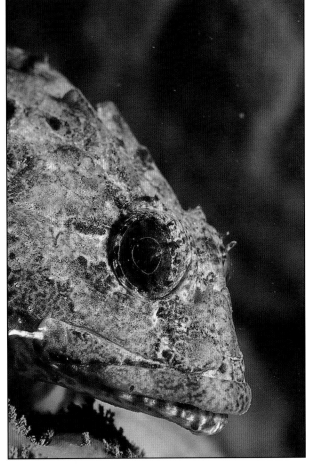

fish and it is often best to prefocus the lens then approach the subject and use a 'rocking' motion when the subject is in frame until the focus is sharp and composition to your liking.

Getting Close for the Picture

Regardless of what camera system you are using all photographers are faced with the same problem – how to get close to your subject to get the picture? The first three rules of fish photography are patience, patience and yet more patience! You must try to see yourself as the fish does, that is a large weird looking marine creature belching noisy bubbles, making a determined approach obviously with the sole intent of making a meal of you! So the first objective is to demonstrate that you pose no threat to your subject. This equates to very slow calm movements and being prepared to stop and remain static in one position for long periods of your dive. Try to breath very slowly and regularly as most species are very sensitive to noise and vibration which your DV exhaust provides in abundance. In fact there is at least one leading underwater photographer who still swears by his old twin hose valve as the bubbles are emitted from behind the diver and his camera. You can go for the quick swim in and the 'grab shot' but although this might secure an image of the intended fish it will

Above left Devil scorpion fish. Red Sea, Nikon F801, 60mm f2.8 micro, Subal housing, Fujichrome Velvia, f11 @ 1/60. Main lighting from Sea & Sea YS50TTL flash gun with a small slave to fill shadows.

Above right: Sea scorpion. Cornwall, UK, Nikon F801, 60mm f2.8 micro, Subal housing, Ektachrome 100S, f11 @ 1/60. Main lighting from Sea & Sea YS50TTL flash gun with a small slave to fill shadows.

rarely be well composed, and for this you need the co-operation of your subject.

Fish are naturally curious and often territorial and this gentle approach will normally result in an inspection from your subject and once you are accepted as part of the scene you can begin to make a cautious approach to improve composition. If you are in an area for long enough and are able to visit a site more than once then you will find your subjects will become increasingly co-operative. There are reefs that I dive regularly in Cornwall where resident wrasse will appear on every dive as though to say hello and welcome you back! You can direct your first efforts towards the more sessile species of the reef such as scorpion fish, tom pot blennies or in the tropics moray eels and clown fish for example. These fish are either so convinced of their camouflage that they will let you make a very close approach, or they make their home in a fixed location and whilst may act defensively they will rarely move far. Having honed your techniques on these species you can move on to the more

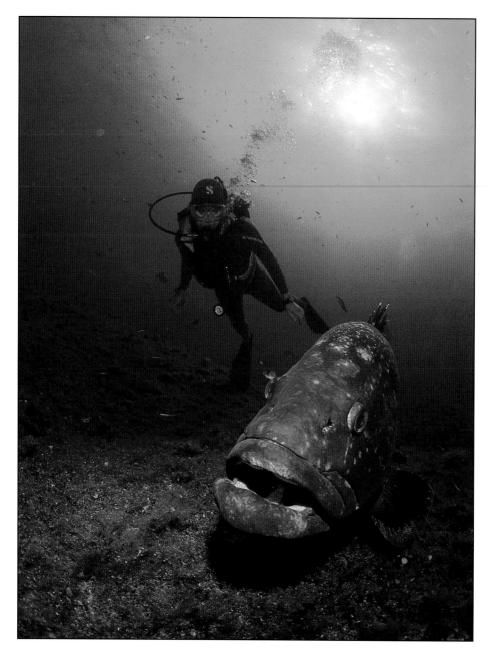

Grouper with diver.
There are very few places in
the Mediterranean which
support colonies of these
large grouper due mostly
to past passions for spear
fishing. The location of this
reef off the island of Corsica
is within a nature reserve
and the grouper thrive here
and are very approachable.
I was busy with a macro
system when my buddy
signalled for me to look over
my shoulder and I came face
to face with this beast
watching me intently. He
came even closer to inspect
his reflection in the dome
port of my housing and
I was able to take several
frames with the diver
swimming in from
the background.
Corsica, Mediterranean Sea,
Nikon F801, 16mm f2.8 fish
eye, Subal housing, Fujichrome
Provia, f5.6 @ 1/60. Lighting
from one Isotecnic 33TTL set to
half power manual.

challenging mobile varieties. Although it is most comfortable to dive in slack water conditions, you will often find fish more approachable when there is a little current running. This is either because they are sheltering from the flow and will therefore move within a smaller protected area, or they are busy holding station in the current, which is common for shoaling fish, watching for a possible meal to come their way. In the latter situation you will find that you can often make a closer side on approach to your subject but this will involve either swimming steadily against the current yourself or using the shelter of the reef to make a close approach.

There is no doubt that the best fish pictures are taken when diving on your own or well separated from your buddy. This statement will no doubt cause shock and alarm amongst novice divers and instructors but it is an accepted procedure amongst

many photographers. There are occasions when a buddy is useful to either interact with your subject or encourage them towards your lens, but generally two divers will spook your fish especially if the other one is circling impatiently in the background! Some may recommend feeding fish as a method of bringing them close to the camera, and in some circumstances this can work but most of the time you will merely encourage several species of fish into the frame who dart about erratically whilst feeding, block your intended subject and muck up the visibility to cap it all! Whilst fish feeding is organised at some tropical locations it is in general now frowned upon and even forbidden in some conservation areas.

Busy tropical reefs are excellent for fish photography, not least due to the number and variety of brightly hued subjects. The density of the reef population means that many of it's residents are

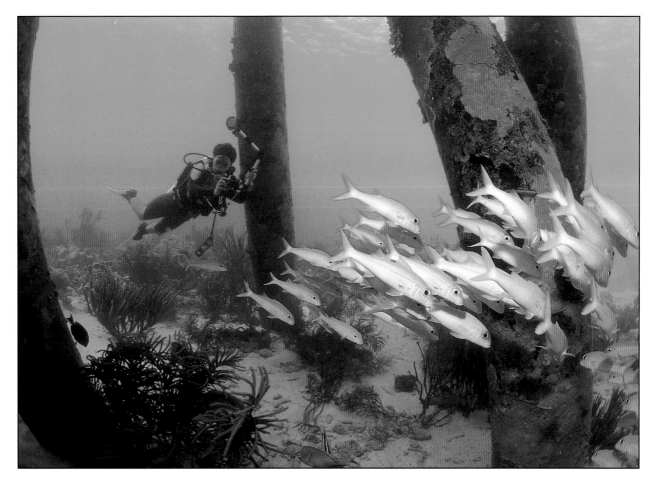

distracted by defending their territory or watching for their natural predators that they will sometimes totally ignore the diver. The other advantage is of course that the fish are often accustomed to seeing divers and do not assume that you are a threat. So settle down anywhere alongside the reef and even if your intended subject is not co-operating you will find many species that are more than happy to do so. Another thing to look out for are the cleaning stations along the reef where you will often find fish of different species waiting for a wash and brush up. Keep your distance for a while and let both the cleaners and customers become accustomed to your presence and then make a slow approach and you will find that you can get a close-up shot of the client fish.

Taking good fish photographs is not easy but getting the shot you want after that long wait is extremely rewarding. Once you have the co-operation of your subject don't be afraid to use film, perhaps an entire roll, as you never know when the right circumstances will prevail again for that particular species. There is no magic formula in terms of technique and equipment, although I am very keen to try a re-breather for a totally silent approach, just persistence and most of all patience!

Diver photographing goat fish. Small shoals of fish require a cautious approach so as not to spook them. It is best to wait close by whilst they accept your presence and observe their pattern of movement. Then move in slowly and take your shot –
if they scatter then retreat and wait for them to reform for the next frame.
Bonaire, Caribbean Sea, Nikon F801, 16mm f2.8 fish eye, Subal housing, Ektachrome Elite II 100, f11 @ 1/60. Lighting from one Isotecnic 33TTL set to manual half power.

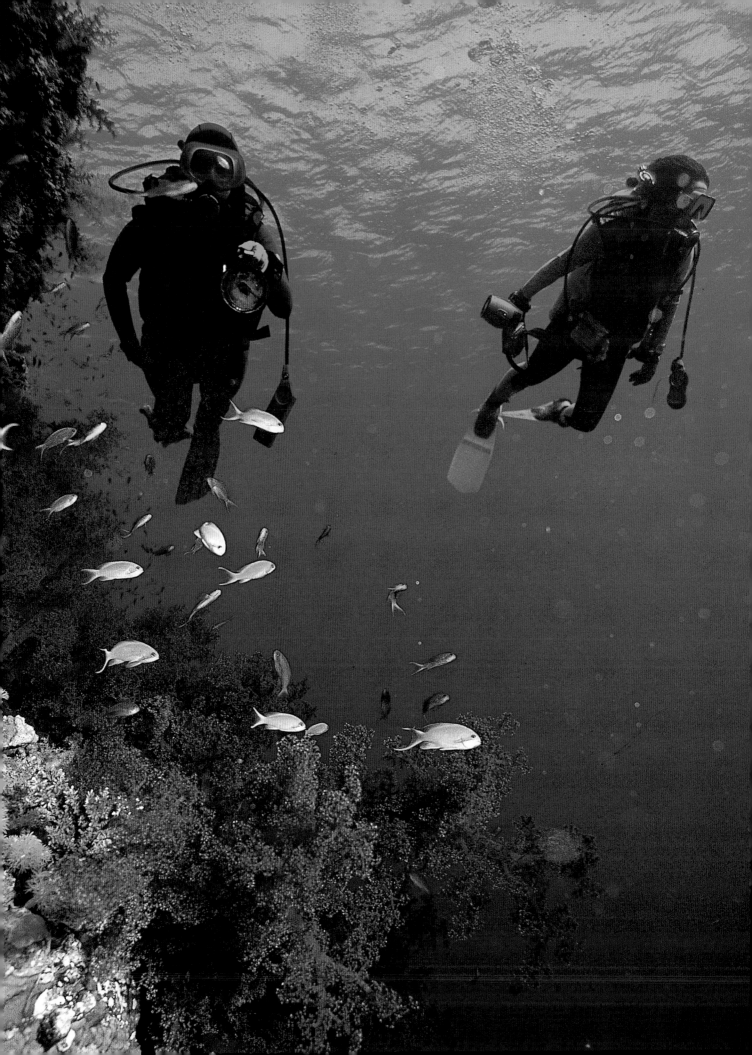

PHOTOGRAPHING DIVERS

The diving press is dominated by one type of underwater shot – that of divers. I specify underwater shots as in many publications a count up might reveal that surface shots out number underwater ones! However, nothing illustrates a diving location or activity better than a picture of a diver doing it, no matter, it seems, how bad the photograph is technically. The fact is that the most popular type of shot is also one of the most difficult to take well and in order to produce good diver images you must more often than not plan them. The first and essential step toward this goal is to select a co-operative model for the shot in mind. The 'model' need not necessarily be the classic female clad in matching kit and accessories, but the subject must be dedicated to your needs, understand your requirements and not be distracted by their own dive plan or interests. By following a few simple guidelines you can produce some stunning diver pictures instead of those which appear to have been snatched of an unco-operative buddy as he steams by after that flattie or porthole!

Equipment

Whether you are working with a Nikonos based system, RS or a housed SLR, to take good diver photographs you will need a wide angle lens. As a minimum I would say a 20mm lens is required, as a 24mm or 28mm will really only produce good head and shoulder shots unless the water has the fabled qualities of gin. Don't forget that more often than not

Left: Divers on coral drop off. This shot is taken on the famous sheer wall on Shark Reef at Ras Mohammed. There is often a strong current running here which makes positioning of yourself and the models quite difficult. So, having discussed the image planned, we decided to drift with me ahead of the divers and be ready to shoot as suitable opportunities arose. To do this you must have your camera and flash set and ready to go whilst constantly watching the light meter for changes in exposure. The resulting image implies movement and exploration, enhanced by the second diver looking out into the blue for pelagic shoals of fish.
Red Sea, Nikon F801, 16mm f2.8 fish eye, Subal housing, Fujichrome Velvia, f5.6 @ 1/60. Lighting from one Subatec S100 manual flash gun on half power.

you are trying to illustrate the diver exploring the underwater world or perhaps performing some task. For this you need to get both the diver and the surroundings in the picture and remain as close as possible to your subject – so 20mm, 18mm and my favourite, the full frame fish eye are the order of the day. Artificial light is normally required and the best tool for this will of course be a wide angle flash gun covering 100 deg. or more. These guns will allow you to light most of the picture area if necessary, but narrower beamed strobes can be used to good effect for balanced light photographs, or consider two narrow beamed strobes (both connected or one on slave) to increase the lighting area.

Communication

Although you may be diving a familiar site with a firm idea in mind you will need to communicate with your model in water no matter how comprehensive your surface briefing. You may change your mind when you view the imagined image through the viewfinder, conditions may be variable or that dreamed of whale shark or manta might make an appearance and you must be able to direct your model as the need arises. So establish a few simple hand signals for basic body positions and postures, for example:- facing head on, vertical, side on (left/right), body angle, arms in/out, direction of gaze, breath held/breathed out, swim through picture, go up/down etc. Also, be prepared to show your model exactly the pose you require in the position you require if communications break down, as this can be frustrating especially if conditions are less than perfect!

Positioning

Having the diver in the right place within the picture is essential. As a general rule, try to ensure that it never looks as though he/she is swimming out of the frame, as this inevitably looks like a snatched shot. If your subject is swimming through or towards you, look carefully at the location in the frame and try to balance the body position and shape with the other subject matter in the frame. For instance, the classic diver on a reef wall shot can either be shot head on with the reef running vertically or diagonally through

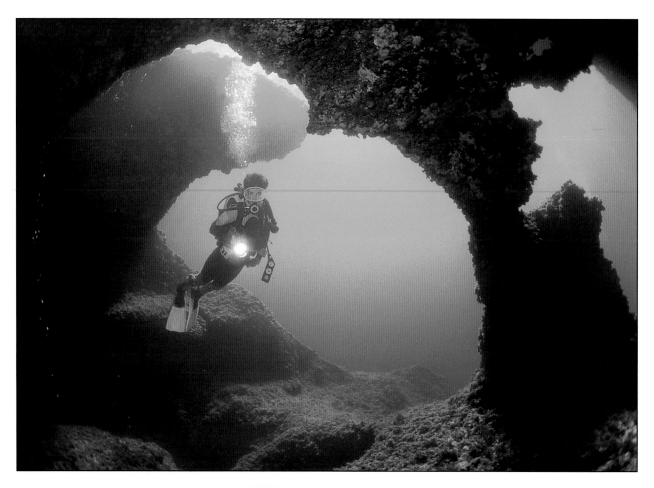

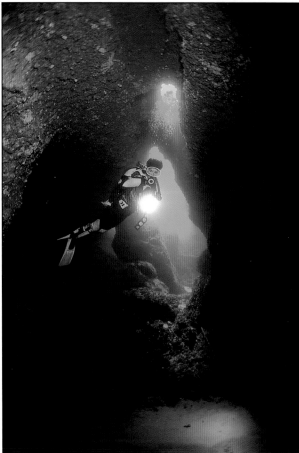

Left: Diver entering cave. When photographing divers it is important to try to imply an activity in the shot in order to 'tell a story' or make the viewer feel that he or she is looking into the underwater world. In this instance the diver is looking into the cave along the beam of the torch, which implies exploration. When you find a location like this be sure to use both formats (i.e. vertical and horizontal) to make the most of the opportunity.

Minorca, Mediterranean Sea, Nikon F801, 16mm f2.8 fish eye, Subal housing, Ektachrome Elite II 100, f5.6 @ 1/60. Lighting from one Isotecnic 33TTL flash gun set to manual on half power.

Above: This is the same location but with a horizontal format. This shot perhaps is better as it shows more of the cave system and the interesting formations created by the entrance. When metering the exposure for a shot like this be sure to consider the settings needed to make the torch stand out in the image. You can only determine the average exposure for your own torch by conducting a trial – the one in this shot is a 30 watt lamp and I find that an average exposure of f5.6-8 with 100ASA @ 1/60 will give a good definition. Unless you have a 100 watt movie lamp you will find that the torch will have to be pointed directly at the lens for an exposure to be acceptably balanced with a background such as this.

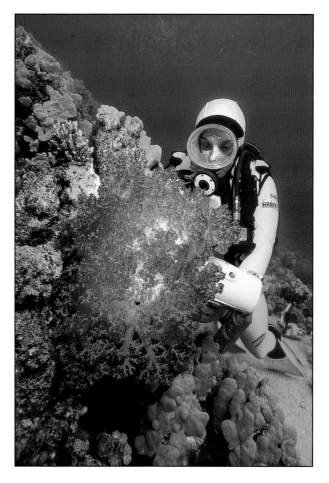

Diver with DPV (diver propulsion vehicle). Although initially the setting for this shot was not very inspiring, the centre of interest in the shot was to be the activity. Framing the diver between the kelp bed and the boats on the surface has created an acceptable negative space around the main subject and also implied a sense of movement and origin,

i.e. the diver is moving away from the boat. The visibility here was poor but by using a fish eye lens I was able to have the diver pass me at no more than 1m which has kept the image sharp.

Cornwall, UK, Nikon F801, 16mm f2.8 fish eye, Subal housing, Ektachrome Elite II 100, f5.6 @ 1/60. Lighting from one Isotecnic 33TTL flash gun set to manual on half power.

the frame, or you can look for a balance in a diagonal composition by positioning the diver to follow or mimic the angle of the reef. In a shot like this, try to balance the background space behind the diver with blue water or a sunburst if available. Another approach is to frame the diver in the entrance to a cave, between natural reef features or marine growth or within the remains of a wreck. Even with a set plan you must move location and constantly look for good 'negative space' which will compliment or support the model. Another important point to remember is that when your model's face dominates the frame, or can be clearly seen, ensure that the eyes are directed at an obvious subject – never at the camera! This is simple to organise with a pre-arranged signal and will avoid that 'hello mum' effect – remember the viewers of your finished image must feel that they are looking into the underwater world not being greeted by the diver within it! Similarly, be conscious of the position of arms and legs and avoid those 'sky diving' images at all costs! The leg position should look natural and arms/hands generally out of the way unless holding a tool (e.g. torch) or reaching for something within the image. A final point to remember is that of forced perspective when using wide angle lenses – for instance if a hand is too close to the lens then it can look massive in comparison to the rest of the body – examine the image carefully through the viewfinder before pressing the shutter.

Diver lighting soft coral with slave flash. You can add interest to the focal point of a diver image with the addition of a prop – in this case a slave flash which is carefully placed behind the soft coral. When using a slave flash in this manner you must be cautious of not pointing it directly at the lens which would cause flare and over exposure. Here the

flash is shielded by the coral and the result is an attractive warm glow – however in situations like this you must be wary of making contact with or damaging delicate corals.

Red Sea, Nikon F801, 16mm f2.8 fish eye, Subal housing, Fujichrome Velvia, f8 @ 1/60. Lighting from one Subatec S100 manual flash gun on half power.

Dressing the Model

There is no doubt that the clichéd shot of a female diver in colour co-ordinated kit does look attractive and has a universal appeal especially to publishers, manufacturers and training organisations. This sort of image says that diving is safe and easy for everyone and also implies that it can be a trendy fashion conscious sport to compete with skiing, sailing, wind surfing etc. Despite this, excellent and appealing pictures can of course be taken of your average diver, and often will look far more realistic as a result. However, an attempt should be made to make your model look tidy and wherever possible bright co-ordinating colours will add to the image, rather than plain black which is making a comeback in

Left: Diver exploring gulley on the Runnel Stone reef. There are some locations in our own waters which challenge or equal warmer locations for profusion of life and colour. These locations are generally in positions exposed to tide and weather such as the Runnel Stone which is open to Atlantic swells. Although visibility is often good here, you still need to work in shallow water to maximise the quality of natural light available. Unfortunately this also means working in the swell zone, exacerbated by the shape of the gulley, which is difficult for both the model and photographer. So you need to visualise and plan the type of image you want before you dive so that communication is not too much of a problem. Here each shot was timed with each surge which brought the model ever closer but many shots were failures due to either model or photographer being displaced!
Cornwall, UK, Nikon F801, 16mm f2.8 fish eye, Subal housing, Ektachrome Elite II 100, f5.6 @ 1/60. Lighting from one Isotecnic 33TTL flash gun set to manual on half power.

technical diving circles. Ensure that hoses, gauges and straps are neatly tucked away and that no items of equipment will float above the model – torches and deco' slates are notorious and day-glow hoods are definitely out. If the model's face is in close-up try to use a mask that does not make he/she look like the bug eyed star of a sci-fi film! The classic oval full face plate mask is the most flattering, especially for a female model, but these are expensive for occasional use. However, there are many economic variations available and perhaps even your own mask would look better on the model?

Props and Accessories

When shooting diver images be careful to ensure that the diver is enhancing the main subject or that the diver is doing something or seen to be going somewhere. An image of a diver and nothing else can be very uninteresting to the viewer. If the location lacks a central point of interest, such as wreckage, or is not naturally attractive then consider adding a prop or tool to enhance the image. By this I do not mean artificial flowers, but adding a torch, camera, slave flash, lifting bag etc. can create a focal point of action round which you can build the image. A torch, for instance, says to the viewer that the diver may be looking for something as he/she swims through the image or could be peering into a hole seeking marine

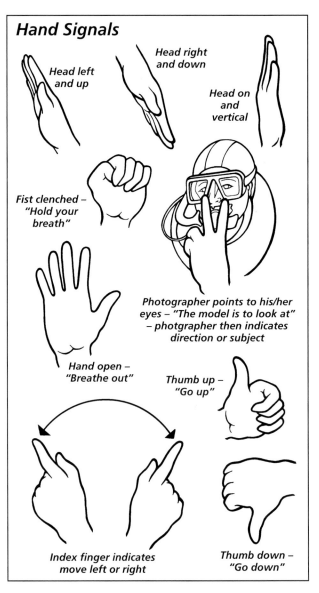

Hand Signals

Head left and up

Head right and down

Head on and vertical

Fist clenched – "Hold your breath"

Photographer points to his/her eyes – "The model is to look at" – photgrapher then indicates direction or subject

Hand open – "Breathe out"

Thumb up – "Go up"

Index finger indicates move left or right

Thumb down – "Go down"

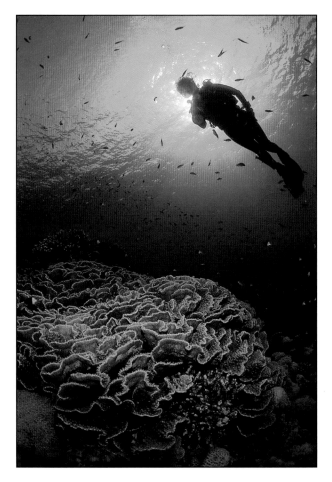

Above left: Lettuce coral with diver silhouette.
It is not always essential to have the diver in a dominant position in the frame – in this shot the model is in silhouette but still close enough to the main subject. The position of the diver and the torch imply that the diver is pausing to examine the coral. Leaving the diver in silhouette is perhaps one of the simplest approaches to diver photography, but you must remember to keep the scale and composition of the main subject and diver well balanced.
Red Sea, Nikon F801, 16mm f2.8 fish eye, Subal housing, Ektachrome Elite II 100, f8 @ 1/60. Lighting from one Isotecnic 33TTL flash gun set to manual on half power.

Above right: Gorgonian coral with diver and video camera.
It is not always essential to have the diver in a dominant position in the frame. Because the sun was behind me, and therefore the wrong side for this fan coral, I got my buddy to switch on the lights on his video housing to add some sparkle to the image.
Red Sea, Nikon F801, 20mm f2.8, Subal housing, Fujichrome Velvia, f5.6 @ 1/60. Lighting from one Subatec S100 manual flash gun on half power.

life. The ultimate prop of course can be interaction between the model and marine life. There are many fish even in British waters which will show a keen interest in divers activities and can often be persuaded to come closer with a little food (I know of one photographer who uses cod's roe in a squeezy bottle!) – although this practice is largely discouraged in many tropical locations now.

Close Focus Wide Angle

Perhaps the easiest style of diver shot to set up features the diver in silhouette which removes the worry of colour co-ordination or eye contact. The classic close focus wide angle shot is the best example of this where the foreground features a brightly coloured subject and the diver is seen in silhouette,

perhaps against a sunburst, in the background. Good communication is still required for this type of shot in order to guide your model to the correct location above you in the image and also to ensure a clean silhouette without arms and legs placed at unnatural and un-attractive angles. The exposure for these type of shots can be quite tricky as the foreground flash illumination must be balanced with the background natural light exposure to produce a good silhouette. Relying on TTL exposure in this situation often does not work unless the foreground subject dominates the centre of the frame. It is often best to calculate a manual exposure using your light meter and flash guide number.

If you decide to experiment with diver photography it is often best to work with another photographer who will understand your needs and perhaps have

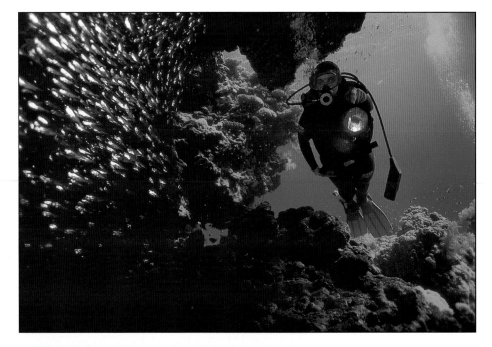

Right: Model looking at camera (wrong!). These two shots demonstrate a simple rule in diver photography – if the model is looking at the camera the image can have an unnatural feel to it. In this shot the diver appears to be swimming towards the photographer shining her lamp straight at the camera.
Red Sea, Nikon F801, 20mm f2.8, Subal housing, Fujichrome Velvia, f5.6 @ 1/60. Lighting from one Subatec S100 manual flash gun on half power.

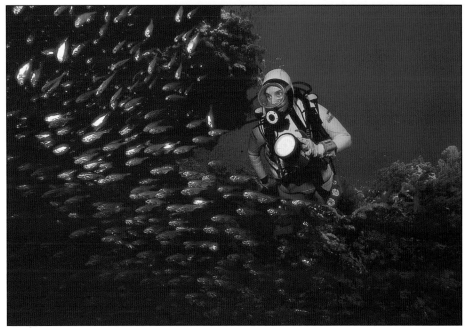

Left: Model looking at subject (right!). The second shot at the same location has the diver looking at the glassfish and shining the torch in the direction of her gaze. This image gives a much better impression of the diver doing something rather than just swimming through the frame. The addition of a brighter wet suit also changes the feel of the image.
Red Sea, Nikon F801, 20mm f2.8, Subal housing, Fujichrome Velvia, f5.6 @ 1/60. Lighting from one Subatec S100 manual flash gun on half power.

more patience with the repetitive posing required! Your may be lucky of course and have a devoted buddy or partner who has an interest in the end product and therefore bucket fulls of the required patience – I found encouraging my wife to dive has solved many of my problems! Once you have an established working pattern you can begin to experiment with variations on standard model photography, such as double exposures and special effects, you will only be limited by your imagination and the limit of your model's co-operation!

Above left: Model looking at camera (wrong!). These two shots demonstrate a simple rule in diver photography – if the model is looking at the camera the image will have an unnatural or "hello mum" feel to it. In this shot the diver is gazing at the camera instead of studying the subject before her.
Bonaire, Caribbean Sea, Nikon F801, 16mm f2.8 fish eye, Subal housing, Ektachrome Elite II 100, f11 @ 1/60. Lighting from one Isotecnic 33TTL set to manual half power.

Above right: Model looking at subject (right!). The second shot at the same location has the diver looking at the subject instead of the camera which improves the image significantly and gives the viewer the feeling that they are looking into the underwater world with the diver.
Bonaire, Caribbean Sea, Nikon F801, 16mm f2.8 fish eye, Subal housing, Ektachrome Elite II 100, f11 @ 1/60. Lighting from one Isotecnic 33TTL set to manual half power.

Right: Diver with soft corals (wrong!). This pretty shot is spoilt for me by the model peering in the direction of the camera. It would be greatly improved just by redirecting her gaze toward the soft coral on her left. Always remember to assess all aspects of the image before you press the shutter.

If it can be improved by requesting that your model looks in the direction of another subject then take the time to signal this.
Red Sea, Nikon F801, 16mm f2.8 fish eye, Subal housing, Fujichrome Velvia, f5.6 @ 1/60. Lighting from one Subatec S100 manual flash gun on half power.

WRECK PHOTOGRAPHY

To many divers some of the most appealing and evocative of underwater images are those of wrecks and divers exploring them. The 'big' shot, of all or part of a shipwreck in clear water, exudes the excitement of exploring the unknown and has been the catalyst for countless novices to take up the sport and pursue wreck exploration. Paradoxically, this type of photograph which sells our sport so well is also one of the most difficult to perfect and requires a mixture of the correct conditions, equipment and technique to prevent the finished image simply reflecting parts of a pile of rusting steelwork!

Wreck photography is possible anywhere, even in British waters, but you must first recognise the limitations of the conditions you are working with. Unless you have exceptional luck, visibility in British waters is rarely good enough to show large sections of a wreck so you must be prepared to tune your techniques to suit whilst perhaps saving your panoramic shots for those wrecks in the tropics where you can expect visibility of 20-50m.

Equipment

Unless you are aiming to illustrate particular details of a wreck then an ultra wide angle or fish eye lens is essential for successful wreck photography. These have been fully discussed in chapter 7.

All extreme wide angle lenses will display some distortion and this is most obvious when photographing subjects where straight lines dominate. So you need to be aware of this problem when photographing wrecks and even divers.

Another problem that can arise with a diver close to the camera is that of 'forced perspective'. This occurs when perhaps a hand, foot or face is closer to the lens than the rest of the diver's body and it appears large and distorted. So you need to be careful how you

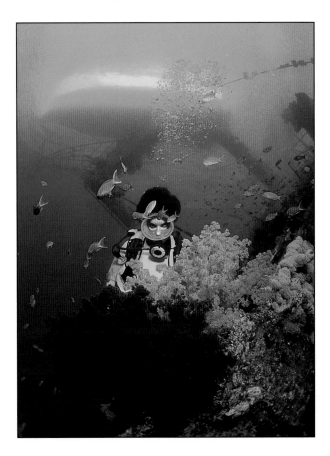

Left: Diver on the bridge deck of the Giannis 'D'.
This is an example of the 'big picture' shot which really can only be attempted in clear tropical waters. The many elements in the frame indicate clearly that this is a large wreck which the diver is exploring and exudes excitement. It is often difficult to compose a picture on a popular, busy wreck, but it is worth being patient
to wait long enough for other divers to pass and their bubbles to disperse. I mostly like to create the impression that the diver in the picture has the wreck to herself!
Red Sea, Nikon F801, 16mm f2.8 fish eye, Subal housing, Ektachrome Elite II 100, f8 @ 1/60. Lighting from one Isotecnic 33TTL flash gun set to manual on half power.

Diver examining soft corals on the Giannis 'D'.
In tropical waters marine life quickly establishes itself on the wreck creating an artificial reef and soft corals are amongst the first species to establish themselves. This impressive cluster was growing on some steel rigging wires running from the mast to the deck which provided me with an ideal upward angle and
included the backdrop of the superstructure of the wreck in the remaining negative space.
Red Sea, Nikon F801, 16mm f2.8 fish eye, Subal housing, Ektachrome Elite II 100, f8 @ 1/60. Lighting from one Isotecnic 33TTL flash gun set to manual on half power.

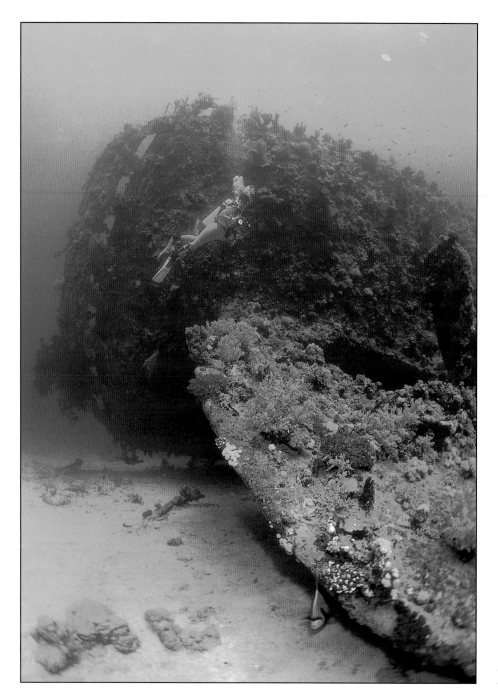

Stern section of the SS Carnatic. The Carnatic is the wreck of a graceful steam liner sunk in the Gulf of Suez in 1869 and must rank as my favourite wreck. I had been planning to take a shot of the intact stern with a diver swimming through for sometime, but had always been frustrated by the presence of other divers. Eventually on one trip we managed to persuade the skipper of our boat to be on location by 7 o'clock in the morning! Whilst this meant that my wife and I had the pleasure of the wreck entirely to ourselves the downside was that the sun was low and therefore the light levels also. So a relatively long exposure was planned which required the model to hold a pose rather than swim through the shot. The stern and the model are between 12-15m from the camera and the rudder in the foreground some 2-3m away, so the exposure is predominantly natural light with a touch of flash on the rudder. The bright yellow wetsuit and movie light ensure that the model stands out against the dark stern section.
Red Sea, Nikon F801, 16mm f2.8 fish eye, Subal housing, Ektachrome Elite II 100, f5.6 @ 1/15. Lighting from one Subatec S100 manual flash gun set to quarter power.

position a diver or a feature of the wreck when you are working very close to avoid this.

Next you must choose a suitable method of lighting for your proposed shot. Flash is not essential especially if you aim to try to illustrate as much as possible of a wreck in clear waters, but more often than not some artificial light will be required for lighting foreground detail or perhaps a diver. A powerful wide angle flash gun is best suited to lighting most of what your lens will see when close-up, although you will rarely use it on full power when balancing natural and flash light. Narrower beam flash guns can also be used to good effect when only the foreground detail requires additional lighting, or you can consider using two narrow beam guns either both fired by the camera or one slaving from the other.

Film choice is largely a personal one although if your aim is to photograph large sections of wreck using natural light in clear water then a faster film is preferred to enable the use of a smaller aperture (this increases depth of field and ensures that more of the picture will be in focus). Using a film speed of 200-400 ASA is normally sufficient, but you can go as high as 1000 ASA or 1600 ASA if you are able to accept the drawback of grainy pictures. Many photographers aim to keep just the foreground sharp, with the background wreckage as secondary interest or framing to the main subject, and are happy to work with 100 ASA in order to minimise the grain in the picture. You need to experiment with the same or similar subjects to find your own preference .

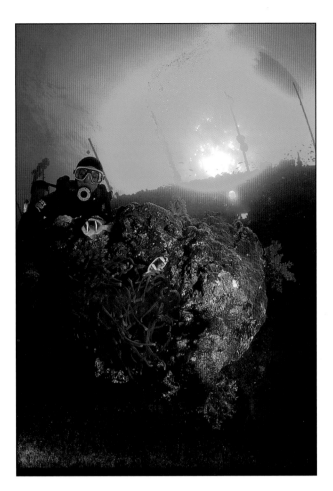

Techniques

When using the camera's TTL light meter bear in mind that these ultra wide lenses collect an awful lot of light especially if the sun is in the picture. This applies especially to the fish eye lenses and you can very easily end up metering for the brightest part of the picture which is not necessarily the main subject area. Some housed systems and the Nikonos RS which offer matrix metering with dedicated lenses will cope with the problem a little better in most circumstances. However, it is often more reliable to use centre weighted (the Nikonos IV/V has this) or spot metering which enables you to meter the critical area of exposure in the picture more accurately. Previous comments regarding TTL flash apply just as much to wreck photography and the problem can be acute when the background wreckage is largely distant, so you must be conscious of the limitations of your metering system.

Having sorted out your exposure you need to consider the composition of your picture. If you are working in British waters with the usual limited visibility it is best to identify an easily recognisable section of wreckage or some other strong foreground subject. You can then aim to try and balance your flash exposure with the natural light which will leave background wreckage in silhouette giving depth and identity to the picture. It often helps to use a diver in

Left: Diver examining steam bollard on the deck section of the SS Carnatic. This feature of the wreck has been overgrown by a carpet anemone, complete with clown fish, and soft corals and is situated on the main deck which lies at an angle of approximately 45°. The position has allowed an upward angle which includes a variety of secondary features of the wreck – davits overhanging the hull, sunlight shining through a porthole and the pick up boat on the surface – which add depth and atmosphere to the image. *Red Sea, Nikon F801, 16mm f2.8 fish eye, Subal housing, Ektachrome Elite II 100, f5.6 @ 1/15. Lighting from one Subatec S100 manual flash gun set to half power.*

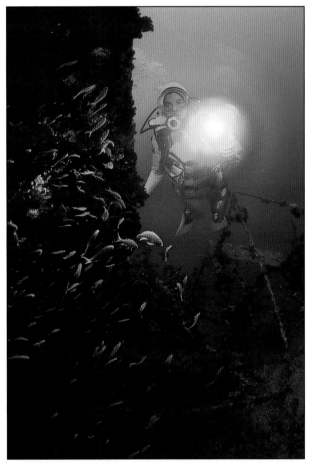

Above: Diver with anthias shoal on SS Thistlegorm. These anthias were shoaling against the side of the stern accommodation of the wreck as though it were an overhanging reef section. I wanted to compose the wreck section and diver diagonally and make an exposure which would retain the moody shadowy lighting. The slave flash held by the model provides the majority of the lighting for the exposure and has a diffuser and orange filter to reduce the light output and enhance the orange colour of the fish. The key flash on my camera is set to its lowest power to fire the slave and just add a touch of light to the fish. *Red Sea, Nikon F801, 16mm f2.8 fish eye, Subal housing, Fujichrome 100, f8 @ 1/60. Lighting from one Subatec S100 manual flash gun set to one eighth power.*

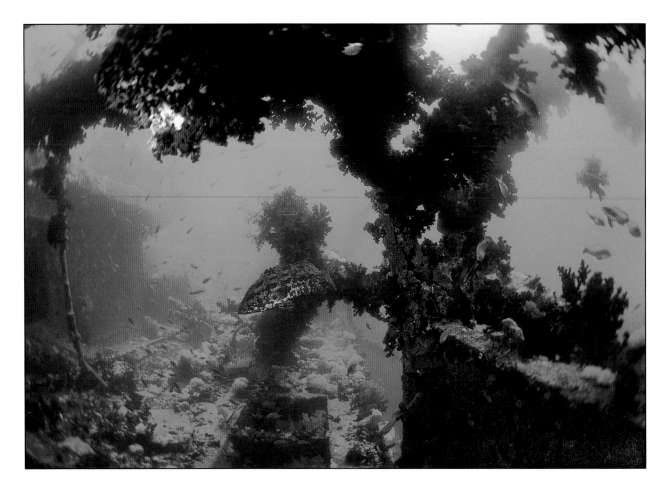

the foreground area perhaps looking at the main subject which adds scale and directs the viewer's attention to the point of interest.

Even if the visibility appears limited to the photographers eye, the camera and film can often resolve much more than is apparent. So it is often worth selecting a small aperture and letting the camera's automatic exposure take over for a wider longer natural light shot, although you must ensure that you have braced the camera and yourself against something solid as the exposure is likely to be one or more seconds – some photographers even use heavily weighted tripods for this type of shot. You may be pleasantly surprised by the developed pictures!

If the visibility is extremely poor then perhaps you should abandon the wide picture altogether and concentrate on detail and maybe try to emphasise the way marine life is colonising a wreck. Inspect any tubular steelwork or overhangs carefully as this can provide a home to anything from a tompot blenny to a large conger! The sedentary life on many wrecks in British waters (e.g. anemones, sponges, sea fans etc.) can make them every bit as colourful as their tropical relatives and it is possible to produce some stunning pictures.

Exploring wrecks in tropical waters will undoubtedly make the photographer's task a lot simpler. Visibility is normally far superior and the wrecks are generally in a more intact condition due

Companionway with grouper, SS Thistlegorm. This shot was taken just a couple of months after the Thistlegorm had been re-discovered and shows the level hard coral growth on the decks, accommodation and fittings. Sadly, a swim down this section will now only reveal naked steelwork due to the explosion in the number of divers swarming carelessly over the wreck. When I took this shot I had a feeling that the near pristine condition of the marine life could not survive once the location became common knowledge. The shape of the superstructure has been used to frame the lone grouper which plays a supporting role in the composition of this picture which I hope reflects the previous serenity of the wreck.
Red Sea, Nikon F801, 16mm f2.8 fish eye, Subal housing, Fujichrome 100, f8 @ 1/60. Lighting from one Subatec S100 manual flash gun set to half power.

to the mostly calmer sea conditions. Marine life is more diverse and has some dazzling colours which can enhance what might have been a plain photograph of shapeless wreckage in temperate waters. However, the same basic principles of underwater photography still apply and you should still be aiming to get as close as possible to your main subject to maintain clarity and sharpness. Good use can be made of brightly coloured corals, fish shoals and the shape of the wreck against bright sunlight to illustrate the mystery and the living beauty of these artificial reefs. Again, remember the value of a diver in the picture to direct attention and add scale, this is especially important if attempting the 'big' shot of the

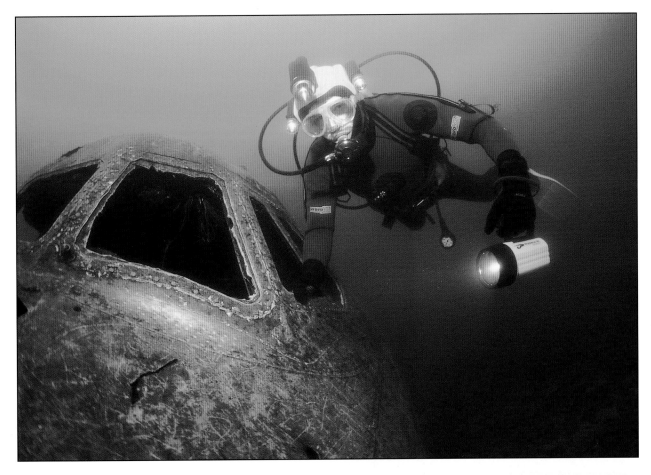

Above: Cockpit of a Victor Viscount, Stoney Cove.
Yes it is possible to take wreck photographs in the UK, even in fresh water! This shot was taken as one of a series to illustrate the brochure of a drysuit manufacturer who also had strong commercial ties with the operation of the location chosen – that of Stoney Cove, a well known flooded inland quarry near Leicester. Parts of this aircraft were sunk as an attraction for visiting divers and we had decided it would make an ideal prop for the shoot. During busy weekends the *visibility in the quarry can drop to near zero, so the diving was planned for a cold Wednesday morning in mid November. Although the water has a green hue, the wreckage lies in only 6m of water, so light levels were quite acceptable. Nevertheless, working with a fish eye lens has kept the subject distance to a minimum.*
Stoney Cove, UK, Nikon F801, 16mm f2.8 fish eye, Subal housing, Fujichrome 100, f8 @ 1/60. Lighting from one Subatec S100 manual flash gun set to half power.

Right: Diver exploring the hull of the wreck of the Hera. Wreck penetration and photography are not generally a good idea in the UK, as the wrecks are often silty or well collapsed. There are some exceptions of course and this particular wreck lies on heavy gravel so visibility is generally reasonable. It is always best for the photographer to enter the wreck first and set *up for the shot to minimise disturbance of any silt. Try to get the shot on the first pass with the first three or four frames. There is an obvious mistake in this shot – the diver is peering at the camera.*
Cornwall, UK, Nikon F2, 18mm f3.5, Hugyfot housing, Ektachrome 100, f5.6 @ 1/60. Lighting from one Sea & Sea YS150 manual gun set to half power.

Sabre toothed blenny at home in a hand rail, wreck of the Giannis 'D'.
Even in tropical waters conditions for wide angle wreck photography can often be less than perfect due to poor visibility or diver traffic. On these occasions you can change your plans to recording the way marine life has colonised the wreck. Wherever there is an open ended tube or a hole in the wreck you are likely to find someone at home.
This curious blenny was happy to pose for my macro lens between excursions from his home to catch a passing meal.
Red Sea, Nikon F801, 60mm f2.8 micro, Subal housing, Fujichrome Velvia, f16 @ 1/60. Lighting from one Sea & Sea YS50TTL flash gun with a small slave to fill shadows.

wreck. Arm your diver with a powerful torch to make him/her stand out in what will be largely a silhouette shot – this may lead to the somewhat clichéd image of a diver on a wreck but it does work and generally assists in identifying elements of the picture. Another tool to employ with a diver is a slave flash but it must be used carefully to avoid flare in the final image. When photographing parts of the wreck in close-up look for shapes that will enable you to frame a passing shoal of fish, your diver or a sunburst to add additional impact.

Photography inside wrecks at home or abroad must be carefully planned. In addition to the hazards of loss and entrapment there is the problem of disturbed visibility by both you and your model. You must know the wreck well in order to envisage and plan what shots you want and enable you to instruct your model accordingly. It is normally best for the photographer to enter the wreck first and settle before the model and then shoot quickly before both fins and bubbles destroy the visibility. It goes without saying that if you are diving with a group persuade them to let you dive first and finish the shoot, or at least give you a head start! I have had many disappointing attempts at internal photography on popular wrecks like the Thistlegorm in the Red Sea, which now has so many divers on a daily basis that the silt inside is almost permanently in suspension!

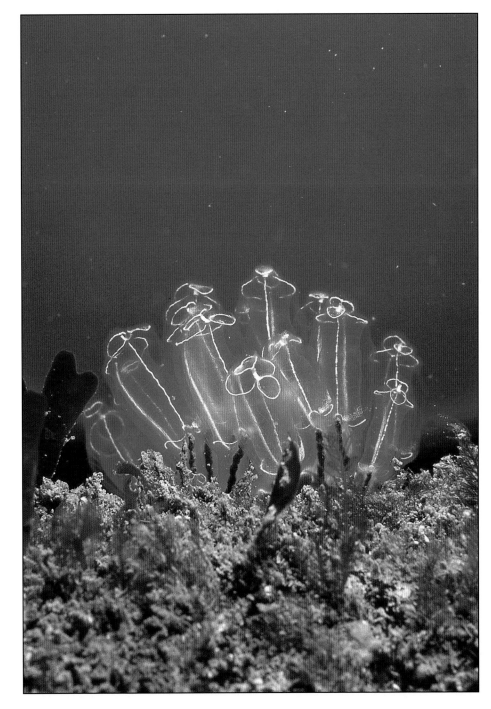

Light bulb tunicates, WW1 U boat wreck. The remains of several U boats from the First World War are located in 8-12m of water in Falmouth Bay. Occasionally the visibility is good enough for wide angle shots, but more often than not I concentrate on macro subjects when diving here. Light bulb tunicates appear in profusion in the late spring and are a common subject for photographers in the UK. In order to produce a more unusual image I have used a third flash gun with a blue filter to give the shot a tropical feel.

Cornwall, UK, Nikon F801, 60mm f2.8 micro, Subal housing, Fujichrome Velvia, f16 @ 1/60. Lighting from one Sea & Sea YS50TTL flash gun, a small slave to fill shadows and a third slave gun with a blue filter back lighting the subject.

Planning and Using your Photographs

Whether you are diving on wrecks at home or abroad you are bound to want to show your photographs to friends and family, the diving club or even members of the public. So it is worthwhile planning the type of shots you intend to take, perhaps to illustrate a journey around the wreck, concentrating on easily identifiable features, or the way marine life has found a home in various parts of the wreck. Whatever the theme it will help your audience to follow and relate to the images and it will also make your presentation far simpler! Be prepared to research the history of the wreck a little to help the audience understand the

emotion of wreck diving. Also, watch out for old photographs or drawings of your wreck during research as they are easy to copy and are excellent for additional illustration to your presentation.

As you experiment you will find that although wreck photography is not the easiest medium it is very rewarding when you get it right and will gain praise and recognition from your diving partners and perseverance might even lead to publication or competition success!

AFTER DARK

Wherever you are in the world, one of the most exciting diving activities will be a night dive. Exciting because it seems almost unnatural to be getting into the water after dark and also because of the variety of creatures you will encounter which are normally hidden during the day. It is also a very productive time to take photographs, which may seem a little daunting at first, but with the correct preparation and equipment is really very straightforward.

Although there are a number of larger predators which are active at night you will rarely see them. Your vision is limited to the extent of your torch beam and therefore photographic subjects are mainly concentrated on close ups, macro and the occasional fish portrait. Although it is possible to take medium wide angle photographs at close focus distances, wider shots are generally a disappointment due to the difficulty of focusing and the fact that most flash guns are unable to completely cover the picture angle of the wider lenses. This leaves you with a subject largely isolated in a black background, which may be desirable for some effects but leads most photographers to prefer frame filling close ups.

Lighting

Regardless of your choice of camera system the most important equipment will be your torches. Some divers work on the principle of "the more light the better" at night in order to light as large an area as possible. However, this is not always the best choice for photographers, as the larger light will often disturb potential subjects before you get to them and I find it is better to use the small powerful narrow beam torches which are available from several

Common lobster eye. Night diving is a whole new experience for the photographer, not least due to the darkness. Many of the creatures we see hiding in the reef during the day are out hunting at night and are often far more approachable in the glare of your torch. This lobster was happy to sit *still whilst I came closer and closer to photograph his eye at a ratio of 1:1!*

Cornwall, UK, Nikon F801, 60mm f2.8 micro, Subal housing, Ektachrome 64, f16 @ 1/60. Lighting from one Sea & Sea YS50TTL flash gun, with a small slave to fill shadows.

manufacturers. Where you choose to mount your torches is also an important consideration as it is essential to keep your hands free for operating the camera. Some photographers prefer to mount the torch directly over the lens either on the accessory shoe (Nikonos/Sea & Sea) or on the port itself on an adjustable bracket so that any subject directly in front of the camera will be lit. This method is particularly useful when using prods or framers and the flash position is largely fixed. Others, myself included, prefer to attach the torches to the flash gun, which is well suited to housed camera systems, so that you know that when you see your subject is lit through the viewfinder your flash gun is also pointing in the right direction. This is also handy for shots which require you to hand hold the flash and also allows you to direct the torch at the camera controls and displays. There are a number of torches which will attach to the side of your mask, which can be used when searching for subjects or looking at the camera settings and

Squat lobster hunting at night. Squat lobsters are notoriously difficult to photograph during the day as they cling tightly to the rock surface at the back of their holes. At night they are more concerned with feeding and you will find them out in the open foraging. This example just *continued to feed happily in the beam of my torch before moving off for a second course after a dozen frames or more.*

Cornwall, UK, Nikon F2, 90mm f2.5 macro, Hugyfot housing, Kodachrome 64, f16 @ 1/60. Lighting from one Sea & Sea YS50 manual flash gun.

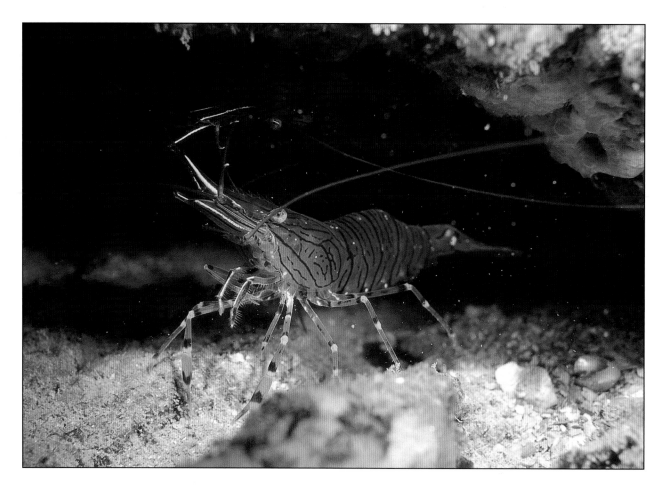

then extinguished for the photography – it is important to try various combinations to discover what is most comfortable for your own equipment and techniques.

Equipment

If you are a Nikonos or Sea and Sea user then your choice is between one of the available supplementary close-up lenses or a set of extension tubes which will allow you to take extreme close ups or concentrate on the macro life which abounds at night. Most close-up kits come with a frame or set of prods to indicate the focused distance and picture area of the lens. These can be a drawback in some circumstances when subjects (such as sleeping fish) are found in cracks and crevices and often it is better to remove the frame/prods and adapt a means of measuring your distance with a separate single prod or by using converging focusing lights. You can either fabricate a bracket yourself for two small spotting torches (Mitylite or similar) or buy one of the commercially available rigs. Either way, the operating principle is the same – the torches are set to converge at the correct focused distance for your lens, and when the two beams meet as a single spot on your subject you know it is in focus and take the shot. Using anything other than close-up or macro equipment involves the usual guesstimation of distance to you subject and framing the shot whilst lighting it.

Above: Common prawn. Prawns can be very shy during the day but are much more co-operative at night. You will see their eyes glowing on the reef edge as you scan your torch across the rocks. Mesmerised by the light they will normally stay absolutely motionless whilst you compose your shots. When photographing a subject like this in a fissure in the reef, remember to position your flash guns so that they are pointing directly at the subject and are not obscured by the rock which will cast a shadow. Having your focusing torch attached to the flash gun will help avoid this.
Cornwall, UK, Nikon F801, 60mm f2.8 micro, Subal housing, Ektachrome 64, f16 @ 1/60. Lighting from one Sea & Sea YS50TTL flash gun, with a small slave to fill shadows.

Right top: Prawns in reef fissure. These prawns were posing nicely like ducks in a row and seemed to jostle for position at the front as I approached behind my
torches. The diagonal composition of the fissure and the contrasting sponge growth complement the colourful prawns. When photographing a subject like this in a fissure in the reef, remember to position your flash guns so that they do not cast a shadow.
Cheju Island, South Korea, Nikon F801, 60mm f2.8 micro, Subal housing, Ektachrome 100, f16 @ 1/60. Lighting from one Sea & Sea YS50TTL flash gun, with a small slave to fill shadows.

Right bottom: Porcelain crab feeding at night. You rarely see crabs in the open during the day when diving in the tropics, but at night they come out to feed and make striking colourful subjects. Look especially in small caves and under overhanging coral for this particular species.
Red Sea, Nikon F801, 90mm f2.8 macro, Subal housing, Fujichrome Velvia, f16 @ 1/60. Lighting from one Sea & Sea YS50TTL flash gun, with a small slave to fill shadows.

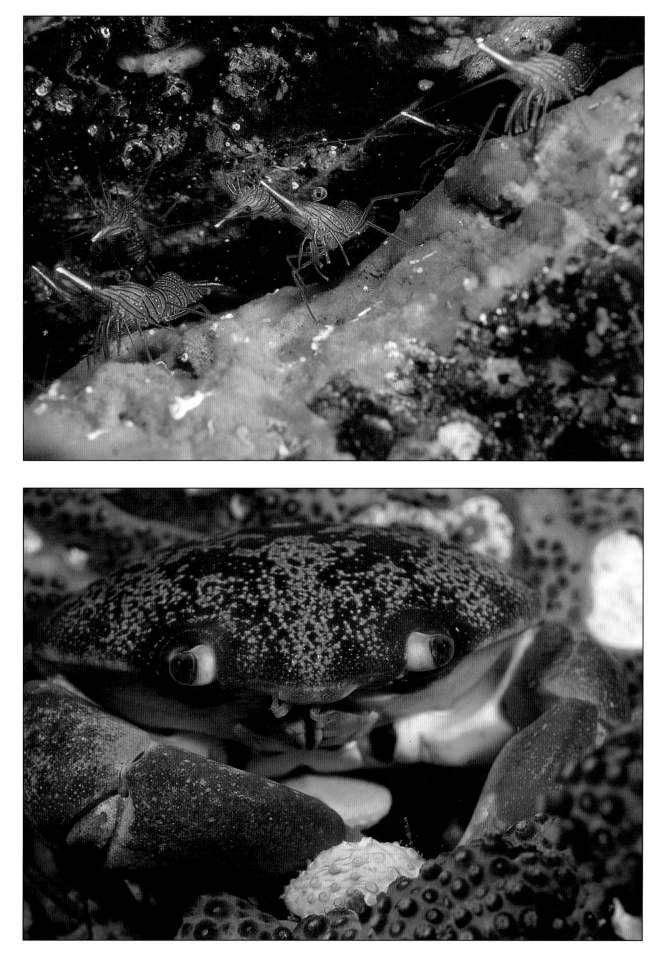

Above: Spotted puffer fish resting at night. As darkness falls all the reef fish disappear mostly into the nooks and crannies of the reef. Occasionally you will find a sleeping fish under an overhang or in a cave in a more accessible position for close-up photography. These puffer fish are normally quite wary during the day and will keep moving as you approach them, but at night are happy to pose in the beam of your torch.
Red Sea, Nikon F801, 60mm f2.8 micro, Subal housing, Fujichrome Velvia, f16 @ 1/60. Lighting from one Sea & Sea YS50TTL flash gun, with a small slave to fill shadows.

Above: Pin cushion sea urchin. Tropical sea urchins are rarely seen during daylight hours but at night they seem to appear from almost every hole in the reef. Most have sharp spines which will give you a nasty sting if you make contact and this species also has small venom sacs attached to each spine. This shot shows *a close-up detail and the contrast between the deep red of the urchin and white of the spines creates a pleasing abstract composition.*
Red Sea, Nikon F801, 60mm f2.8 micro, Subal housing, Fujichrome Velvia, f16 @ 1/60. Lighting from one Sea & Sea YS50TTL flash gun, with a small slave to fill shadows.

Right: Coral polyps feeding at night. Their patterns and texture, particularly the brain corals, make attractive and interesting abstract compositions.
Red Sea, Nikon F801, 60mm f2.8 micro, Subal housing, Fujichrome Velvia, f16 @ 1/60. Lighting from one Sea & Sea YS50TTL flash gun, with a small slave to fill shadows.

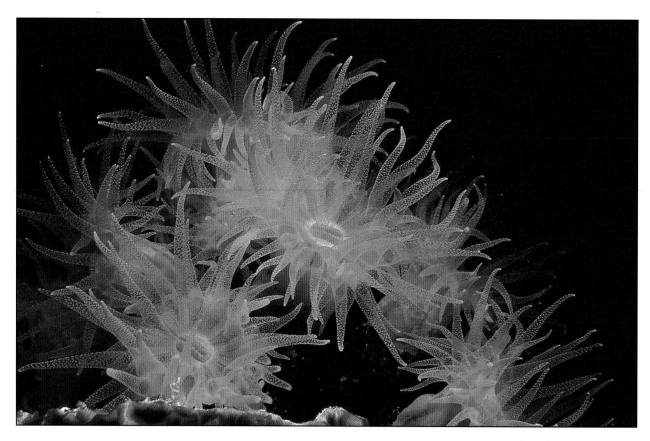

Above: Strawberry corals feeding at night. These single cell corals only emerge to feed during the hours of darkness. During the day they appear to be no more than quite dull looking calcareous stubs with a castellated end, but by night there is a total transformation as these delicate tentacles emerge to feed. However, once spotted *be careful not to keep the beam of your torch on too long as they will retract quickly. Focus on another subject at a similar range and then recompose quickly for the shot of the polyps.* *Red Sea, Nikon F801, 60mm f2.8 micro, Subal housing, Fujichrome Velvia, f16 @ 1/60. Lighting from one Sea & Sea YS50TTL flash gun, with a small slave to fill shadows.*

Those photographers who use a housed SLR system (or the RS) will normally choose to use either a macro lens in the 50mm to 105mm range or perhaps a zoom lens in the 24-100mm range which often have a close-up or macro setting at their 'long' end. Auto focus cameras will work well provided there is enough light and it is directed at the main subject. Shadows cast by the edges of rocks and crevices can upset the system and it is often useful to either use auto focus lock or be able to switch to manual focusing. Having your torch mobile on the flash gun, as described above, will help a great deal in these situations allowing you to light the subject more directly.

Flash lighting can be either TTL or manual. TTL works well at night as the subjects are often bright and contrasty, generally fill the frame and there is no natural light to upset the exposure – your torches will have no effect. Manual guns are well suited to macro or the close-up kits for the Nikonos or Sea and Sea

Above: Parrot fish sleeping. Parrot fish are always on the move during the day which makes them difficult to photograph. At night, however, they hide in small spaces in the reef to sleep, where they exude a mucus cocoon to obscure their scent. This shot was taken *soon after darkness had fallen before the fish had begun to form its cocoon.* *Red Sea, Nikon F801, 60mm f2.8 micro, Subal housing, Fujichrome Velvia, f16 @ 1/60. Lighting from one Sea & Sea YS50TTL flash gun, with a small slave to fill shadows.*

Top: Decorator crab.
These little crabs remain
almost motionless and
hidden during the daytime
due to their excellent
camouflage. At night they
emerge to feed and are
easier to spot as they move
about. This little chap is just
about distinguishable under
its fancy dress of sponges
and hydroids.
Red Sea, Nikon F801, 60mm
f2.8 micro, Subal housing,
Fujichrome Velvia, f16 @ 1/60.
Lighting from one Sea & Sea
YS50TTL flash gun, with a small
slave to fill shadows.

Above: Coral polyps.
Many species of coral only
extrude their polyps at night
to feed. This red gorgonian
coral has particularly striking
yellow polyps which contrast
well with the bright red
calcareous skeleton.
Red Sea, Nikon F801, 60mm
f2.8 micro, Subal housing,
Fujichrome Velvia, f22 @ 1/60.
Lighting from one Sea & Sea
YS50TTL flash gun, with a small
slave to fill shadows.

cameras when the flash position is often fixed.
Try running a test film to determine the best aperture
for subjects with differing contrasts and then simply
bracket around this setting.

Techniques

Night photography is simple as long as you keep your
equipment, techniques and objectives simple. Keep all
your torches fixed to your equipment so that they are
easy to find and use and ensure that all potentially
loose items are clamped tightly and have safety lines
attached in case they part company with the camera.

You will need to adopt slightly different techniques
and approaches for different subjects. Many night
active fish and shell fish are mesmerised by the torch
light and will freeze when caught in the beam. This
makes them particularly easy to approach, set up the
camera, focus and take the shot. However, many
night feeding corals, anemones and invertebrates are
very light sensitive and will often retract if a light is
directed at them for too long. For these subjects it is
best to try to spot them swiftly then take the torch
beam off the subject whilst you settle down and
prepare for the shot. I find it is best to pre-focus on an
adjacent piece of rock and then swing onto the
subject for final composition and take the shot before
it has time to react and retract.

Sleeping fish are a good subject – wrasse for
instance in our home waters and parrot fish in the
tropics – but are often well protected by the crevice
they have chosen. So they are best photographed

with a housed system or using one of the techniques using a close-up lens as described above. Many species which hide from you during the day will pose happily at night, such as squat lobsters and decorator crabs in the UK and coral and porcelain crabs in the tropics. As you play your torch across the reef watch out for those tell tale specks of light reflected from the eyes of prawns, lobsters, crabs and even octopuses. Once locked into the torch beam they will normally happily pose for several photographs, but will be quickly gone if the beam leaves them. When photographing a subject in a hole or crevice, pay attention to the position of your flash, as although your torch may be illuminating the subject the beam of the flash can easily be obstructed by rock or coral and can cast a dense shadow over part or all of your picture.

Try looking for abstract colours, patterns and bold mixtures of colour which are often found in the polyps of night feeding corals, sea urchins, anemones and sleeping fish. You can then fill the frame with only the pattern which produce striking photographs. However, if you are using prods or framers take care not to touch or damage the delicate polyps and coral structures or distress the fish.

Leave a few frames at the end of your dive when returning to the boat, especially in tropical waters, as the surface lighting will often attract squid and garfish looking for an easy meal. They will often drift around

Top: Parrot fish eye.
When fish are sleeping it gives you the opportunity to concentrate on close-up details of the animal, such as the eye or pattern on the skin. However, this sort of subject is best suited to a housed macro system as framers, which would have to touch the subject, would distress the fish.
Bonaire, Caribbean Sea, Nikon F801, 105mm micro f2.8 , Subal housing, Ektachrome Elite II 100, f16 @ 1/60. Lighting from one Sea & Sea YS 120 TTL with a small slave to fill shadows.

Above: Fusilier.
This small fish was frozen in the beams of my torches shortly after dusk, presumably looking for somewhere to sleep. Night diving often gives you the opportunity to get close to certain fish species which are normally wary by day.
Red Sea, Nikon F801, 60mm f2.8 micro, Subal housing, Fujichrome Velvia, f11 @ 1/60. Lighting from one Sea & Sea YS50TTL flash gun, with a small slave to fill shadows.

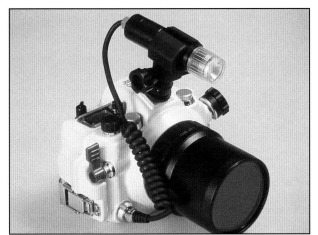

Top left: Torch on flash gun. The simplest way of attaching a torch to your flash gun for night diving is to use strong rubber bands.

Top right: Torch on port. For more direct lighting on the subject you can make a simple bracket to attach a small torch to the top of a port or to the top of a Nikonos/Sea & Sea camera.

Left: Torch on camera housing. If you do not want to fabricate your own torch bracket then consider the manufacturer's options such as this neat system from Sea & Sea for the the Canon CX600 housing system.
(photo courtesy of Sea & Sea).

the edge of the pool of light but will remain immobile when a torch is directed at their eyes.

Safety

At the best of times photographers have difficulty keeping track of their buddy and at night this problem is exacerbated by his/her attention being totally focused only on what is within the torch beam! However, we tend not to stray too far within a location and if the visibility is reasonable you can often spot a buddy with his torch not far away and join up at the end of the dive. It is wise though to recognise that you may well part, intentionally or otherwise, and you should plan for separate ascents and return to the boat, shot or beach. Whether diving as a pair or solo you should always carry a spare torch which is reserved for emergency use only and I would recommend a small inexpensive flasher in addition. A boat will normally be well lit for your return, but shot lines and dark beaches should also be equipped with a flasher or constant light source to aid your return. Finally, it is wise to agree with the beach or boat cover and your fellow divers a maximum duration of the dive so that there is adequate warning of anyone losing their way or being caught by errant currents.

If you are diving in the tropics remember that a number of species with painful defensive mechanisms emerge at night. Lion fish are particularly active,

especially at dusk, together with moray eels and a number of species of urchins which can give a very unpleasant sting. Also, remember all those scorpion fish and stone fish which are so difficult to spot by day are still there at night and have particularly potent venom's – check the seabed carefully before you kneel down or steady yourself with a hand.

Finally, bear in mind that your vision is severely limited and pay particular attention to where you place your fins and hands, whether you are diving a tropical or temperate reef, as delicate marine organisms are all too easily wiped out by careless or blundering movements in the dark.

Night photography can produce some dazzling and unique images and is really worth the effort and organisation involved. It is all too easy, especially on a diving holiday, to think you have had enough as the sun goes down. So get organised, get into that dark water and you will be surprised at how exciting and productive this underrated activity is.

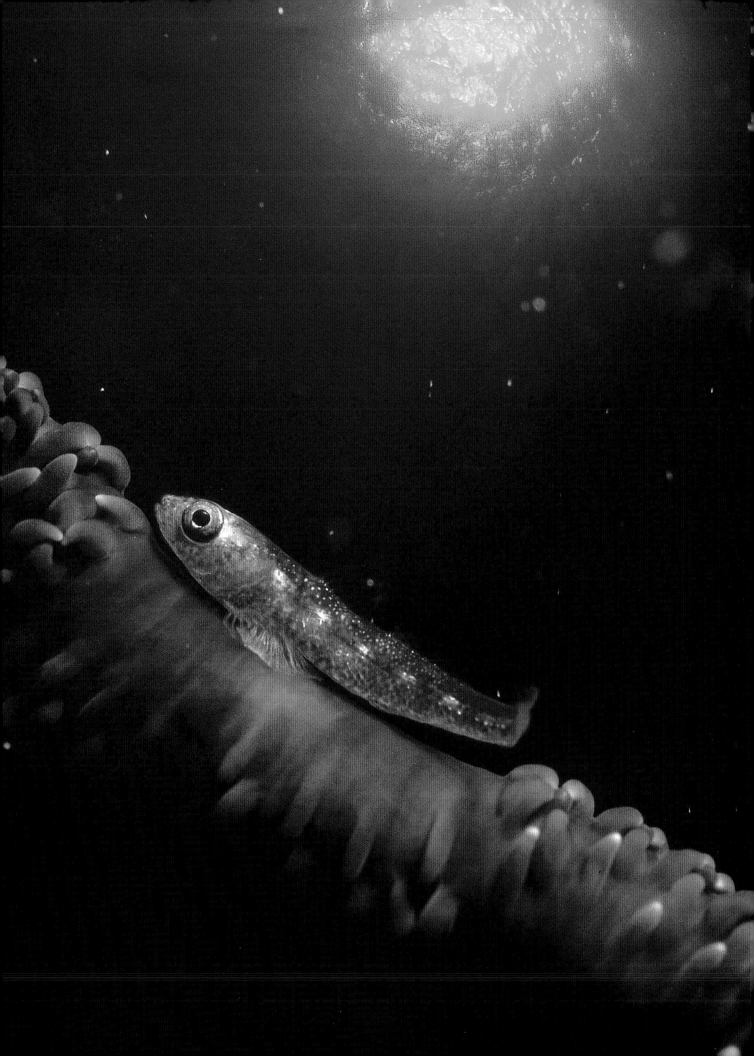

CREATIVE TECHNIQUES

Over the last four or five years we have seen an increasing number of manipulated images winning underwater photography competitions. There has inevitably been much controversy over whether this is real underwater photography and some purists even suggest that they be banned in competitions. However, manipulated images, multiple exposures and creative images are here to stay and in recognition of this many competition organisers now include a 'creative' category to avoid dispute in the judging. My own feeling is that as long as the image is all created in camera, on the same film and underwater they should be allowed and if you want to be competitive you had better know how to do it! The other side of the coin is that double or multiple exposures can create stunning images in conditions which are less favourable than tropical waters, hence their increasing popularity on the UK scene. So, whilst this chapter won't appeal to all underwater photographers many may see the techniques as a way of breathing some new life into their images.

Double Exposures

Taking double or multiple exposures is the most frequently used technique and it is important to grasp how it works and the equipment required to achieve it. In essence you will be running the same film through your camera twice (or more) and selectively exposing an area of the film frame each time. In order to do this you must know the point at which the film started and you must be sure that each film frame is in register, i.e. subsequent exposures do not overlap into the next frame. To achieve this you need a camera with a mechanically actuated sprocket drive such as the Nikonos III, IVa, and V, or a mechanical SLR, e.g. Nikon F series, Pentax LX, Canon F1 etc.

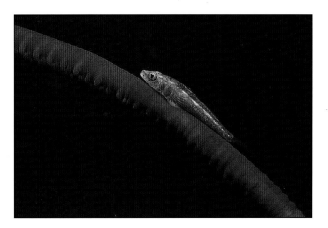

Goby on whip coral. Comparing this picture with the one opposite illustrates how the appearance of a shot can be transformed by the use of creative techniques. The straight shot of the goby has a horizontal format with a black background and classic diagonal composition and is attractive in its own right. Red Sea, Nikon F801, 60mm f2.8 micro, Subal housing, Fujichrome Velvia, f16 @ 1/60. Lighting from one Sea & Sea YS50TTL flash gun, with a small slave to fill shadows.

Some auto focus cameras are suitable for this whilst with others you can make use of the multiple exposure programme, but more of this later.

So, step by step, this is what you do:
– Open the camera back and watch the sprocket drive whilst you stroke the wind on lever and fire the shutter several times.
– Now mark one of the sprocket teeth (top dead centre is best) and the camera body adjacent to it. White paint or Tippex is suitable.
– Stroke the shutter several times again and watch that the two marks repeatedly line up. Some cameras will line up on each stroke of the wind on lever, others will be every second or third turn dependant on the drive mechanics.
– Next load your film and once secured on the take up spool mark your film with a vertical line where the marked sprocket tooth engages the sprocket hole in the film leader. Use an indelible pen for this.
– Now you can make your first series of exposures. Keep a careful note of frame numbers and subject positions.

Goby on whip coral with sun burst. In this shot the format is vertical and a double exposure has been made to add a sun burst on the top right by re-exposing the film with a wide angle lens. Remember that the second exposure must leave the first area underexposed by at least three stops, which in this case has been quite straight forward as the small sun spot would need f22 at 1/250 for example. *Red Sea, Nikon F801, 60mm f2.8 micro and 16mm f2.8 fish eye, Subal housing, Fujichrome Velvia, f16 @ 1/60 and f22 @ 1/250. Lighting from one Sea & Sea YS50TTL flash gun on manual for the first exposure.*

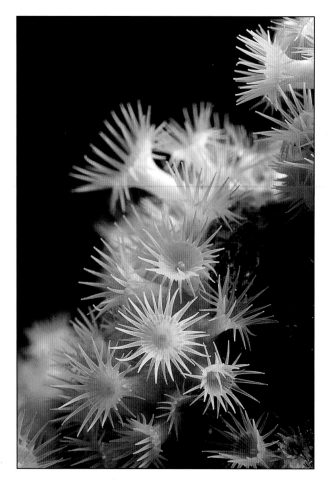

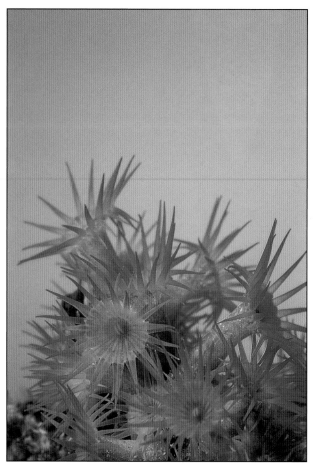

a) Find a suitable foreground subject, such as an anemone, which stands proud of its surroundings. Light the subject selectively using a snoot on the flash which keeps the remainder of the frame underexposed and black.

b) Rewind and reregister the film and fit a wide angle lens. Find a suitable overhang on the reef and compose the surface and sun in the top of the frame using the rock to shield the first exposure.

c) The finished shot should be 'seamless' but the technique will require some practice to perfect.

Above left: Zooanthellae anemones. This series of three shots shows the same species of anemones photographed in three different ways, which changes their appearance dramatically. This first shot is taken with a small aperture and fast shutter speed to ensure that the background remains black and the bright subject will stand out. *Minorca, Mediterranean Sea, Nikon F801, 60mm f2.8 micro, Subal housing, Ektachrome Elite II 100, f16 @ 1/60. Lighting from one Sea & Sea YS50TTL flash gun, with a small slave to fill shadows.*

Above right: As a second, creative alternative, this shot has been backlit using a third slave flash gun with a pale blue filter to simulate blue open water behind the subject – although the shot appears natural, it is in fact not possible as these anemones are only found in caves and under overhangs. Getting the exposure correct with back lighting is difficult initially – much depends on the power of the flash gun and the density of the filter that you use. *Lighting from one Sea & Sea YS50TTL flash gun, a small slave to fill shadows and a third flash with blue filter for back lighting.*

Right: Zooanthellae anemones. The third creative alternative is a double exposure with a cluster of the anemones initially shot against a black background by using a small aperture, fast shutter speed and a snoot on the flash. The film is then rewound and the sunburst exposed in the dark area of the frame by using a full frame fish eye so that it appears small and distant in the final image. Exposure for the second half of the shot is based on the sunburst so as not to overexpose the anemones. *Nikon F801, 60mm f2.8 micro and 16mm f2.8 fish eye, Subal housing, Fujichrome Velvia, f16 @ 1/60 and f22 @ 1/250. Lighting from one Sea & Sea YS50TTL flash gun on manual for the first exposure.*

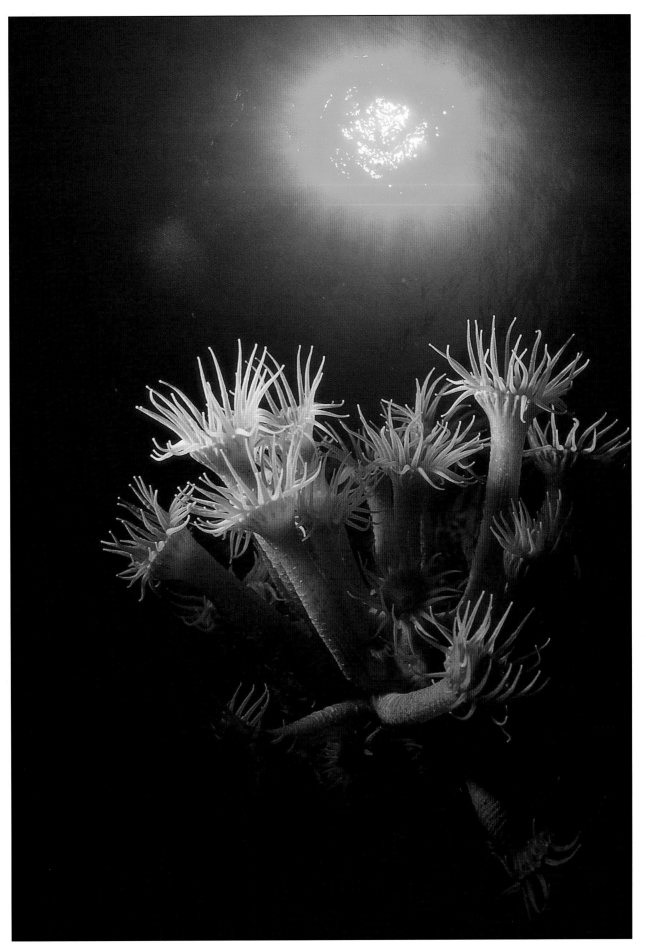

Above left: Canary blenny. These two shots of a canary blenny illustrate how the appearance of a shot can be transformed by the use of creative techniques. Both shots of the blenny have a vertical format, but the straight shot has a black background and is an attractive shot in its own right.

Red Sea, Nikon F801, 60mm f2.8 micro, Subal housing, Fujichrome Velvia, f16 @ 1/60. Lighting from one Sea & Sea YS50TTL flash gun, with a small slave to fill shadows.

Above right: Canary blenny with sunburst. In this shot the format is also vertical but a double exposure has been made to add a sun burst at the top left by re-exposing the film using a fish eye lens. Remember that the second exposure must leave the first area underexposed by at least three stops, which in this case has been quite straight forward as the sun needed an exposure of f22 at 1/250.

Red Sea, Nikon F801, 60mm f2.8 micro and 16mm f2.8 fish eye, Subal housing, Fujichrome Velvia, f16 @ 1/60 and f22 @ 1/250. Lighting from one Sea & Sea YS50TTL flash gun on manual for the first exposure.

– You then rewind the film, taking care to leave the leader out, and reload following the same procedure. The film will now be registered in exactly the same position for the second or subsequent series of exposures.

The classic double exposure is a 'forced perspective' image which combines a macro foreground shot with a sweeping wide angle background to it, thus giving a feeling of depth to the photograph and the illusion of marvellous visibility. This type of shot is especially useful in UK waters where on the whole visibility is rarely stunning! To achieve this type of shot you will need both a macro system and a wide angle lens for your camera. Combining the two halves of the image without showing the 'join' is the tricky part and as with all aspects of underwater photography requires patience, practice, a few rolls of film and usually not a little disappointment on the way.

Photographers using housed SLR's do have a distinct advantage with this technique as they are able to directly view the picture area and place subjects accurately. However, excellent results are also achievable with the Nikonos system and the basic exposure techniques are the same for both options. Described below is a guide to the needs of the foreground and background exposures which is not necessarily gospel as most photographers develop their own variations.

Foreground Exposures

The easiest way to start is to pick a subject which will fill no more than half the bottom of the frame at a magnification of say 1:3, a cup coral or anemone is ideal. You must now be able to light this subject selectively with your flash gun so that the remainder of the frame is unexposed. This is best done by making a 'snoot' for your flash which will direct a cone of light at the subject. Snoot size can depend on subject size but I find that between 1/2" and 1" is ideal for most applications. This will obviously affect the power output of the flash generally by a couple of stops – you will find TTL does not work. If your camera has the option of fast synchronisation speeds (e.g. 250th of a second) then use it as this will help keep the background dark. Now make a series of exposures for the foreground bracketing with both aperture and flash distance and vary the position of the flash. Keep a note of your positions and apertures for future reference. Do not be afraid to use the whole film on this, perhaps choosing one or two other foreground subjects, as you will find initially that the results are unpredictable. On completion return to the real world and rewind your film.

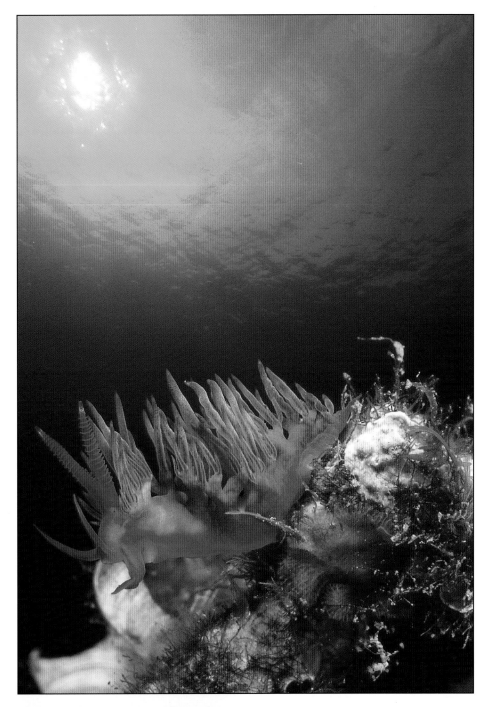

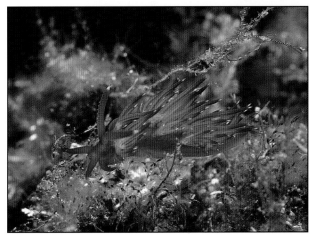

Left: Purple nudibranch. These two shots of a small purple nudibranch illustrate how the appearance of a shot can be transformed by the use of creative techniques. The straight shot of the nudibranch has a horizontal format and is an attractive shot in its own right.

Above: Purple nudibranch with sunburst. The second shot has a vertical format and a double exposure has been made to add a sun burst. Remember that the second exposure must leave the first area underexposed by at least three stops.

Minorca, Mediterranean Sea, Nikon F801, 60mm f2.8 micro and 20mm f2.8 , Subal housing, Ektachrome 100S, f16 @ 1/60 and f22 @ 1/125. Lighting from one Sea & Sea YS50TTL flash gun on manual for the first exposure.

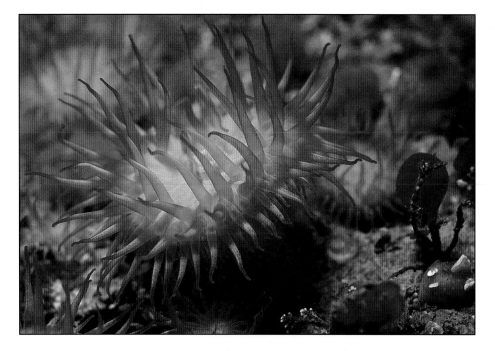

Left: Purple and orange dahlia anemone. These two shots are of similar subjects in British waters and demonstrate how the use of an additional flash can add impact to a subject which, although colourful and technically acceptable, perhaps does not stand out as being truly individual. Cornwall, UK, Nikon F801, 60mm f2.8 micro, Subal housing, Ektachrome Elite 100, f22 @ 1/60. Lighting from one Sea & Sea YS50TTL flash gun, with a small slave to fill shadows.

Right: White dahlia anemone. Whilst this second white anemone would not seem as attractive as the first it has been transformed into a more striking image by the addition of a third flash gun with a blue filter back lighting the subject. Getting the exposure correct with back lighting is difficult initially. This is a particularly useful technique for British waters as it appears to be a balanced light shot with a truly tropical feel it. Cornwall, UK, Nikon F801, 60mm f2.8 micro, Subal housing, Fujichrome Velvia, f16 @ 1/60. Lighting from one Sea & Sea YS50TTL flash gun, a small slave to fill shadows and a third flash with blue filter back lighting the subject.

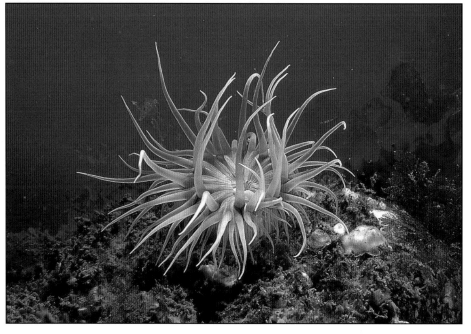

Background Exposures

Having re-registered your film fit your wide angle lens, which really needs to be 20mm or wider for the most pleasing results. Remove your flash gun and return to the water. Remember the orientation of your original macro shots, which leaves you the top half of the frame to fill with the wide angle view. The trick now is to ensure that you do not re-expose the bottom half of the frame. The best way to approach this is to find an area of overhanging reef or kelp which will 'cover' the bottom half of the frame. You can then meter the two halves of the frame and ensure that there is at least a 2-3 stop difference between them, i.e. you are underexposing the bottom half of the frame. Now you can make the series of background exposures including perhaps a diver, the sun or a passing fish shoal. Vary the composition and move around to find varying overhangs and backgrounds. Again keep a note of what you do.

Auto focus Cameras

There are some auto focus cameras which utilise a suitable film transport system whilst others may be modified to use this technique, but this is really beyond the scope of this chapter and it is best to consult the camera manufacturer or specialist supplier. However, most auto focus cameras do have a multiple exposure facility allowing you to make several exposures on a single frame. You will need to ensure that your housing allows you to access the multiple

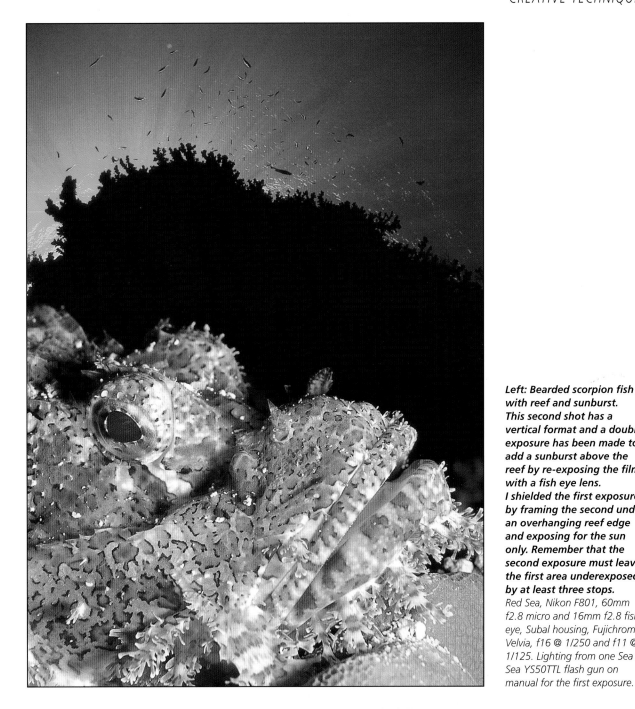

*Left: Bearded scorpion fish
with reef and sunburst.
This second shot has a
vertical format and a double
exposure has been made to
add a sunburst above the
reef by re-exposing the film
with a fish eye lens.
I shielded the first exposure
by framing the second under
an overhanging reef edge
and exposing for the sun
only. Remember that the
second exposure must leave
the first area underexposed
by at least three stops.*
*Red Sea, Nikon F801, 60mm
f2.8 micro and 16mm f2.8 fish
eye, Subal housing, Fujichrome
Velvia, f16 @ 1/250 and f11 @
1/125. Lighting from one Sea &
Sea YS50TTL flash gun on
manual for the first exposure.*

*Right: Bearded scorpion fish.
These two shots of a
common bearded scorpion
fish illustrate how the
appearance of a shot can be
transformed by the use of
creative techniques. The
straight shot of the scorpion
fish has a horizontal format
and is an acceptable shot in
its own right.*
*Red Sea, Nikon F801, 60mm
f2.8 micro, Subal housing,
Fujichrome Velvia, f16 @ 1/60.
Lighting from one Sea & Sea
YS50TTL flash gun, with a small
slave to fill shadows.*

Young snorkeller prepares to dive. A creative technique can be as simple as this half in half out image of my daughter preparing for one of her first snorkel dives. A fish eye lens is best for a shot like this as the inherent depth of field will keep both halves in focus. This technique can be achieved with an 18-20mm lens, but you may find that you need a split dioptre to bring the underwater half into focus. Even if the water surface is glassy calm, the technique is easier with a large dome port which increases the surface area of the water/air interface and therefore minimises apparent movement. Either choose a dull day or put the sun behind you so that the exposure both above and below is reasonably close. I generally expose for the surface half then bracket around that reading. The inclusion of mother and sister on the rocks in the background adds interest and an implied story line to the remaining negative space.
Cornwall, UK, Nikon F801, 16mm f2.8 fish eye, Subal housing with a 15cm dome, Fujichrome 100, f8 @ 1/125 to freeze any water movement.

exposure control on your camera and if it does not then perhaps consider modifying it. Because each double or multiple exposure is to be taken consecutively on each frame you have to have both the close-up and wide angle elements available in one lens – in short a zoom lens. What has become known as a 'standard zoom' is most suitable, e.g. 28-72 mm, 28-105 mm etc., most of which have a macro setting at the long end. This method is some what of a compromise as the macro settings of these lenses rarely go beyond 1:4 or 1:5 and the wide end at 28 mm is sometimes not wide enough. However, by choosing your subjects carefully you can produce some very effective results, but you must keep your wits about you and remember to keep selecting the number of exposures you require with each frame and also remember which end of the zoom lens you should be using!

Your first attempts with this technique may not be a resounding success, but perseverance will bring repeatable results and some very pleasing images. Once you have mastered the basics you can begin to experiment with horizontal compositions, three or four exposures on a frame and variations in lighting techniques. The only limits are your patience and imagination!

Creative Techniques

The majority of underwater photographers are predominantly interested in recording the marine world or perhaps man's exploration of it. If they enter a competition then it is likely to be one which largely features categories for natural history or wide angle/scenic shots. However, there are a growing minority of photographers who, in addition to an interest in imaging marine life, also want to explore the possible variation and manipulation of techniques underwater and view the underwater location as merely a studio much as a land photographer would. As mentioned above, many competitions now include a 'creative category' to cover these manipulative techniques, which have been a source of much heated debate amongst purists when previously included in open competitions. In fact, in addition to specialised categories there is a now a biannual 'World Championships of Swimming Pool Photography' which is totally dedicated to this pursuit.

Creative photography does not appeal to all, indeed some regard it as not being true underwater photography as it often does not include the patient stalking of wildlife but more often consists of pre-planned set piece shots. But you should not immediately dismiss these techniques even if you feel that your interests lie with 'straight' photography. It is

Pipefish are difficult to photograph as a whole fish due to their length. I shot a few straight 'head and shoulders' portrait shots of this one and then decided that it might make a good subject for a double exposure. This is a good example of a 'forced perspective' shot in British waters which I feel gives the subject greater impact. The second half of the shot was taken from inside a small cave fringed with kelp which shielded the first exposure of the fish. Remember that the second exposure must leave the first area underexposed by at least three stops.
Cornwall, UK, Nikon F801, 60mm f2.8 micro and 16mm f2.8 fish eye, Subal housing, Ektachrome 64, f16 @ 1/250 and f5.6 @ 1/60. Lighting from one Sea & Sea YS50TTL flash gun on manual for the first exposure.

often a good idea to experiment a little with offbeat ideas in order to develop and hone your skills of composition, lighting and exposure in what is often a more controlled environment. Creative ideas can range from half in half out shots or double exposures which are difficult to detect (and therefore more acceptable to some) to the subtle use of models and props to literally outrageous ideas with combinations of coloured lights and mirrors.

A creative technique can really be classified as anything other than a 'normal' exposure. This would include the use of filters, props, back lighting and even divers modelling in anything less than full equipment. Shots using coloured filters on flash guns or torches, mirrored diving masks, multiple image

filters, rubber octopuses and divers dressed for climbing, skiing, weddings or in nothing at all have all been used to good effect in many magazines, books, exhibitions and competitions. The only thing holding you back will be your imagination and it is often a good idea to look at the terrestrial photographic press and publications for inspiration as many studio ideas can be adapted for underwater use with a little lateral thinking.

This type of photography requires a greater degree of dedication and planning and is not something you can decide to do on a typical club diving outing. You will generally need the assistance of at least your model and in some cases other divers to assist with setting up a shot or a complicated lighting array. Even

*Top left: Following
a creative theme for a
competition. Many
competitions have a creative
category specifically for
manipulated shots. Entries,
especially at photosub
events, often try to follow
the theme or location of the
event. The 1994 CMAS World
Championships of
Underwater Photography
were held in South Korea as
one of the promotional
events during 'Visit Korea
Year'. This first shot shows
the symbol which was used
to promote the sports
competitions which sparked
the idea of combining this
with an underwater image –
i.e. we would replace the
figures in the centre of the
symbol with an underwater
image of South Korea using
the double exposure
technique. Top right: This
shot shows the black board
with the flags and text
which formed the second
half of the double exposure,
all of which had to be
completed in water in
accordance with the rules.
The board was mounted on
a framework which attached
to the camera housing.
Bottom: This is the finished
shot. The central circular
image was taken using an
8mm fish eye lens which has
an angle of view of 220° and
therefore produces a circular
image (the lens was kindly
loaned to me for the event
by Sigma Lenses, UK). Being
a circular format there is an
unexposed area on the film
frame which is where
I placed the text and flags
in the second exposure.
When using a lens as wide
as this you have to hold the
flash well behind the lens
and be extra careful not to
include your feet or
equipment in the shot!*

*Cheju Island, South Korea,
Nikon F801, Subal housing,
background: 60mm f2.8 micro
f16 @ 1/250 with Sea and Sea
YS50 TTL, and centre: 8mm
f5.6 Sigma fish eye f11 @ 1/60
with Subatec S100 at half
power, Ektachrome Professional
100 film. This shot went on to
collect fifth place in the
competition.*

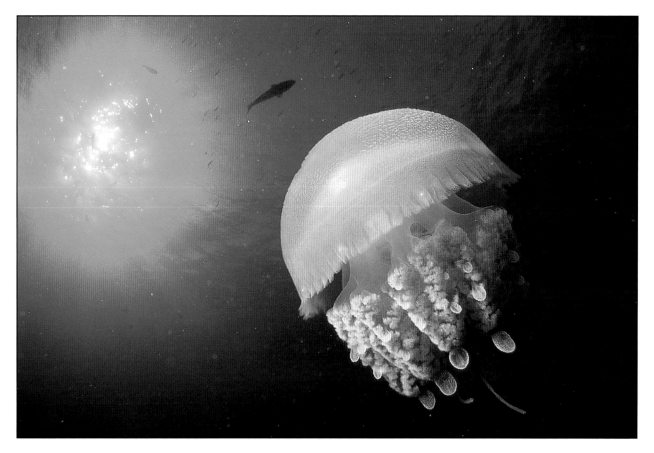

**Jellyfish and sunburst.
Is this a straight shot or a
double exposure? This is a
good example of a seamless
double exposure which looks
entirely natural. The jellyfish
is in fact only 3-4cm in
diameter and was positioned
on one side of the frame
using a 90mm macro lens
with a small aperture and
fast shutter speed to keep
the rest of the frame black.
The sunburst was then
added a couple of days later**

**using a 16mm fish eye.
Perhaps only one thing
provides a clue to the
construction of this shot –
the scale of the fish in the
background compared to the
size of the jellyfish.**
*Nikon F801, Subal housing,
90mm macro and 16mm fish
eye, Ektachrome Elite II 100,
f22 @ 1/250 for both
exposures. The jellyfish was lit
with one Sea & Sea YS50TTL
flash gun on manual power.*

**A Sea & Sea YS50 TTL flash
gun with a snoot used to
direct the light to a single
part of the frame when
taking double exposures.**

if your idea is totally original it is worth studying
books on studio photography, especially those which
describe advertising, creative and special effect
photography, which provide all sorts of useful
information on lighting and prop construction which
can be adapted for the underwater environment.

Ideas should be sketched up in detail to predict
lighting angles and positions of props or your model
and then be tested in a swimming pool to ensure that
the effect is what you expected. These practice
sessions will ensure that things run a little smoother
when you try the shot in open water. Practice is
particularly important if the shot is intended for a
'photosub' style (real time) competition, where you
are likely to be diving on totally new territory and may
have time restraints or unexpected topographical and
environmental influences to deal with as well.

Planning a shot for a particular competition can be
a spur for ideas and you can try to adopt a theme in
the shot which reflects the location or event. Once
again research can help here as very often guide
books and brochures for a location can produce a
theme which can be illustrated in the shot.

You may find that you have a flair for this style of
photography and it can become a consuming passion
driving you to seek out new ideas and objectives for
them. If the reverse is true your abilities will have
benefited from dabbling in this strange art and you
should see the evidence of this in the way you
approach your photography and the results produced.

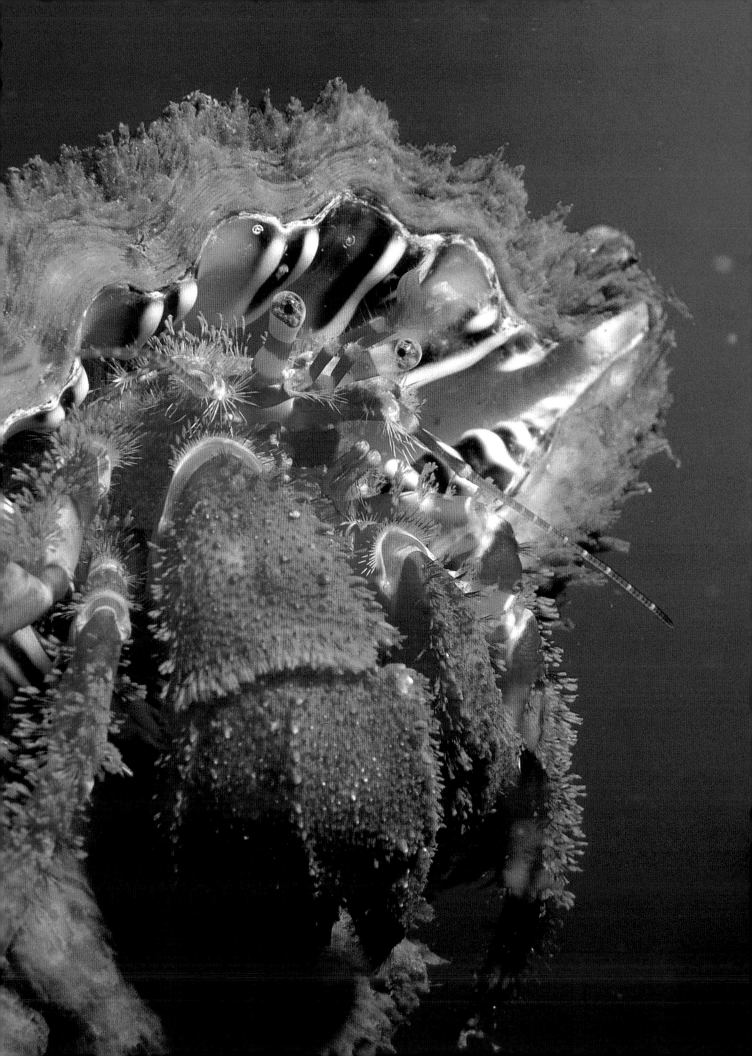

COMPETITIVE EDGE

Once you have mastered the basic techniques of underwater photography you will begin to amass a library of acceptable and pleasing shots. At this point most photographers will begin to look for something to do with all this material and perhaps to create a purpose for future photography. Activities will include creating slide shows for clubs and friends, pursuing specific marine life species, illustrating magazine articles and books and, what some might regard as the ultimate test for your skills, entering competitions.

If you choose to measure your skills in this way a little investigation will reveal that there are a wide range of competitions which could attract entries taken underwater. Additionally there are the 'traditional' underwater photography competitions, often sponsored by diving magazines, federations or the CMAS (Confederation Mondial des Activities Sub-Aquatiques) and can take the form of submissions to a panel of judges, or the 'real time' photosub events. Often it is a good idea to consider competitions outside the diving world as an underwater photograph can stand out amongst the terrestrial entries and therefore do well. Summarised below are some of the options you might consider:

- Competitions organised by diving clubs, national federations, and the CMAS.
- Photographic club competitions, e.g. BSoUP's In Focus (monthly), Beginners Portfolio,

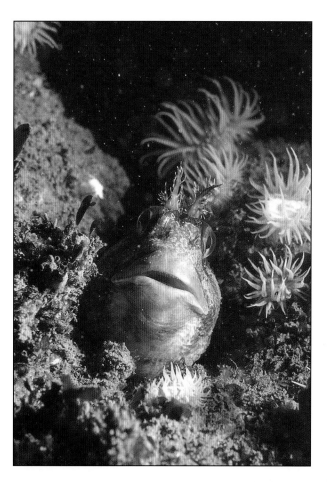

Above: Tompot blenny. Sometimes just the "pussy cat factor" is enough to attract the judges' attention. These comical looking fish always make good subjects and can be found on almost any reef in the UK.

The upward angle and vertical format of this shot add impact to the image. *Salcombe, UK, Nikon F3, 55mm f2.8 micro, Ikelite housing, Ektachrome 64, f11 @ 1/60. Lighting from one Sea & Sea YS50 manual flash gun.*

Macro category: Hermit crab with blue water background. The winning shots in many competitions, particularly photosubs, are not always the most technically challenging and are often images of very common subjects. The secret seems to be in simple bold compositions or perhaps to photograph a common subject in an unusual way. This hermit crab is a typical example – had it been photographed in the expected horizontal format head on then it would not *be such a striking composition. By adopting a very low angle and using a vertical format I have been able to include the bright coloration on the inside of the shell and also an open, blue water background which provides a very positive contrast with the crab.* *Cheju Island, South Korea, Nikon F801, 60mm f2.8 micro, Ektachrome Professional 100, f11 @ 1/60. Lighting from one Sea & Sea YS50TTL flash gun, with a small slave to fill shadows.*

Best of British and Open Portfolio
- Annual film and photography festivals. e.g. Antibes, Okeanos, Camera Louis Bouton etc.
- Competitions organised by diving magazines – do not just restrict your search to UK based magazines. There are a number of publications in Europe, USA, Far East and Australia which all organise regular submission competitions.
- Competitions organised by photography

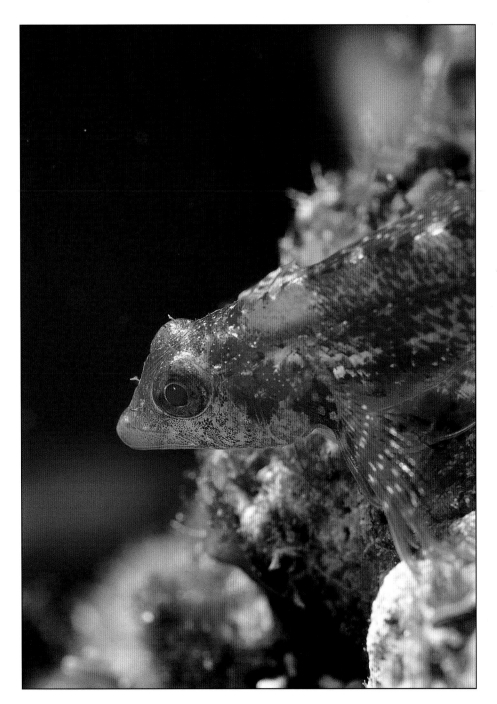

Left: Macro category: Long spined blenny with open water background. This shot was taken during the 1996 CMAS World Championships of Underwater Photography where we were plagued by bad weather and therefore restricted to sites where marine life was not abundant. I knew that there would be a lot of these very common fish photographed, so, to be noticed, my shot had to be different. By waiting patiently (some 40 minutes!) with my subject it eventually hopped to the top of a rock which allowed me to get a very low angle using a vertical format thus including an open water background. This has separated the fish from the busy background of marine growth contrasting its head and shoulders with the dark blue/grey of the water and so improving the impact of the image.

Minorca, Mediterranean Sea, Nikon F801, 60mm f2.8 micro, Ektachrome 100S, f8 @ 1/60. Lighting from one Sea & Sea YS50TTL flash gun, with a small slave to fill shadows.

This shot was one of a pair placed second in the macro category and one of a portfolio of six in three categories which was placed third in the individual world rankings.

Right: Macro category: Long spined blenny. These two shots of the same species of fish show how the feel and presentation of a subject can be varied through composition. This shot has a distracting background which does not contrast well with the coloration of the fish – the shot lacks impact.

Minorca, Mediterranean Sea, Nikon F801, 60mm f2.8 micro, Ektachrome 100S, f11 @ 1/60. Lighting from one Sea & Sea YS50TTL flash gun, with a small slave to fill shadows.

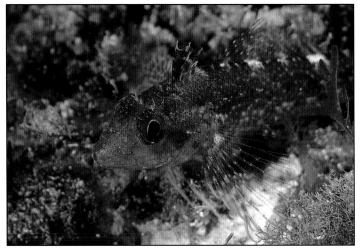

magazines – look for those which include a nature category, patterns or abstracts and any water related categories.

– Wildlife competitions – often organised by wildlife magazines and conservation groups. The best known is the annual British Gas/BBC Wildlife magazine sponsored 'Wildlife Photographer of the Year' event which attracts entries from all around the globe. This has one specific and several suitable categories for underwater photographs.

– Photosub competitions – real time events over 1-7 days where the photographer is required to produce a portfolio in specific categories. There are regular annual events in the UK, Mediterranean, USA, Far East and Australia which culminate in a bi-annual World Championships organised by the CMAS.

– Fish hunt competitions – similar in style to photosubs but dedicated to fish photography only, as an alternative to spear fishing.

Having chosen the style of competition you must then begin to consider the type of photograph to enter which will have the best chance of being placed or even winning! All competitions have their little nuances which with a little experience and forethought can be read and will assist with reducing the number of photographs to choose from. Photosubs are a particular challenge and will benefit from specific planning and even practice. It is perhaps easiest to consider the planning and preparation separately under the three headings below:

Submission Competitions

Regardless of who is organising the submission competition that you are considering, the most important first step is to study the rules and conditions of entry. In particular, study the categories which may be specifically for underwater photographs or may be more general such as macro, portraits, wildlife or themes like patterns in nature and water. If it is a predominantly terrestrial competition, try to imagine what subjects other competitors might use and how your entry might appear alongside them – you want your photographs to jump out as being radically different or unusual amongst the others. Be wary of any exclusions in the rules which might preclude your work, e.g. only plant life, captive conditions, manipulative/creative techniques, digital enhancement etc.

Life is a little easier if the competition is dedicated to underwater photographs, although the same advice applies to the categories and the rules. Competitions in diving magazines are often sponsored by travel companies or tourist boards with the intention of promoting their particular destination to the readers of the magazine and perhaps to use the winning shots in advertising campaigns. The

Creative category: Slide frame 'prop'. The inspiration for this shot used in the 1996 CMAS world Championships of Underwater Photography came from an everyday action for a photographer – raising a slide to the light and viewing it. This was to be a double exposure using a fabricated oversized slide mount which had a matt black centre. There would be two scales to the shot; the first a close-up of the slide mount held by a thumb and finger towards the light and the second a wide angle image in the centre. After much experimentation the required focused distance and scale was determined and the first half of the shot became reliably repeatable. A mask was fitted to a 16mm fish eye lens to produce the central image during the second exposure.

Creative category: Finished slide frame shot. During practice for the event it had been possible to hold up the slide frame blank towards a light sunlit surface giving the impression of light behind it. However, as so often happens, weather during the event spoilt this plan. The sky was overcast, visibility poor and we had to dive below 15m to avoid a heavy swell! So the background ended up being dark, but the shot still works quite well. Minorca, Mediterranean Sea,

Nikon F801, 60mm f2.8 micro, Ektachrome 100S, f8 @ 1/60 with lighting from one Sea & Sea YS50TTL flash gun, with a small slave for the first shot. **For the second exposure a 16mm 2.8 fish eye with lighting from one Isotecnic 33TTL set to manual half power. This shot was one a portfolio of six in three categories which was placed third in the individual world rankings during the 1996 CMAS World Championships of Underwater Photography.**

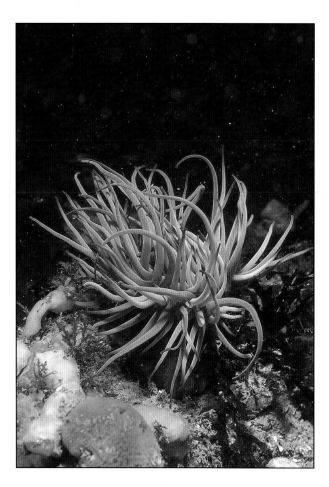

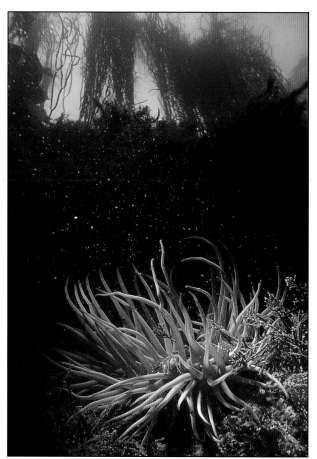

successful shots in these competitions are often the simplest and most classic of compositions, perhaps showing a diver exploring the destination or a reef scene bursting with life, which flatter the destination and therefore catch the eye of the organisers.

One of the highlights of the competition year is undoubtedly the British Gas/BBC Wildlife magazine 'Wildlife Photographer of the Year' competition which attracts more than 16,000 entries world-wide. This may sound daunting at first, but the specific underwater category attracts hundreds rather than thousands of entries and there are several other suitable categories for underwater photographs. Although the best known underwater photographers often do well in this competition, sometimes the winning shot is a surprise and will come from a newcomer to the art. This is a competition which has no set style in the winning photographs and is therefore difficult to predict a winning composition or subject, so it is very much worth a try.

Finally, it is worth looking at who the judges are for a particular competition and, where available, looking at previous winning shots to see if there are any particular themes you could follow, especially if the judges return each year. I keep a library of old magazines from the diving, photographic and wildlife press, particularly those with competition results for just this purpose. The Wildlife Photographer of the Year competition publishes a portfolio of winning and

Above left: Snakelock anemone. Whilst this shot of a snakelock anemone may be fine technically it is not very inspiring and is unlikely to attract the judges' attention. When competing in photosub events you are often confronted with poor visibility and perhaps only very common subjects which you know all the other photographers will find. So you must use a different technique to make your shot stand out as different to all the other entries.
Cornwall, UK, Nikon F801, 60mm f2.8 micro, Fujichrome Velvia, f11 @ 1/60. Lighting from one Sea & Sea YS50TTL flash gun, with a small slave to fill shadows.

Above right: Snakelock anemone with stringweed. By using a double exposure technique when the visibility is poor you can give the impression of far better conditions. This shot was taken at the annual "Splash In" organised by the British Society of Underwater Photographers in Plymouth. A very popular event, but one which is rarely blessed with perfect calm conditions and good visibility. The competition has two categories – Open and Humorous – and many of the entries are double exposures like this one.
Plymouth, UK, Nikon F2, 55mm f2.8 micro and 18mm f3.5 , Hugyfot housing, Agfachrome RS50, f16 @ 1/60 and f11 @ 1/60. Lighting from one Sea & Sea YS50 manual flash gun for the first exposure.

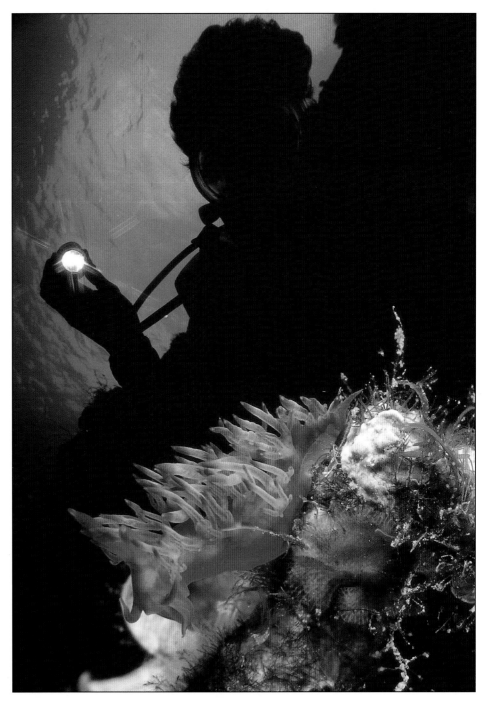

Sketch contents:

BACKGROUND –
Shield foreground
with ROCK-DIVER
in silhouette
20mm + starburst
for torch & sun
? f11/16 @ 1/125
FOREGROUND –
Purple or White
NUDIBRANCH
up to ½ frame
60mm f16/22
@ 1/250 snooted
flash for BLACK background

Sketch of planned double exposure. I find that when I am planning a series of shots, particularly for a competition, it is easiest to visualise the image I want by sketching it and detailing the probable composition and exposure. These sketches can be adjusted as the shots are practised so that when the event occurs, or you are away on that expensive overseas trip, you have a reminder before you enter the water and then it is a matter of finding the location and suitable subject – the planning is hopefully largely complete. This sketch illustrates the composition of a nudibranch and diver for the 1996 CMAS World Championships of Underwater Photography – we knew that this species of nudibranch is very common in the Mediterranean and so could reasonably expect to find one. Notes made around
the sketch are to remind me of the position of the subject and the expected exposures – this is especially useful when the two halves of the exposure may be a day or more apart. I also make notes on a scratch board during the dive so that I can update the sketch if necessary. You must also remember to mark the relevant film with the frame details and the orientation of the camera etc. Nudibranch and diver with torch. This is the finished
shot which I felt was reasonably close to that planned in the sketch. The nudibranch was found on the top of a rock and lit with a snooted flash for the first exposure. The second half has the diver peering over a rock in silhouette, thus keeping the foreground and nudibranch well under exposed. The addition of a star burst filter adds a little extra sparkle to the image – I had hoped for a sunburst too but the weather did not co-operate on the day!

Minorca, Mediterranean Sea, Nikon F801, 60mm f2.8 micro and 20mm f2.8 with star burst filter, Subal housing, Ektachrome 100S, f16 @ 1/250 and f5.6 @ 1/60. Lighting from one Sea & Sea YS50TTL flash gun with snoot on manual for the first exposure.

This shot was one a portfolio of six in three categories which was placed third in the individual world rankings during the 1996 CMAS World Championships of Underwater Photography.

commended entries each year which is well worth studying for tips, subjects and compositions. It is also worth referring to the books published by well known underwater photographers (David Doubilet, Kurt Amsler, Chris Newbert etc.) for inspiration and style. When you have picked up a tip plan to practice it and also discipline yourself to take shots to suit a particular competition or category on your next diving trip.

Photosub Competitions

Photosubs or real time events are perhaps unique to underwater photography. In theory these events expose all the photographers to the same conditions and available subjects and so could be said to be the fairest test of skills, but of course preparation and luck will inevitably play a part to some extent. These competitions range from smaller events, for example the BSoUP Splash In, which are held over one day and are open to all photographers, to the larger international events held over 3-7 days with entries from invited 'professionals' and from photographers willing to fund their own entry. The pinnacle of the photosub competitions is the World Championships organised by the CMAS every two years to which national federations (e.g. the BSAC) are invited to submit portfolios from suitably qualified photographers for team selection. In this context suitably qualified means those who have proved their

SHARK ATTACK!
Some competitions have a humorous category which helps lift the tension a little at the big events. This shot shows a diver about to become lunch to a hungry shark and has been fairly simple to achieve by making up a "mask" of the inside of the shark's mouth to go over *a 16mm fish eye lens – it was then just a case of positioning the diver within the jaws!*
Blue Dolphin of Malta, Mediterranean Sea, Nikon F801, 16mm f2.8 fish eye, Subal housing , Fujichrome 100, f8 @ 1/125. Lighting from one Subatec S100 manual flash gun set to half power.

work is of a sufficiently high standard through success in international competitions, either photosub or submission. The CMAS 50 Judges submission competition is often used for preselection purposes.

The pattern for the larger events is very similar and normally allows the teams and individuals one or two days familiarisation diving within the competition area prior to the event itself. Increasingly there are specific categories to fulfil (e.g. macro, wide angle, fish and creative) and there will be restrictions on the number of films and air available to both the photographer and model during the timed sessions. The teams will be rotated through the selected dive sites during the event to make the opportunities as fair as possible. Films are returned to the photographers daily so that they can assess their own successes and failures – to preclude the temptation to cheat, each film is normally video recorded to enable the organisers to

Diver holding an underwater globe. This was a shot taken during the 1994 CMAS World Championships of Underwater Photography held in South Korea. The shot was designed to captivate an image of the underwater world of South Korea which is represented by the blue and red "yin and yang" filter overlaid onto the globe. This symbol is found in the centre of the South Korean national flag and is a common symbol throughout the country. The shot is taken in two halves – 1) the globe with an 8mm circular fish eye lens with the coloured mask in front of it, and for 2) the film is rewound and advanced one sprocket to place the globe at the top of the frame. The diver and hands were then exposed at the bottom of the frame using a 20mm lens.

Cheju Island, South Korea, Nikon F801, Subal housing, foreground: 20mm f2.8 f16 @ 1/250 with Subatec S100 at half power, and centre: 8mm f5.6 Sigma fish eye f11 @ 1/60 with Subatec S100 at half power, Ektachrome Professional 100 film. This shot went on to collect fifth place in the competition.

check the entries before judging! Many of the European teams are very well organised and funded by their national federations. Often they will bring both models and assistants and even a team captain to help whilst the other end of the scale will see single photographers competing on their own. All, in theory, have an equal chance, especially in the individual categories, but it is a distinct advantage to have a model dedicated to you, particularly in the Mediterranean events where life is sometimes sparse for the wide angle category. There are awards in each category and overall awards for the best individual portfolio entry (generally the overall winner) and the best team entry, all calculated on the basis of points awarded to individual slides.

In order to increase your chances of success in a photosub you must ensure that your approach is well organised and that you prepare as much as possible in advance. Take the opportunity to research the location of the competition to determine the underwater topography, marine life, water temperature, visibility etc. Much of this can be gleaned from diving guides, dive centre brochures, magazine articles and best of all photographers or divers who have visited the area. With this basic information you can begin to plan some of your likely shots and even practice some of the compositions with your model. If there is a creative category then it is essential to practice your technique or idea before leaving for the competition. This can even be achieved in a swimming pool if you

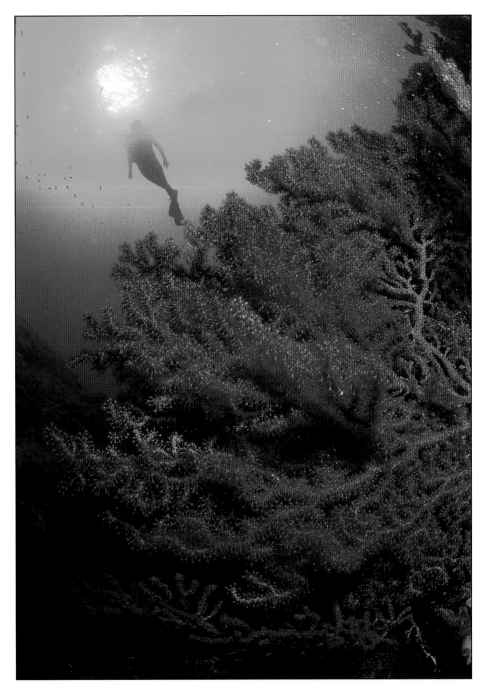

Left: Scorpion fish and kelp. This shot was taken at the annual 'Splash In' organised by the British Society of Underwater Photographers in Plymouth. A very popular event, but one which is rarely blessed with perfect calm conditions and good visibility. The competition has two categories – Open and Humorous. This shot is a double exposure which has produced a moody image with far greater depth than a 'straight' photograph of the same subject.

Plymouth, UK, Nikon F801, 60mm f2.8 micro and 16mm f2.8 fish eye, Subal housing, Fujichrome Velvia, f16 @ 1/250 and f5.6 @ 1/60. Lighting from one Sea & Sea YS50TTL flash gun with snoot on manual for the first exposure.

Above: Red gorgonian and diver. This shot was taken during the annual "Les Rendez-vous de L'emotion" photosub organised by Club Atoll on the island of Corsica. The nearby marine reserve of the Levezzi Islands has an abundance of these attractive sea fans. Classic simple compositions such as this are often more successful than more complex shots as they stand out on a light box during the initial judging.

"Les Rendez-vous de L'emotion", Corsica, Mediterranean Sea, Nikon F801, 16mm f2.8 fish eye, Subal housing , Fujichrome Provia, f8 @ 1/125. Lighting from one Subatec S100 manual flash gun set to half power.

Photographers preparing for a competition session from their boat during the 1996 CMAS World Championships of Underwater Photography in Minorca.

live inland or the sea conditions here are not suitable. Final practice sessions will be available on location, but it is of great benefit to arrive a few days early if time and budget allow – you will certainly not be on your own as many of the big teams will arrive a week or more in advance of the prestigious competitions.

It is best to have a working plan or shot list to work to as you will be operating under intense time pressure. Sessions are typically two per day of 1.5 to 3 hours duration with 2-3 films to be exposed per day and you are likely to change location with each session. Time and the allocated air soon runs out, especially if you are making multiple dives for multiple exposures in the creative category, so it is of great benefit to have more than one camera system available with different lens combinations to save time and to capture anything unusual during the dives.

These events are extremely hard work, but also have an immensely enjoyable social side to them with the chance to meet photographers from other nations and discuss techniques and experiences. They are a

real challenge, can be expensive to reach and generally do not bring instant success. However, they will teach you to focus your skills, preparations and techniques and you will benefit greatly from the experience of others and see for yourself how those winning images are achieved.

Regular photosub events include: BSoUP Splash In; Isle of Man Splash In; St. Abbs Splash In; Blue Dolphin of Malta; World Cup of Ustica; Les Rendezvous de l'Emotion in Corsica; the Egyptian National and Open Festival in Sharm el Sheikh; Flores Underwater Festival in Indonesia; Land of Adventure Underwater Photography Competition in Papua New Guinea; the Subios Festival in the Seychelles; the Nikonos Shoot Out series in the Caribbean; the CMAS World Cup.

Fish Hunt Competitions

Photo-Fish Hunts are a relatively new concept in underwater photography but are fast gaining in popularity and the number of venues increase each year. They have their origins in the spear fishing centres of the Mediterranean which awoke (some would say belatedly) to the fact that damage to fish stocks caused by repetitive spear fishing competitions was almost irrecoverable. So the technique of hunting with a camera was developed as an alternative, which requires as much if not more hunting skills to get close to the fish.

Although these events are organised along similar lines to photosubs, there is only one category – fish. Essentially you are aiming to capture as many different

Yacht at anchor.
Some photosub competitions are entirely open and merely require the photographer to submit a portfolio of perhaps six slides. By including an unexpected underwater subject such as this you can make your portfolio more noticeable during the initial judging.

This shot was taken during the annual "Les Rendez-vous de L'emotion" photosub organised by Club Atoll on the island of Corsica.
Mediterranean Sea, Nikon F801, 16mm f2.8 fish eye, Subal housing , Fujichrome Provia, f8 @ 1/125. Lighting from one Subatec S100 manual flash gun set to eighth power.

Left: An enviable array of equipment on show as photographers prepare their cameras during the 1996 CMAS World Championships of Underwater Photography in Minorca.

Right: Scorpion fish. If the competition requires the submission of a portfolio, often in specific categories, include some simple well composed portrait shots. Marks are also awarded for technical perfection, so do not try to be too clever with all your submissions.
Cheju Island, South Korea, Nikon F801, 60mm f2.8 micro, Ektachrome Professional 100, f11 @ 1/60.

species as possible during the time allowed on the film available. The rules which dictate an acceptable picture and the award or forfeit of points are well defined. Free swimming species score more points than sessile and the whole fish must appear in the picture facing the camera and in sharp focus. Poorly focused or framed pictures will lose points, and if your entry includes too many unacceptable shots you can even acquire a negative score!!

You can improve your chances by researching the species which are likely to inhabit the location. There are a multitude of natural history and fishing publications to be studied for likely habitats and feeding habits which will assist you to find your prey. Once again it is beneficial to arrive early for the competition in order discover what the area has to offer, see where the best sites are likely to be and most important watch the local competition at work.

One word of warning, some of these events offer a further complication – breath held techniques only!! This is especially popular in the Mediterranean in order to mimic the spear fishing origins, but if like me you hardly ever touch a snorkel then some serious fitness training in open water is required if you expect to be able to stalk a fish underwater let alone take its photograph.

There are now regular fish hunt events in Europe (Malta, Sicily, Sardinia, Italy, France and Spain) and it is proposed to hold regular events in the UK with the BSoUP and St. Abbs Splash In's, so there is plenty of scope if this type of photography appeals to you. In order to collect advance information and entry details it is best to contact the national federations in the first instance – addresses and contacts are available through the BSAC head office.

If there is one thing I think I have learnt from successes and many failures in competitions it is that you should aim not to be too clever with your entry. The winning photographs are nearly always the simplest in terms of composition, style and subject matter. They are the most striking and colourful and will instantly jump off the judges light box during their first review of the entries. So don't become too concerned with searching for that unusual subject or the most difficult technique, think more about the colours, contrast and composition of some of the most obvious and most photographed subjects and you may well produce that winner!

Dive Plan:
NB. Schedule may change following practice days and allocation rota of sites.
Assume 6 films over 3 days, two tanks each per day.

DAY	DIVE NO.	FILM NO.	SUBJECT	LENS/COMMENTS
1	1	1	slide frame b/g straight macro + blue b/g	60mm
	2	2	cave reflection straight shots or with slave	16mm
2	1	1 3	slide frame centre shot straight macro + D/E F/G's for star/B	16/mask/20 port
	2	4 3	straight WA shots cave reflection D/E B/G's with star burst	16mm 20mm + star burst
	3	5	? time/air, straight macro & D/E F/G's F/Gs	60mm
3	1	5 6	straight macro & D/E F/G's straight WA, slave torch, cave reflection etc.	60mm 16mm
	2	6 5	straight macro/fish portrait, re-shoots D/E B/G's (classic, cave entrance sun spot)	? 90/180 for fish 16mm

Above is a typical dive plan you might compile for a photosub competition.

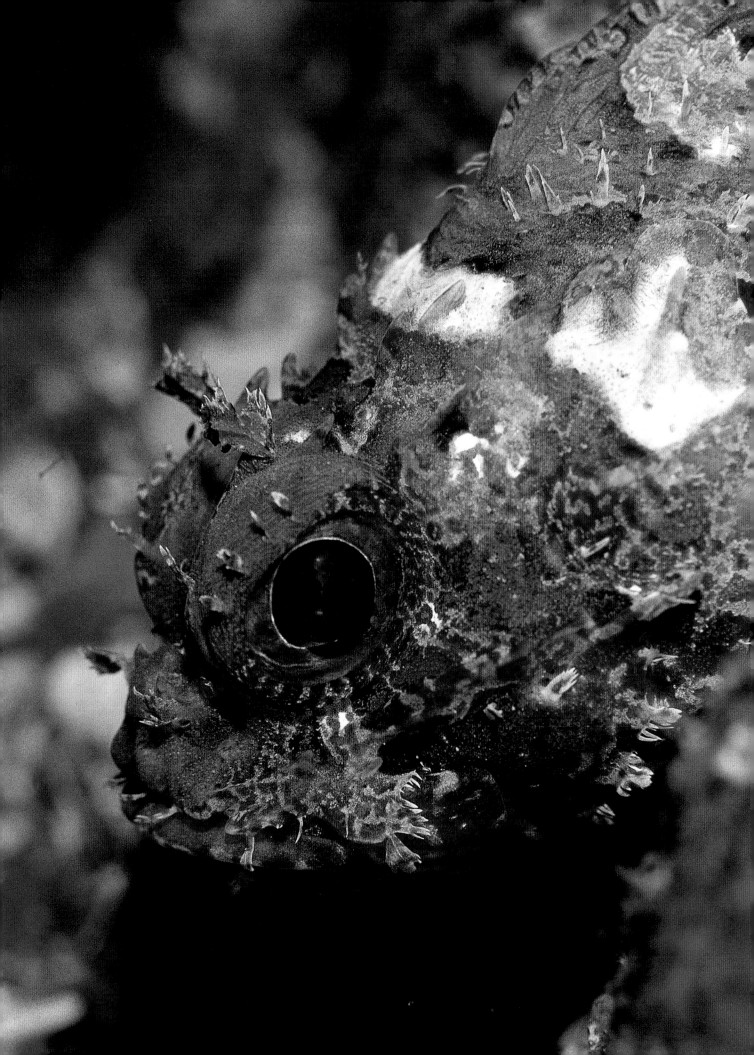

CAMERA MAINTENANCE

Water, particularly salt water, is an extremely hostile environment to take any type of mechanical equipment into. Although our amphibious cameras, housings and flash guns are designed to keep water out and operate under these harsh conditions they will not do so forever unless a little tender loving care is applied at regular intervals to keep control of that marine attrition. The same basic principles will apply to both amphibious cameras and housed systems containing manual or the latest auto focus models, although the hazards of even a minor flood for the latter are much more dangerous as water and electronics generally do not mix!

The best approach is to establish good basic procedures for 'every dive' maintenance backed up with regular detailed attention and your camera system should then last you a lifetime. You may even want to plan more advanced servicing and maintenance which is not as complicated as it may first appear. For those with slightly less confidence or time there are a number of specialist suppliers and service agents who will undertake those longer term complete overhauls.

Preparing for a Photo Dive

When planning to take your camera on a dive, be it a single day out or part of an extended trip, the first step is to ensure that you have enough time set aside to attend to the preparation of your equipment. More cameras and flash guns have been flooded by inadequate or rushed preparation than any 'O' ring or structural failure. Even the experts and professionals flood their equipment and it is almost always due to something forgotten in the haste to get into the water to chase that special shot. So find a clean area, decide what lens and film combination is required for the dive and then commence a set of routine steps to prepare the camera system for the water. Listed below is a suggested procedure which should help to establish your own requirements:

Remove the main 'O' rings from the back plate (amphibious camera or housing) and lens or port. Clean the 'O' ring seats thoroughly with a cotton bud or the edge of a paper kitchen towel. Now clean each 'O' ring by wiping it with a paper kitchen towel and

Washing camera equipment after a dive. Whenever possible it is always preferable to completely immerse your equipment to soak it, rather than just rinsing under a running tap. Soaking allows the salt crystals which build up around controls to dissolve. Finish off with a final rinse.

Make sure that "O" ring seats are cleaned regularly. Cotton buds are ideal for this purpose.

When removing an "O" ring try to squeeze it out rather than using a tool to dig it out of the seat. If you do need to use a tool then make sure that it is blunt so as not to damage the "O" ring.

Use only a small amount of silicone grease to lubricate the "O" ring. The grease is used merely to lubricate the rubber – too much will only attract grit, hairs and dust.

146

Grease the "O" ring by running it through your fingers through the dab of grease.

Once the "O" ring is cleaned and greased carefully put it back into the seat – in this case the backplate of a Nikonos RS.

Once all the greasing of your camera/housing is complete, load the film. By doing this last you will avoid getting grease on the film which can damage internal camera parts.

Always remember to rewind the film before you open the camera!! Everyone will make this mistake at some point, but if you stick to an established routine for stripping and preparing your camera you can help to avoid this disaster.

A strong carrying case is a must for travelling with your expensive camera equipment. Various designs are available in resin, fibre glass, plastic or aluminium. They may appear expensive at first but are a wise long term investment.

Equipment packed for travel. Packing for a photo trip can be a bit of a jigsaw! Watch out for potential abrasion between items or items being crushed by the closure of the lid.

then re-grease each one. Many people make the common mistake of assuming that more silicone grease on the 'O' ring will produce a better seal. Wrong! This will only attract more in the way of dirt and debris – the 'O' ring should only be lubricated lightly until it shines by putting a dab of grease between you thumb and forefinger and then gripping the 'O' ring as you pull it through. Replace the 'O' rings and, if using a housing, install the camera and connect the hot shoe.

Prepare your flash gun or flash housing in the same way, remembering to fit fresh batteries if necessary.

Before loading a film in the camera, connect up your flash gun, having cleaned and greased the connector 'O' ring, and test fire it. This way if you have a malfunction you will not unnecessarily waste film as you test the system. If you have a TTL flash system it is wise to also check that this is functioning correctly at this point. This is simply done by setting the flash and camera to TTL, setting the lens to a medium aperture (say f8 or f11) and pointing the gun straight into the lens from 15-20cm. When the flash is fired from this range then the TTL indicator on the gun or in the viewfinder should indicate that the shot was OK and TTL has functioned correctly. The flash should also recycle almost immediately indicating that it has not fired on full power and that TTL control has functioned.

Once you are happy with the flash you can load your film and check it is advancing correctly – also confirm you have the correct film speed selected on the camera! Close up the camera back or fit the back plate of your housing with a final check that the 'O' is clean and seats properly as you close-up and latch.

Now you are ready to assemble the remainder of the system. Connect flash arms, base plates, aiming torches etc. and check their functions. Give the lens or port a final polish and the system should be ready for the water.

Post Dive Maintenance

With the correct preparation your camera system should have survived the dive intact and dry inside. However, it is after the dive some of the greatest potential damage can occur as the water evaporates and leaves behind salt crystals which will cause corrosion, dry out 'O' rings and eventually cause leaks if not properly washed off. This is particularly important if you are diving in tropical water with a

high salinity, such as the Red Sea, where the water will evaporate quickly leaving large crystals which are especially invasive.

The best treatment is to submerge the system totally in luke warm fresh water to soak for a while and then work all the controls to ensure that the salt water is fully flushed out. You can then finish off with a general rinse under running water before leaving the system to dry. If soaking is not immediately available then a quick rinse under running water will suffice in the interim, but the system should be soaked when the opportunity arises. If you are on an extended trip going through this operation after each dive, it is still worthwhile soaking all your equipment once again when you return home as the water in the rinse buckets at dive centres or on live aboards quickly becomes contaminated with salt from other equipment. Between dives prepare your camera system as described above.

General Maintenance

Many photographers use their equipment in short intensive bursts, such as a week's live aboard trip, or regularly for a few months during a summer diving season. During these periods the pre and post dive maintenance is normally sufficient to keep your system up to scratch. However, when the time comes to store the equipment for a period or the equipment has been in regular use for some time then it is a good idea to extend your maintenance procedures to ensure all will be working when next required. The suggestions below are not gospel, but once again I hope will aid you to establish your own procedures for your system:

If you are storing your equipment for any length of time it is best to remove all 'O' rings. If they are left in place with the camera or housing closed they will become squashed and deformed and retain that shape, which could have disastrous consequences. For 'O' rings which are difficult to remove with your fingers, use a blunt instrument to ease them out – never a knife point or pin as this will cut the 'O' ring. Clean and grease them and store in a zip lock plastic bag. Make sure you mark the bags with the origin of each 'O' ring if they are similar in size and section.

Do the same for all leads and connectors and then clean and grease all threaded shafts, locking catches, baseplate attachments etc. Use a silicone spray or silicone grease and this will ensure that items do not seize during storage. Electrical contacts can be cleaned with a pencil eraser or, if inaccessible with a proprietary electrical spray cleaner.

It is best to remove all batteries in case of leakage during storage. Before removing them from your flash, turn it on to let it charge up then remove the batteries without firing. Flash gun capacitors are best stored charged. If you use Ni-Cad batteries it is best to fully discharge them and then fully charge them for

storage, this will help them retain their 'memory' of being fully charged.

Check ports for scratches. If your ports are perspex then it is possible to polish out the scratches using 'T' Cut (abrasive car polish) or Brasso, finishing off with toothpaste for a really smooth finish. If you have a glass port which is scratched then there is not much you can do with it. Small scratches will fill with water when you dive and often will not be noticeable in your pictures. However, deep scratches will show and will require the replacement of the port.

Clean lenses with a lens cloth or proprietary cleaning fluid and remove dust from the inside of the camera body, especially around the film transport mechanism and pressure plate. You can use a camera blower brush for this or one of the canned compressed air products from photo shops.

Your system should now be ready for storage in a dry dust free environment, either a cupboard or a camera case will do nicely.

Longer Term Planned Maintenance

Just like a car a schedule of routine maintenance supported by regular detailed servicing will ensure that your camera system won't let you down at the crucial moment. The frequency of these services will be largely dictated by how much you use your equipment and how well you conduct your routine pre and post dive maintenance. If you are only using your system occasionally, say for an annual overseas trip, then you can probably plan to service your camera or housing every eighteen months to two years. If you use your system more frequently then an annual service is probably advisable.

Whether you have an amphibious camera (Nikonos or Sea & Sea) or a housed system, the objective is the same – to dismantle, clean and grease the 'O' rings and control shafts which are inaccessible during routine maintenance. These are the areas which will gradually dry out or suffer from a build up of salt crystals on shafts or under controls which eventually work their way past a seal and cause a flood.

It is perfectly feasible for the 'amateur' technician to strip and service his or her own equipment given reasonable manual skills, the correct tools and guidance from a handbook. These guides tend to be written by independent photographers, who have developed their own procedures, rather than the manufacturers. There are several excellent publications with procedures supported by illustrations and photographs for the Nikonos and Sea & Sea owner and servicing kits are available either from the manufacturer or from specialist dealers. I will not attempt to guide you through the individual systems here, but simply recommend that you consult books such as 'A Manual of Underwater Photography' (De-Couet and Green), the Nikonos Book series (Jim and Cathy Church) and How To Use Sea & Sea

(Joe Liburdi and Cara Sherman) all of which provide sufficient guidance if you have the courage.

If you own a housing then the prospect of a full strip down and service is perhaps not so daunting. Controls, shafts and 'O' rings are larger and more accessible although you must be cautious not to break components whilst dismantling the housing – housing designs and manufacturers come and go frequently and it is not always possible to get spares. Whether you are stripping a camera or housing adopt a methodical approach. Keep a series of notes as you strip a component detailing spring positions and the orientation of controls on shafts. Place parts into individual containers (ice cube trays are good for this) so that parts do not get mixed up during reassembly. Replace all accessible 'O' rings and clean and grease those that cannot be removed by coating the cleaned control shaft with grease and running it back and forth through the seal.

Occasionally you will encounter seized controls or attachments, especially where stainless steel or brass is mixed with aluminium. Do not try to free these by force as it will inevitably end with either the bolt/screw shearing off or the thread stripping in the camera /housing. I have found that soaking parts in warm water with a little vinegar normally helps dissolve the corrosion deposits. Having done this apply WD40 or Plus Gas and leave the parts whilst this penetrates. If the parts still refuse to come apart then you can try applying a little heat with a heat gun and try to free the parts as they expand. This treatment is a last resort, heat should not be excessive and should not be used anywhere near plastic parts or very fine control rods for obvious reasons.

If the prospect of this effort and responsibility fills you with horror then the easy alternative is to pack your kit and send it to a specialist service centre or dealer and let them deal with the potential problems! A full service appears to be expensive at first, but if it saves you from a flood then it is money well spent. Most service agents return the equipment pressure tested and with a short term guarantee which gives you time to test the equipment before your next trip.

Travelling With Your Equipment

In my view protecting your equipment whilst travelling is a key requirement in your preventative maintenance procedure. All that effort will be totally wasted if your equipment is damaged in transit to that exotic location you have saved for months to afford. Strong equipment cases with plenty of foam padding internally should be used. The injection moulded resin cases are some of the hardiest (e.g. Pelican, Underwater Kinetics etc.) although aluminium and plastic are also suitable dependant on their contents and how you travel. Fragile items, such as lenses, should be wrapped individually in foam or felt to prevent them chaffing against other equipment.

When packing the cases consider that you may well have to unpack them all for a security or customs inspection – repacking a complete jigsaw can be very frustrating and stressful especially if you are running a little late for your flight!

If you are travelling by air it is always preferable to hand carry expensive camera equipment as cabin baggage. However, airlines are becoming increasingly strict on the allowable size and weight of hand baggage, so it is sometimes necessary to place it in the hold. If this is the case then pack your equipment very carefully with extra padding around individual items even if this means using additional equipment cases – you have to imagine not only the rough treatment it will receive during handling, but also the weight of all the other baggage on top of it in the aircraft hold! It is wise to lock or padlock each case and add a luggage strap to each in case of a failure of a hinge or latch on the journey. Covering hold baggage with stickers identifying it as containing photographic equipment is obviously not wise.

Whether your equipment travels with you in the cabin or in the hold, there is one very important action not to forget whilst packing the equipment – remove at least one main 'O' ring from each camera, housing or flash gun. Even the cabin pressure will be slightly less than atmospheric pressure at sea level and unless this differential is allowed to equalise in your equipment small 'O' rings can be displaced by the now higher pressure in your equipment. Many photographers have suffered thinking that their equipment cases are 'pressure proof' because they have an 'O' ring in the lid, only to find that a camera or flash floods on the first dive via an unseen 'O' ring dislodged on a cable gland or control shaft.

Protecting Your Equipment on a Photo Trip

So you have arrived for your one day dive excursion or that long awaited live aboard trip to coral seas, but your troubles are not over yet! More often than not you will be joining a group with mixed interests and perhaps assisted by a crew who have little appreciation of the fragility of you expensive camera equipment. In order to ensure that your precious equipment survives the first day let alone a week you must take some basic precautions and offer some guidance to your fellow divers and crew.

Here are a Few Tips for a Happy Trip

Make sure that anyone likely to handle your camera system (crew or divers) knows how to lift it and hold it correctly – I have witnessed more than once camera gear being hauled in by the flash lead. If you use the flash arm to lift the system then make sure it is attached securely before you enter the water and at the end of a dive – if it parts company then the camera hits the deck!

If you are diving from a small boat, RIB or inflatable try to carry your system in a brightly coloured plastic storage box with foam padding and find space for it at the stern of the boat (less slamming movement here). Make sure everybody knows it is there and that it should be placed in the box immediately it is handed back into the boat after a dive. These boats are always cramped and heavy equipment is constantly dropped or falls over especially when deploying and recovering divers. By taking these precautions hopefully you will avoid errant feet or worse still a weight belt or cylinder making contact with your camera system.

If you are on a live aboard then find a safe storage area which will not allow your equipment to fall to the deck if the boat rolls. Many boats provide 'cubby holes' for photographers with charging points which is very convenient until items begin to roll out – make sure everything is chocked to prevent movement when the boat is beam onto the swell. Often the best place for your system between dives is on your bunk well supported by blankets and towels.

Be wary of leaving your system in direct sunlight as the internal pressure in cameras and housings can rise rapidly. This could cause condensation on lens elements or ports when you enter the cooler water, or worse a flood from a popped 'O' ring seal. Keep your equipment cool by covering it with a towel when you bring it on deck for the dive.

If you are making a safari style trip, such as those popular in the Red Sea, then you must take extra precautions for the preparation of your equipment. There is almost always a breeze on the coast which will carry fine sand particles. Make sure you prepare your equipment inside you safari vehicle or inside a tent on a clean surface. It is best to bring a small table cloth to lay out when you change films and clean 'O' rings and bring plenty of small plastic bags for storage of clean items. Washing your equipment after a dive is even more important under these conditions as you have sand and salt to contend with. Fresh water is often at a premium on these trips so make sure that there is sufficient allowance for photographers when you book.

The above listing is by no means exhaustive and will probably seem daunting to consider at first. However this cautionary approach is more than worthwhile as it will ensure the survival of your equipment and you peace of mind. More importantly it ensures that your equipment remains intact to bring back those stunning images of the underwater world.

EQUIPMENT SUPPLIERS

Aqua Vision Systems
7730 Trans Canada Highway, Montreal (Quebec), Canada, HT4 1A5
Tel 514 737 9481 Fax 514 737 7685

Adorama
42 West 18th Street, New York, NY 10011, USA Tel 212 741 0052 Fax 212 463 7223

Aquatron
Mainzer Landstrasse 4a, 5439 Irmtraut, Germany Tel. 064 36 3638

B & H Photo and Video
119 West 17th Street, New York, NY 10011, USA Tel 212 242 1400 Fax 212 242 1400

Hartenberger
Rennebergstrasse 19, D-50939 Koln, Germany
Tel 0221 41 5000 Fax 0221 41 5050

Berger Bros
209 Broadway (Route 110), Amityville, NY 10011, USA.
Tel 516 264 4160 Fax 516 264 1007

Hugyfot
CH 8700 Kusnacht, Zurich, Switzerland
Tel 910 5886 Fax 910 8086

Kevin Cullimore (flash gun housings)
7 Mount Echo Drive, Chingford, Essex, UK
Tel. 0181 529 6493

Ikelite
50 West 33rd Street, PO Box 88100, Indianapolis, IN 46208 Tel 317 923 4523

Cameras Underwater
East Island Farmhouse, Slade Road, Ottery St. Mary, Devon, EX11 1QH, UK
Tel 01404 812277 Fax 01404 812399

Isotecnic
Via Milano 177, 37014 Castelnuovo, D/Garda VR, Italy
Tel 045 6450480 Fax 045 6450477

Current State Diving
8-10 Kellaway Avenue, Redland , Bristol, BS6 7XR, UK Tel 0117 944 2102

Nikon (UK)
308 Richmond Road, Kingston Upon Thames, KT2 5PR Tel. 0181 541 4440

Greenaway Marine
Basset Down, Swindon, Wilts, SN4 9QP, UK
Tel 01793 814992 Fax 01793 813973

Nikon (USA)
PO Box 6948, Melville, NY 11775-6948, USA

Helix
310 South Racine Avenue, Chicago, IL 60607, USA Tel 312 421 6000 Fax 312 421 2804

Nexus (Anthis)
1-16-1 Yabuta, Okazaki, Aichi 444-21, Japan
Tel 81 564 25 3937 Fax 81 564 25 2205

Oceanic Products
Pelagic House, Mink Bridge Estate, Dunkeswell, Honiton, Devon, EX14 0RA, UK
Tel 01404 891819 Fax 01404 891909

Sea & Sea (UK)
Phillip House, Aspen Way, Paignton, Devon, TQ4 7QR, UK
Tel 01803 663012 Fax 01803 663003

Ocean Optics
Ocean Leisure, Embankment Place, Northumberland Avenue, London, WC2, UK
Tel. 0171 930 8408

Sea & Sea (USA)
2105 Camino Vida Roble, Suite L, Carlsbad, CA 92009, USA.
Tel 619 929 1909 Fax 0098

Underwater Images
216 Uxbridge Road, Shepherds Bush, London, W12 7JD, UK Tel 0181 743 3788

Seacam
A-8570 Voitsberg, Cv Hotzendorfstrasse 40, Austria Tel 031 42 22885 Fax 03142 228454

Videoquip
5 Foss Road South, Leicester, LE3 0LP, UK
Tel 0116 255 8818 Fax 0116 255 7725

Sealux
Peter-Dorfler-Str. 28, D-8960 Kempten, Germany Tel 0831 79427 Fax 0831 71865

Warren Williams (domes and housings)
30 Windmill Road, London, N18 1PA, UK
Tel. 0181 807 2596

Subal
PO Box 25, Leopold-Werndl-Str 31, A-4406 Steyr, Austria
Tel 43 7252 46424 Fax 43 7252 52651

Subatec
1093 La Conversion, Lausanne, Switzerland
Tel 021 39 2777

Subtronic
Postfach 1544, 7312 Kirchheim-Teck, Germany
Tel. 070 21 46480

Tussey Underwater Systems
5724 Dolphin Place , La Jolla, CA 02037 7519, USA Tel 619 551 2600 Fax 619 551 8778

UK Germany
Hermann-Lons-Strasse 9, D-6251 Beselich 1, Germany Tel 06484 6621

Ultralight
3304 Ketch Avenue, Oxnard, CA 93035
Tel 800 635 6611 Fax 805 984 3008

USEFUL ADDRESSES

British Society of Underwater Photographers
Chairman: Brian Pitkin,
12 Coningsby Road, South Croydon, Surrey, CR2 6QP

MARKETING YOUR PHOTOGRAPHY

Many photographers are satisfied with the achievements of taking a good underwater photograph, capturing an unusual species or displaying the wonders of the underwater world to family and friends or their diving/photographic club. But some of us, having reached a certain standard, will begin to see that there may be a market for our photography and so begin to contemplate how to make this enjoyable but expensive pursuit pay for itself. This is not as easy as it first seems despite the fact that the press, wildlife books and advertising seem increasingly to feature underwater images. The simple facts are that, in the majority of circumstances, the return on a published photograph is very low and there is an awful lot of competition from other talented photographers, some of whom are satisfied with merely seeing their work in print!

Although the ideal vision for many of us is to travel the world making a living from selling our photographs, the harsh reality is that this is only possible for a handful of photographers internationally and most of them will not rely solely on underwater photography for their income. However, it is not all doom and gloom, there is a market out there and if you accept its limitations you will find that there are ways of supplementing the cost of your hobby through sales of your photographs.

Although we will all see photographs published which we will consider dreadful in terms of subject, composition and quality, do not be fooled into thinking that the industry generally accepts these standards. Often bad photographs are published for no fee and if you want to be paid for yours you must ensure that they are of high quality in order that they stand out from the rest of the submissions. This means using only the best films (slow speed, low grain, good colour rendition – e.g. Fuji Velvia, Provia, Kodachrome etc.), ensuring your focusing, exposure and composition are faultless and only submit originals and not duplicates – unless this can be justified by the rarity of the subject or activity. When you take photographs, plan for publication and take several frames at each exposure and composition so that you have several originals to submit and keep on file. When reviewing your photographs try to be wholly objective and ask yourself "would I be satisfied

Diving magazines. The sport diving press has to be the best market for your work. However, many magazines prefer to have an accompanying article with photographs rather than look for copy which suits your shots. Perseverance is the key to getting published, but don't expect to make a living from selling your photographs to magazines.

to see this published" – if not, then it is not up to scratch, so throw it away. This is sometimes difficult, especially as the shots may have involved a lot of time and effort but if you are not harsh on yourself you will certainly find that picture editors are when your work is returned.

It is best to slowly and specifically to build up a stock of saleable shots and this is better done with a little forward planning rather than randomly on your dives. Shots which sell well often feature divers exploring the underwater world, interacting with marine life or undertaking some task, e.g. archaeology, recording marine species, photography etc. Marine life shots also sell well but the best of these are those which have impact and character rather than those which are generally identification shots. You should be looking for subjects which have striking colours and composition with plenty of contrast with the background whether they are fish, invertebrates or scenic shots. Wreck diving is popular with the majority of divers and therefore shots of divers exploring wrecks always sell well. This is just the sort of shot which needs to be pre-planned for success and you will need to use the correct

Brochures and book marks. Another potential market for your work is the travel market. There are literally hundreds of travel companies now specialising in diving trips and all produce a brochure of some description.

equipment with a dedicated model to assist to produce striking images.

What ever your intended market, ensure that you present your work professionally. Mount each slide in glassless mounts, label them clearly with appropriate details and your name and address and number them sequentially to match a full listing of your submission. Keep copies of the details of your submissions so that you will know which slide a client is referring to if he calls to request permission to publish, or wants more just like it! It is best to present your slides in 'view pack' files which can be directly viewed on a light box – this way your photographs are much more likely to be viewed when they arrive rather than later if they have to be removed from a slide box to be viewed.

Below is a listing of potential markets which are worth pursuing. However, you must be prepared to exercise patience with them as success is not guaranteed overnight – indeed you may wait years before a photo library finds a market for one of your shots!

Photo Libraries

There are a number of photo libraries which specialise in wildlife and water sports some of which are known to deal specifically in underwater images. Make an initial contact by telephone or letter to arrange to make a submission for consideration. Libraries will only retain the highest quality work on the best film emulsions – some even insist on only one emulsion! Expect to be asked to submit between 200-1000 slides initially, from which the library may retain a small proportion if you are lucky. Don't be put off by rejection, ask why your slides were not up to par, put it right and try again. Labelling and itemising your slides is very important so that the library does not have to identify species and locations when reviewing slides for a client. Fees are normally between 40-60% of the sale value to the client and often you will not be paid until the book/magazine has been published. Be warned, unless you have some very unusual shots, sales through a library can be very slow.

Diving Magazines

Magazines dedicated to sport diving are obviously one of the best markets for your photographs. There are several magazines to approach in the UK and more in Europe, the USA, the Far East and Australia. and all are worth targeting at some point in your sales push. Some magazines like to keep a small stock library of shots whilst others will request a particular type of shot from known photographers when a need arises. Whilst these magazines are always looking for good photographs of divers and marine life, undoubtedly the best way of selling your shots is when they accompany an article. This gives the magazine a package to work with and the editor does not need find a suitable piece to use your shots with. If you are not keen or able to write your own articles then consider teaming up with someone who is and split the potential profits. Review the magazines for the type of feature which appeals to the editor and then expand your ideas from there. Once you have a subject in mind you can then shoot specifically for it if your own stock library has nothing suitable. Remember to vary the format and composition of your shots to suit the coveted front cover shot – having your picture on the front cover is not only a sign of success but also pays well!

Wildlife/Sports/Fishing/Photography Magazines

Other magazines will have requirements for underwater photographs on a surprisingly regular basis. Keep submitting and ask for their requirements list for any specific shots. Some hold small stock libraries whilst others prefer to send out requests. The aim is to get the features editors familiar with your name and work. Photography magazines occasionally run pieces on unusual photographic pursuits or specifically on underwater photography, or they may run 'gallery' style features of photographers work. All offer publication potential.

Left: Postcards. Producing postcards of your favourite shots can produce a small income.

Right: Manufacturers' brochures. All manufacturers require illustrations for their brochures so it is worthwhile approaching individual companies if you have shots of their products. You may not always be able to sell the photographs, but often you can barter for equipment or discounts.

Advertising Agencies

Advertising agencies most often source their requirements from stock photo libraries. However, occasionally they have very specific requirements and it is worth approaching those that specialise in image manipulation which may require underwater images for background or detail work. Some agencies also distribute requirements lists to their registered photographers.

Holiday Companies

Diving holiday companies all produce brochures some of which are works of art and others are definitely produced on a tight budget. All have one thing in common, they rarely pay for photographs as so many of their clients submit photographs to them. However, if you have some appealing shots, perhaps even featuring their boats or dive centres it is worth approaching the operator. If he wants your shots, then you may be in a position to negotiate a discount for your next trip!

Diving Equipment Manufacturers

Most manufacturers produce brochures of their products but increasingly these are studio based or use computer enhanced and manipulated images. If you have shots which feature a product strongly then it is worth submitting it to the manufacturer for consideration, perhaps with some background shots suitable for dropping the products or divers using them onto when the next brochure is produced.

Post Cards, Greetings Cards and Calendars

This is a very difficult market to break into, although pictures of marine mammals (dolphins, whales, seals etc.) do sell well, but returns are low. Try visiting one of the Tourism Retail Trade Fairs around the country with a portfolio of your work to show to the card manufacturers and distributors. You can consider producing your own post cards or greetings cards to sell direct to dive shops etc., but often you will find that the profit margin is exceedingly low, if not non-existent, when you add up production, marketing and distribution costs!

Selling Your Prints Direct to the Public

If you still have time on your hands then you can consider putting together a small exhibition of your work to try and generate sales either to the general public or to the sport diving community. You will find that banks, restaurants and small galleries are often willing to host small exhibitions, sometimes for a percentage of sales. Or you could aim to show them at one of the diving trade fairs or national diving conferences, although the cost of stand space may be prohibitive – consider approaching another exhibitor (e.g. holiday company, manufacturer etc.) offering to decorate a stand with your prints in return for displaying your order forms or even selling from the stand.

No doubt the thought of pursuing some or all of the above markets will be daunting to many. Selling your photographs is very hard work and requires large amounts of persistence, patience and the ability to take rejection stoically. When you eventually succeed and see your work in print the pride and feeling of success will make it all worthwhile and more importantly the fees will enable you to justify that next diving trip or equipment purchase to your doubtless long suffering partner!

BIBLIOGRAPHY

Creative Techniques in Underwater Photography
D.Berwin and D. Barber – Batsford Press

Beginning Underwater Photography
Jim and Cathy Church – Jim and Cathy Church Publishing

Underwater Strobe Photography
Jim and Cathy Church – Jim and Cathy Church Publishing

The Nikonos Book
Jim and Cathy Church – Jim and Cathy Church Publishing

A Manual of Underwater Photography
H. De Couet and A. Green – Hemmen Press

Light in the Sea
David Doubilet – Swan Hill Press

Pacific
David Doubilet – Bullfinch Press

Manfish with Camera
Gerry Greenberg – Seahawk Press

A Manual of Underwater Photography
T. Glover, G. Harwood, J. Lythgoe – Academic Press

Successful Underwater Photography
Howard Hall – Marcor Publishing

Fish Watching and Photography
Kendal McDonald – John Murray Publishing

Underwater Photography (macro and camera basics)
Gerry Murphy – Santa Ana/PADI

Within a Rainbowed Sea
Christopher Newbert – Beyond Worlds Publishing

Sea of Dreams
Christopher Newbert – Beyond Worlds Publishing

The Living Sea
Linda Pitkin – Fountain Press

The Underwater Photographers Handbook
Peter Rowlands – McDonald Press

Underwater Photography
Charles Seaborn – Amphoto

How To Use Sea & Sea
Joe Liburdi and Cara Sherman – Orca Publications

Underwater Photography for Everyone
Flip Schulke – Prentice Hall

Coral Reefs, Natures Richest Realm
Roger Steens – Letts Publishing

Underwater with the Nikonos and Nikon Systems
H.Taylor – Amphoto

Underwater Photography
John Turner – Focal Press

Basics of Underwater Photography
Doug Wallin – Amphoto

ACKNOWLEDGEMENTS

Over the years many kind souls and companies have helped and supported me in my efforts to produce some superb images either for pleasure, competition or publication. I would like to take this opportunity of extending my thanks as they have all played a part in the production of this book. If I have omitted anyone in this list it has not been intentional: Amanda Levick, Rachel, Lynne, Sue, Alison and Christine at Oonasdivers. Martin Parker at AP Valves, Helston, Cornwall, UK. Peter Oakes and the staff of the Oonasdivers dive centre in Sharm El Sheikh. Martin Woodward at Hydrotech, Stoney Cove, Leceister, UK. Bill Bowen, Skipper and often diving buddy of Mounts Bay Diving and MV Son Calou, Penzance, Cornwall UK. David Chandler at Sea & Sea Ltd, Paignton, UK. Nick Davies and the staff at Captain Don's Habitat, Bonaire. Peter Rowlands and Steve Warren at Ocean Optics, London, UK. Nigel Eaton and the editorial team at Diver Magazine, Teddington, UK. Arnold Stepanek at Subal, Austria. Udo Fischer, Skipper and crew of the Dive Runner, Red Sea. Graham Armitage at Sigma UK Ltd. Terry Warner at Dolphin Diving and the crew of MY Jaariya in the Maldives. Elaine Swift at Nikon UK. Caroline Cameron and Edmond and Cristine Cridel at Club Attol in Corsica. Benny Sutton at Underwater Images, London, UK. John and Mike Anselmi at the Portkerris Diving Centre, Lizard, Cornwall, UK. Clive Fletcher at Crystal Seas Scuba in Minorca. Members of the British Society of Underwater Photographers. Members of the Cornish Society of Underwater Photographers. To Harry Ricketts and Grant Bradford for their guidance and enthusiasm for this book and helping me achieve one of life's ambitions. To Peter Scoones, whose work has provided inspiration to me, for kindly writing the forward to this book. Most of all to my wife Susanna for learning to dive so that she could join me on many of the trips and competitions and for the seemingly limitless patience to swim around once again for one more shot!

GLOSSARY

Aberration
Any optical defect in a lens which causes blurring or distortion of the image.

Absorption
In underwater photography this term generally refers to the selective absorption of the warmer colours of the light spectrum as depth increases.

Ambient Light
This term refers to the natural sunlight available to the photographer.

Angle of Coverage
This describes the angle of coverage which a particular lens 'sees', expressed in degrees – e.g. a 20mm wide angle lens has a wide angle of view covering a picture angle of approximately 94°

Aperture
This is the eye or iris of the lens which allows light to reach the film when the shutter has been opened. It is in effect an adjustable hole, calibrated in 'F stops' generally in the range F22 to F2.5 – the larger the F stop number the smaller the hole and conversely a lower F stop number indicates a larger aperture.

Apparent Distance
Subjects seen through a diving mask (effectively a flat port) will appear to be 25% closer than they actually are due to refraction.

Artificial Light
Any light source that you carry with you – in underwater photography this is generally electronic flash or strobe.

ASA
America Standards Association – This term is used to express film speeds, e.g. slow film 25ASA

Attenuation of Light
The weakening and dispersal of light due to the combined effects of reflection, scatter, diffusion and refraction.

Auto Focus
An auto focus camera together with the correct system lenses will focus automatically on your subject.

Backscatter
Particles which are suspended in the water between your camera and your subject will reflect light from your flash towards the lens. Avoid positioning your flash gun close to the camera lens pointing straight at the subject – light from a oblique angle so that light is reflected away from the lens.

Centre Weighted Metering
Light is read from the centre of the film plane – the most common design and found on many SLRs and the Nikonos IVa, V and Sea & Sea Motormarine

Chromatic Aberration
This is the break down of light to it's constituent parts, i.e. colours. Often seen at the edge of a picture as a rainbow effect when a lens has been poorly corrected for underwater use.

Close Focus Wide Angle
A classic technique in underwater photography using an ultra wide angle lens. The main subject is no more than 15-20cms from the lens lit by flash balanced with the natural light in the background of the picture.

Close Up Dioptre
An additional supplementary lens which fits to the front of the prime lens on the camera to reduce the minimum focused distance. The strength of the lens is expressed in dioptres, e.g. +1, +2, +3 etc.

Colour Balance (film)
This refers to the sensitivity of a particular film emulsion to particular colours. For instance, some films reproduce reds vividly, whilst others are better with blues or greens.

Colour Compensating Filters
Filters which are used to correct the blue or green cast of sea water when taking natural light photographs, e.g. CC30 red, CC60 red etc.

Colour Temperature
The temperature of daylight is expressed in degrees Kelvin – approx. 6500°K. Flash guns are tuned to either match this temperature, or often to be slightly warmer, e.g. 5700°K.

Concentric Dome Port
A hemispherical dome, or section of it, which is used to optically correct the angle of view of a wide angle lens underwater.

Contrast
The definition between various elements within a picture due to colour, texture, shading or position.

Depth of Field
The area both in front of and behind the subject on which the lens is focused which will also be in focus at a given aperture. Smaller apertures generally increase the depth of field in a picture.

Diffuser
Opaque plastic cover fitted to the front of a flash gun to spread and soften the beam of light. Fitting a diffuser reduces flash power between 1-2 stops.

Diffusion of Light
The loss of light intensity and quality due to suspended particles in the water between the camera and subject.

Distortion
Any unnatural reproduction of a subject due to lens construction or poor correction of optics underwater, e.g. barrel, pin cushion, forced perspective.

Double Exposure

Making two or more exposures on an individual frame of the film.

Effective F Stop

When using extension tubes or an extended macro lens, the light path to the film is lengthened and the light reaching the film reduced. This results in the 'effective' F stop being smaller than that selected on the lens, therefore requiring more exposure.

Exposure

The moment you press the shutter release and allow a certain amount of light (aperture), for a known duration (shutter speed) onto film of a known sensitivity (film speed) and produce an image on the film.

Exposure Compensation

Many cameras provide a means of overriding the exposure selected by the metering system of the camera. Under or over exposure is selected in fractions of a 'stop' dependant on the desired result.

Exposure Latitude

The range of over or under exposure that a given film will accept and still produce an acceptable picture. Slide films have a very low exposure latitude whilst negative films have a far broader latitude.

Exposure Mode

Some cameras allow the photographer to select alternative exposure modes, e.g. shutter priority, aperture priority, programme mode.

Exposure Table (flash)

A table compiled using the guide number of a flash gun to calculate the correct aperture to use at a given distance from a subject.

Extension Tubes

A light tight tube that fits between the lens and the body of the camera to reduce the minimum focused distance of the lens and increase therefore the magnification of the subject.

Fill Flash

Balancing the power of a flash gun to match the exposure of a natural light exposure to add colour and fill shadows.

Film Format

The size of the negative or transparency produced by the film in use, e.g. 24 x 36mm (35mm), 60 x 60mm (large format).

Film Speed

The sensitivity of a film to light expressed in ASA or ISO, e.g. slow film 25ASA or fast film 400ASA.

Filter

A piece of optical quality glass, plastic or gelatin placed in front of the lens either to correct colour loss, add colour or introduce a special effect to an image.

Filter Factor

When using a filter in front of a lens the amount of light reaching the film is reduced. This affects the exposure required, generally requiring additional exposure. The filter factor refers to the extra exposure required for a particular filter.

Fish Eye Lens

An ultra wide angle lens with an angle of view between 160° and 220°.

Flat Port

A flat perspex or glass port through which the lens views the subject underwater. Best suited to lenses with longer focal lengths (e.g. 50-100mm) due to the effects of refraction.

Focal Length

This is the measured distance from the lens to the plane of focus (the film) when the lens is set to infinity. The focal length of a lens is then expressed in millimetres.

F Stop

The term used to describe the graduation of the various aperture sizes for a given lens, e.g. f22, f16, f11, f8 etc.

Grain

The particle structure of a film emulsion. A slow film will have a fine grain structure whilst a fast film will have a larger more visible grain.

Guide Numbers

The power of a flash gun is expressed as a number to enable the photographer to calculate a correct exposure with a given film speed at a particular distance from the subject.

Hot Shoe

The flash connection on top of an SLR pentaprism

ISO

International Standards Organisation
– Film speeds are sometimes expressed in ISO degrees with the ASA rating, e.g. 100ASA/ISO 21°.

Ivanhoff Corrector

A water contact corrective port designed for individual lenses, not generally found on commercially available housings.

LED

Light emitting diode
– found in camera viewfinder displays.

Lens Speed (fast lens)

The maximum aperture of a lens, e.g. f1.5 indicates a fast lens which can operate in low light levels, conversely a maximum aperture of f5.6 would be a slow lens.

Light Meter

A built in or separate meter which indicates the correct exposure for a given selection of film speed, aperture and shutter speed.

Macro Lens

A lens, generally with a focal length of 50-200mm, which is able to focus from infinity down to a reproduction ratio of 1:1 or 2:1

Matrix Metering

The viewfinder area is divided into several segments and light read from them is compared to give a correct exposure. This type of metering is available on the majority of auto focus SLR cameras suitable for housing and on the Nikonos RS.

Matrix TTL Flash

Many TTL flash systems work only from a centre weighted sensor. The latest generation of auto focus cameras now feature matrix TTL sensors when used with the correct dedicated flash gun.

Modelling Light

A light built into or attached to a flash gun to aid aiming and focusing.

Multiple Exposure

See Double Exposure.

Negative Space

The picture area which surrounds the main subject of a picture. Good negative space compliments rather than distracts or dominates the main subject.

Neutral Buoyancy
When the buoyancy of the photographer or his equipment is trimmed to neither sink nor rise.

Neutral Density Filter
A filter which tones down the intensity of the light/intensity of all colours but does not affect contrast or colour reproduction.

Optical Viewfinder
A supplementary viewfinder attached to a Nikonos or Sea & Sea camera which indicates the picture area of the lens in use. Some are adjustable for the subject distance to account for parallax.

Over Exposure
Allowing too much light to reach the film, burning out detail.

Panning
Following a moving subject at the same speed whilst taking the picture to avoid a blurred image.

Parallax
The mismatch between picture area viewed by the lens and the viewfinder of a range finder camera,e.g. Nikonos/Motor Marine II.

Pentaprism (removable etc.)
The viewfinder system of an SLR camera which allows through the lens viewing. Some professional cameras have interchangeable pentaprisms allowing one with a large viewfinder to be fitted for underwater use, e.g. Nikon F3/F4/F5, Canon F1, Pentax LX.

Port
Literally the 'porthole' through which a lens views underwater.

Programme Mode
A fully automatic mode on a camera which selects aperture and shutter speed for an exposure.

Range Finder Camera
A camera which has a separate lens and viewfinder system. When focusing the photographer must measure or estimate the subject distance and set it on the lens, e.g. Nikonos/Sea & Sea.

Recycle Time
The time taken for the capacitors in a flash gun to recharge after it has been fired.

Reflex Camera
A camera which has a through the lens viewing system, e.g. SLR single lens reflex; TLR twin lens reflex.

Refraction
The bending of light rays as they pass from one medium to another, e.g. from water through glass or perspex to air.

Relative F Stop
See Effective F Stop.

Reproduction Ratio
The size at which a subject is reproduced on film, e.g. 1:1 = life-size, 1:2 = half life size, 1:3 = one third life size and so on.

Resolution
The sharpness at which an image is produced or resolved by a particular lens, film or printing process.

Selective Metering
Where the photographer meters the light in one specific area of an image, e.g. spot metering, selective matrix metering.

Shutter Priority
An exposure mode which allows the photographer to choose the shutter speed and the camera selects the appropriate aperture.

Shutter Speed
The speed at which the camera shutter opens and closes, expressed in fractions of a second, e.g. 1/60, 1/125, 1/250 etc.

Slave Flash
A flash, not connected to the camera, which is fired by the camera activated flash.

Slow Film Speed
A film with a low sensitivity to light, e.g. 25ASA, 50ASA, 64ASA.

SLR
Single Lens Reflex Camera – see Reflex Camera

Snells Window
With calm waters and the sun at the correct angle the effects of refraction form a circular 'window' on the surface of the water. This effect is accentuated by using a super wide or fish eye lens.

Spot Metering
Light is read from a very small area in the centre of the picture area, similarly to centre weighted metering.

Stopping Down
Closing the aperture of the lens.

Strobe
Alternative name for an electronic flash gun.

Supplementary Lens
A lens which fits to the front of a prime lens on the camera, e.g. a close-up dioptre or wide angle converter.

Synchronisation Cord
The lead which connects the camera to the flash gun.

TTL
Through The Lens metering exposure control.

Under Exposure
Insufficient light reaching the film for a correct exposure, resulting in a dark image.

Viewfinder
The device for framing the subject or picture area on a camera. See SLR and Range Finder camera.

Virtual Image
The image created by the negative lens effect of a dome port in water. The image appears to be much closer to the lens than it is in reality.

Water Contact Lens
A lens with a corrective port which only operates when in contact with water, e.g. Nikonos 28mm and 15mm.

Wide Angle Lens
Any lens which reproduces an angle of view greater than that perceived by the human eye, e.g. for 35mm format lenses with a focal length of 35mm or less.

Wire Framer
The framing device used with some extension tubes and close-up lenses for Nikonos/Sea & Sea to indicate the picture area.

Zoom Lens
A lens which combines a range of focal lengths, e.g. 28-70mm, 80-210mm.

DIVING LOCATIONS

This section details some of the locations which I have found to be most productive for underwater photography. Often photographers either want to organise their own diving in order to maximise their time in the water, or organise small dedicated groups or workshops which gives them total control over the day's diving activities. The most popular locations therefore often offer a good combination of beach and live aboard diving or centres dedicated to the needs of underwater photographers. When diving overseas, one of the most cost effective ways of diving is from a live aboard which places your home and dive platform right above the dive site. Three or four dives a day are then possible, on the same location if desired, which is often the most productive approach to a variety of subjects using differing techniques.

Some centres and boats will also permit solo diving for experienced photographers. Whilst this is popular with some photographers, you should not consider it unless you have sufficient experience and confidence and the correct back up equipment, e.g. alternate air source, surface marker 'sausage' in case you drift, strobe flasher etc. Additionally you should ensure that you never undertake hazardous diving alone, e.g. deep, caves, wreck penetration, drift, poor weather etc., and you should always ensure that someone knows you are in the water and your approximate return time.

Cornwall, United Kingdom

I am fortunate that my home base is also one of the best diving locations in the UK. The peninsula of Cornwall juts out into the Atlantic and is bathed by the waters of the Gulf Stream. The granite geology of the coastline creates dramatic cliffs and undersea topography. Strong tides in places feed a diverse range of invertebrate life and fish life is profuse, with occasional visits from Mediterranean or southern Atlantic species. There are some wonderful beach dives and a good range of day boats and live aboards available to groups and individuals. Both the north and south coats are littered with wrecks of various vintages which provide a habitat for marine life and photographic opportunities. A good location for a photographer with a family as the county offers splendid beaches and a variety of alternative activities.

Mediterranean Sea

The Mediterranean has suffered some very bad press with regard to its marine life over recent years chiefly due to over fishing and pollution from the tourist industry. However, there are some pockets of outstanding life where conservation legislation has taken hold, most notably in the Levezzi islands between Corsica and Sardinia and the Medas islands off Estartit in Spain. Here you will find splendid red gorgonians, dozens of fearless groupers and even the occasional shoals of barracuda and jacks. Other locations have a good diving infrastructure and offer good macro photography and clear waters for diver shots with many photogenic caves and wrecks. These include Malta, Gozo and the Balearic islands. The great attraction of the Med' is that it is easily accessible from Europe, relatively cheap and offers good facilities for divers holidaying with their family.

Canary Islands

The volcanic Canary islands may lack reef building corals but do have some spectacular lava reefs teeming with tropical species of fish. The infrastructure of the islands is excellent for a family holiday with some diving and the diving centres here are well organised and run predominantly by European staff. You will find familiar Mediterranean and Caribbean species here in excellent visibility, but for me the greatest attraction has been the opportunity to photograph pods of pilot whales at close quarters. All sorts of cetaceans congregate in the deep waters just off the south west of the island of Tenerife who are accustomed to the daily visits by tourist boats. Some of the diving centres have a licence to take snorkellers out to swim with the pilot whales, who show absolutely no concern for your presence in their environment – the experience is unforgettable.

The Red Sea Reefs

The Red Sea not only ranks as one of the premier dive destinations of the world, but it is also the closest and therefore cheapest coral destinations from Europe. It is an immensely popular area and has seen some explosive development over the last 15 years in the larger centres on the Sinai peninsula and main Egyptian coasts. This inevitably has had a detrimental effect on some of the popular dive sites close in shore, but there is still some pristine diving to be found only a short boat ride from the harbours. It is a paradise for underwater photographers boasting reliable visibility and countless species of corals, fish and invertebrates. The Gulf of Aquaba in the Northern Red Sea boasts some of the most spectacular wall dives to be found any where, whilst exploring further south will reveal hundreds of islands and offshore reefs teeming with life and many of them rarely dived. You can choose to be shore based and take daily beach or boat dives, safari down the desert coast if you are adventurous and don't mind sand in your sleeping bag, or choose a live aboard trip to more remote locations, a favourite with many photographers.

Red Sea Wrecks

The Red Sea has been a major shipping route since biblical times, so if wall and reef diving begin to pall then there are a surprising variety of old and modern wrecks to dive which support their own reef infrastructures. One of the best known locations is the reef of Abhu Nuhas at the mouth of the Gulf of Suez which boasts a total of 5 wrecks ranging in age from 1869 to 1982. These hulks have become coral encrusted and make wonderful photographic backdrops. Further north is the now famous Thistlegorm, whilst south towards Sudan lie a number of commercial ships, historic wrecks and the Umbria outside port Sudan made famous by Hans Hass. If you want to photograph wrecks specifically you will find that a number of live aboard operators offer trips dedicated to wreck diving, particularly in the hotter summer months when the southern Red Sea is at its calmest.

Cuba

Cuba has been quick to recognise that it has a reef system largely untouched by Caribbean standards and since emerging from the protection of the USSR the country has been gently expanding its tourist infrastructure. The majority of visiting divers are from Europe who can choose between the best diving areas on the north coast of the main island and from the southern offshore island of 'Ile Juventos' or isle of youth (sometimes also referred to as the isle of pines). The north offers shallow lush coral reefs similar to those found off the nearby Florida keys, but they are in pristine condition by comparison having seen a fraction of the diver traffic. Diving from the Isle Juventos offers some spectacular wall diving and shallow coral gardens from offshore locations. All the diving is from day boats here using a system of permanent moorings spread over a wide variety of sites. Whilst hotels and food sometimes struggle to meet European standards, this is more than compensated for by the quality of the diving.

Turks and Caicos Islands

The Turks and Caicos are a group of islands, cays and reefs which lie at the southern end of the Bahamas chain. With the exception of the main island of Providenciales, the development here has been relatively low key but all the inhabited islands have a diving centre of some sort. My most memorable diving was at West Caicos island (uninhabited), Grand Turk and Salt Cay, which have areas of unspoilt reef and healthy fish and invertebrate populations. Diving options are by day boat if you are island based, or from a number of luxurious live aboards which are now offering this island group on their itinerary. Grand Turk in particular has a very relaxed turn of the century feel to it and also lays claim to being the actual first landing point of Columbus. These islands are a little off the beaten track and therefore maybe a little more expensive to reach, but the benefits of smaller groups of divers and less crowded boats and reefs make it worthwhile.

Bonaire

Bonaire, one of the Dutch Antilles, promotes itself as the Divers Paradise in the Caribbean, and this is very much an accurate appraisal. There are no seasonal diving restrictions here as the island lies south of the hurricane belt and provides a lee shore on it's western side year round. The reefs and reef life are outstanding, but what really sets the island apart for photographers is the ease and quality of the beach diving here. Boat dives are available to numerous sites and to the small neighbouring island of Klien Bonaire, but most of the diving centres have tanks available for literally unlimited beach diving 24 hours a day. Many of the hotels have a good reef on their doorstep, or you can hire a car to visit one of the sites further afield all of which are identified by a roadside marker. Facilities at most centres for photographers are excellent, particularly Captain Don's Habitat which has a very relaxed approach and atmosphere. Live aboard boats do visit here and the neighbouring islands of Aruba and Curacao, but this is one location where there is no advantage to being ship based.

Florida

For most the mention of Florida will immediately bring to mind the reefs of the Florida keys. However, whilst this is a favourite location for some a really different diving experience for photographers is to be found in the freshwater springs and rivers of the west coast. The visibility in the spring areas of Crystal River and Ginnie springs has to be seen to be believed and will produce some fantastic photographic opportunities. The other great attraction here is the opportunity to dive with and photograph manatees who move into the warm spring areas during the chillier winter months. It is best to investigate on arrival where the manatees are congregating before choosing a specific area and dive operator, as they tend to migrate between areas. The area also offers excellent distractions for an accompanying family, with Disney World and other theme park attractions all close at hand.

The Maldives

The Maldive comprise a group of 1,196 islands and atolls off the west coast of India which stretch for more than 470 miles (752 km) toward the equator. The islands have been subjected to very controlled low key development which has kept the tourist industry restricted to a relative handful of islands and largely remote from the Muslim population. There is superb diving throughout these islands which offer warm clear waters teeming with Indo/Pacific marine and coral life. It is a wonderful destination for divers, particularly photographers but offers nothing to those not dedicated to island life, sun worship and water sports – it is not a place to bring children! The range of diving is diverse – from the house reef on every island to oceanic drop offs on the edge of the atolls, where currents can be strong and swells uncomfortable. Most visitors choose the island experience with daily diving, but the dedicated photographer will probably opt for one of the live aboards many of which offer luxurious accommodation. This is a remote location to consider, although there are a number of charter flights now available from Europe and the infrastructure is good, so it is well worth the effort as the photographic opportunities are seemingly endless.

Oman

Oman is probably better known as a middle eastern oil producer than a diving destination. However, their is a growing tourist industry and there is some very interesting diving to be experienced on the gulf coast and the Indian Ocean coast. The desert capital Muscat offers a cosmopolitan base for diving the gulf coast which offers fringing reefs, drop offs and islands all rich in fish and invertebrate life. The waters here are nutrient rich, which means visibility is rarely stunning, but attracts huge shoals of fish and regular visits from mantas and whale sharks. A complete contrast awaits you on the sub tropical Indian Ocean coast of Oman at Salalah, which has a very Indian or Sri Lankan feel to it. This area is not dived during the rough monsoon season, but directly after this period offers the chance to see coral reefs and temperate giant Japanese kelp forests on the same dive! Sea weeds and some temperate species take hold temporarily after the waters have been cooled by the monsoon, but die off quickly as the summer temperatures rise, so time your visit well. Almost every Indo-Pacific species is found here and the southern coast is famed for its exotic range of nudibranchs.

South Korea

South Korea is not a diving destination which would immediately spring to mind, but I was fortunate enough to be invited to sample the location during the 1994 CMAS World Championships of Underwater Photography. Although there is diving available around the South Korean peninsula, the most popular location is the sub tropical island of Chejudo. This volcanic island offers a truly different diving experience with it's mix of tropical and temperate marine life. Imagine swimming through a kelp forest with urchins and wrasse and then being confronted by a wall of yellow soft coral with lion fish and jacks cruising by – this is what Chejudo island offers. Visibility varies with the seasons, but at it's best will be 20-25m, but the macro life here is stunning. The diving infrastructure is at present still basic by Red Sea or Caribbean standards, but is still more than adequate and you have the feeling you are breaking new ground. An awkward destination for many to reach, it is becoming increasingly popular with Japanese tourists, so expansion would seem inevitable. Diving is only available from day boats which will often leave groups for the day on one of the small volcanic islands with a picnic and enough tanks for two or three dives. Shore based accommodation ranges from basic local to luxury western style and the cost of living is reasonable by western standards.

INDEX